exploring

3D MODELING WITH CINEMA 4D R9

exploring

3D MODELING WITH CINEMA 4D R9

Tony Alley

THOMSON

DELMAR LEARNING™ Australia Canada Mexico Singapore Spain United Kingdom United States

Exploring 3D Modeling with Cinema 4D R9
Tony Alley

Vice President, Technology and Trades SBU:
Alar Elken

Editorial Director:
Sandy Clark

Senior Acquisitions Editor:
James Gish

Development Editor:
Jaimie Wetzel

Marketing Director:
Dave Garza

Channel Manager:
William Lawrensen

Marketing Coordinator:
Mark Pierro

Production Director:
Mary Ellen Black

Production Manager:
Larry Main

Production Editor:
Dawn Jacobson

Technology Project Manager:
Kevin Smith

Editorial Assistant:
Niamh Matthews

Cover Image:
Signs of the Times
oil on canvas © David Arsenault

Library of Congress Cataloging-in-Publication Data

Alley, Tony.
 Exploring 3D modeling with Cinema 4D R9 / Tony Alley.
 p. cm.
 Includes index.
 ISBN 1-4018-7877-6
 1. Computer graphics. 2. Cinema 4D XL. 3. Three-dimensional display systems. 4. Computer Animation. I. Title.
 T385.A457 2005
 006.6'93 – dc22
 2005010650

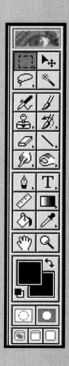

| contents |

contents

CONTENTS

To my students.

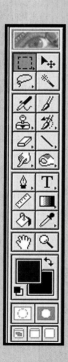

| preface |

preface

INTENDED AUDIENCE

You see 3D models everywhere today: feature films, television shows, commercials, virtual environments, education and training materials, scientific and medical visualizations, print ads, and even as fine art in galleries. Creating 3D models, scenes, and animations is wonderfully fulfilling work. The process is especially interactive and you have unprecedented control over the look and feel of characters and scenes, lighting and shadows, materials and textures, and every other aspect of your work. It's also a treat to be working at the leading edge of technology and aestheticism, defining new genres as you go.

Perhaps you're a college student or enthusiastic hobbyist just starting out in computer graphics and new media, or perhaps you're an accomplished 2D designer interested in exploring the expanding world of 3D. Whatever your background, *Exploring 3D Modeling with Cinema 4D R9* has something for you. This book has been written in such a way that you should be able to get going with 3D in no time at all. Basic concepts are clearly presented with plenty of examples and supporting material, and you'll be presented with lots of opportunities to practice what you've learned with one of the most capable modeling and animation applications available today, Maxon's *Cinema 4D* version 9.1.

BACKGROUND OF THIS TEXT

Computer-based 3D modeling certainly isn't new. Consumer-level 3D modeling programs have been around since the early-1980s. However, it's only within the last few years that hardware capabilities and the costs associated with 3D production have evolved to

where casual users, hobbyists, and freelance professionals on a budget can explore its potential.

Many would-be users have been put off by the complexity of 3D modeling software; and in those instances where a user was able to find a software package that wasn't especially complex, it was usually because it wasn't especially capable either. Maxon's *Cinema 4D* is an exception to that rule. An extremely powerful 3D modeler, *Cinema 4D* is also quite easy to use. Its interface is straightforward and simple to understand. With a modest investment of time and study, you can create compelling visuals.

Really, as long as you have a good understanding of your computer's operating system (Macintosh or Windows), you should have no problem working your way through this text. You'll be at an advantage if you have a fair grasp of basic computer graphics concepts and applications like *Adobe Photoshop* and *Illustrator* or Macromedia *Freehand*, but that isn't essential. Using *Cinema 4D*, you'll quickly pick up the foundational concepts behind 3D modeling.

Deciding what to include and what to leave out of this book was a challenge. My goal was to provide enough foundational material to get you started and to whet your appetite with interesting examples that you might put to good use right away. Most of the images in the color insert were created by my students, many after only a couple weeks of experience with *Cinema 4D*; so, the types of models you see there should be well within your grasp by the time you finish this book. Certainly, I hope you enjoy the book and find it useful but more than that, I hope you find as much enjoyment crafting 3D worlds and characters as I do.

TEXTBOOK ORGANIZATION

This book is organized into eight chapters. The three chapters on modeling (2, 4, and 6) are separated by chapters on using materials, lighting your scenes, and rendering. Chapters are organized such that most users will want to start with Chapter 1 and work sequentially through to the end of the book, but depending on your interests and abilities, you could follow almost any path you'd like. For instance, you could tackle the chapters on modeling first if you wish. Likewise, if you're in a hurry to learn about applying materials and textures, you might work through Chapters 3 and 7 imme-

diately after you've completed Chapter 2. Skim through the book and the brief descriptions of chapters below and choose a route that works best for you.

Chapter 1: Overview and Tour

The opening chapter of the book presents foundational 3D modeling concepts and introduces you to the *Cinema 4D* graphical users' interface.

Chapter 2: Parametric Primitives

You start modeling in Chapter 2 using parametric primitives, the predefined basic building blocks included with 3D modeling applications. These include shapes like cubes, spheres, cones, and cylinders. In addition to getting you started modeling simple objects, the chapter will put much of the background information from Chapter 1 into practical use.

Chapter 3: Basic Texturing

Until you've applied a material to your model, it appears a neutral gray. That won't do! Chapter 3 introduces you to basic texturing concepts and teaches you to apply materials to your models.

Chapter 4: Spline-based Modeling

Parametric primitives are great. They are easy to use and because they're defined mathematically, they don't place much of a strain on your computer. Unfortunately, you're limited in what you can do with them. Chapter 4 introduces splines which allow you to model much more complex shapes: drinking glasses, doorknobs, chess pieces, table legs, bottles, light bulbs, 3D icons, and more.

Chapter 5: Lighting the Way

Now that you're modeling with splines and primitives and you have a fair understanding of materials, Chapter 5 adds a little light to the environment. Here, you'll learn about the three-point lighting system and many of the options for configuring light sources and shadows in *Cinema 4D*.

Chapter 6: HyperNURBS and Polygonal Modeling

Chapter 6 takes you back to modeling with extremely powerful HyperNURBS, a special tool for modeling smooth-flowing and organic models. In this chapter, you'll modify your models at the level of points, edges, and polygons.

Chapter 7: Texturing: Part II

Chapter 7 introduces you to some of the more advanced aspects of applying materials and textures. You'll use textures to cut away at the models you've created and to enhance their surface features. You'll create decals that you can apply to your models. In this chapter, you'll also learn to create your own textures.

Chapter 8: Rendering

Finally, Chapter 8 introduces you to *Cinema 4D*'s powerful rendering engine. You'll learn to adjust settings and optimize the rendering process for specific purposes. You'll also learn to render your scenes such that the look like flat, 2D cartoons or photorealistic images.

Companion CD

The CD bundled with this book contains lots of helpful material. The folder called "Demo Software" includes both Macintosh and Windows-compatible demo versions of *Cinema 4D* version 9.1. Also in this folder, you'll find a copy of the *Cinema 4D* Reference Manual, QuickStart Manual, and files used in the QuickStart tutorials. Also, each chapter of the book has its own folder on the CD. These folders contain the files you'll need to complete the tutorials for the chapter. Some chapter folders also include additional files (such as models and textures) for you to experiment with. Finally, the "Bonus Material" folder contains three recent issues of *3D Attack,* a phenomenal resource for *Cinema 4D* users. The magazine, available online at www.3dattack.net, typically includes several great articles, tutorials, plug-ins, textures, interviews, and more. Many of the resources on the CD are compressed to save space. These files are easily expanded using *WinZip* on the PC or *StuffIt Expander* on the Macintosh or some similar utility.

FEATURES

The following list provides some of the salient features of the text:

- Learning goals are clearly stated at the beginning of each chapter.

- Projects presented throughout the book allow readers to take a practical "tools and techniques" approach to putting what they've learned to work.

- In Review sections are provided at the end of each chapter to quiz a reader's understanding and retention of the material covered.

- Exploring on Your Own sections offer suggestions and sample projects for further study of the content covered in the each chapter.

- A full-color section provides stunning examples of 3D modeling results that can be achieved using *Cinema 4D 9/9.1*.

- A back-of-book CD contains files necessary to complete the book's tutorials, video demonstrations of some complex 3D modeling techniques, interesting textures, a few goodies, plus a trial version of *Cinema 4D 9.1*.

- All files and exercises are fully compatible with Maxon's *Cinema 4D* release 9.1

E.RESOURCE

This electronic manual was developed to assist instructors in planning and implementing their instructional programs. It includes sample syllabi for using this book in either an 11- or 15-week semester. It also provides answers to the end-of-chapter review questions, PowerPoint slides highlighting the main topics, and additional instructor resources. ISBN: 1-4018-7878-4

HOW TO USE THIS TEXT

The following features can be found throughout the book:

◢ Charting Your Course and Goals

Each chapter begins with a brief introduction and a set of goals to guide your learning. These frame the materials and establish competencies that the reader should achieve upon understanding the chapter.

◢ Don't Go There

These boxes appear periodically throughout the text to steer you away from common pitfalls and suggest cautionary practices.

In Review and Exploring on Your Own

Near the end of each chapter, you'll find a set of review questions designed to help you assess your learning and reinforce key concepts. Also at the conclusion of each chapter, suggestions for further explorations are provided to guide you toward additional applications of chapter concepts and practices.

Adventures in Design

These brief spreads contain examples of how approach a design project using the tools and design concepts taught in the book.

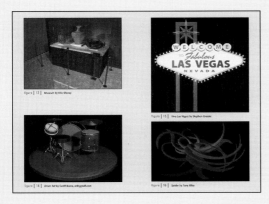

Color Insert

The color insert demonstrates work that can be accomplished using Maxon's Cinema 4D.

ABOUT THE AUTHOR

Dr. Tony Alley is an Associate Professor of both Art & Design and Mass Communication at Oklahoma Christian University. He teaches a variety of CG courses using Adobe *Photoshop* and *Illustrator*; Maxon *Cinema 4D*; and Macromedia *Freehand, Flash,* and *Director;* graphic communications, and interdisciplinary works in leading-edge media. His dissertation research, completed in 2003, focuses on college students' understandings of creativity in the field of computer graphics. Tony also holds an education specialist's degree in adult education, a master's degree in educational psychology, and a bachelor's degree in psychology. In addition, he is a retired US Air Force tactical reconnaissance pilot and worked as an instructional systems designer for the Air Force, creating multimedia-learning applications for pilot training and professional officer education. He is also an active member of the Association for Computing Machinery's Special Interest Group in Computer Graphics and Interactive Techniques (ACM SIGGRAPH).

ACKNOWLEDGMENTS

I would like to thank all the fine people at Maxon USA for their support and assistance, especially Paul Babb, Rafi Barbos, Diana Lee, and Nicole Hogan. They're a top-notch crew and I couldn't have pulled this off without their help.

I am especially grateful for the encouragement, assistance, and support provided by the Thomson Delmar Learning team, especially Jim Gish, Acquisitions Editor, and Jaimie Wetzel, Development Editor. Their dedication to this effort was an inspiration for me. Thanks also to Niamh Matthews, Editorial Assistant, and Dawn Jacobson, Production Editor. I'd also like to acknowledge the great help of Lauren Dowd and her team at Pre-Press, Inc. They're all true professionals!

A special thanks goes to Tavy Hillaker and Thomas Pasieka at *3D Attack* for allowing me to include a small sampling of their truly great work on the CD.

I must thank my Fall 2004 3D Modeling students (Autumn, Cary, Casey, Charles, Chris, Dustin, the twins [Erin 1 and Erin 2], Hayley, Heath, Janie, Jennifer, Kelli, Libbie, Rachel, Ryan, Stephen, Zane, and Geoff) for their contributions, their inspiring works, their humor, and their camaraderie. I'd also like to extend my gratitude to my peers at Oklahoma Christian.

Finally, I want to thank my wife whose tolerance and love know no bounds!

Thomson Delmar Learning and the author would also like to thank the following reviewer for his technical expertise:

ERIK S. MILLER
Assistant Professor
Computer Graphics & Visual Communication
The Community College of Baltimore County
Baltimore, Maryland

QUESTIONS AND FEEDBACK

Thomson Delmar Learning and the author welcome your questions and feedback. If you have suggestions that you think others would benefit from, please let us know and we will try to include them in the next edition.

To send us your questions and/or feedback, you can contact the publisher at:

Thomson Delmar Learning
Executive Woods
5 Maxwell Drive
Clifton Park, NY 12065
Attn: Graphic Communications Team
800-998-7498

Or the author at:

Tony Alley
Oklahoma Christian University
2501 E. Memorial Rd.
Edmond, OK 73013
tony.alley@oc.edu

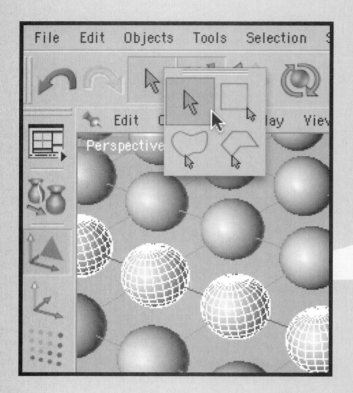

overview and tour

1

 charting your course

Even if you have a fair bit of experience with computer graphics software—programs like Adobe *Photoshop* or Macromedia *Flash*—modeling and animating in 3D is probably unlike anything you've ever done before. Consequently, it is especially important that you take some time early on to get to know, in general terms, what 3D modelers and animators do; that is, the process they go through to produce a still image or an animation. Understanding the process will give you some insight into why the book is organized as it is and help you see how concepts and practices fit together.

But you'll want to go beyond the conceptual just as soon as possible and begin building models and scenes you can use in your work. To that end, a demo copy of Maxon's *Cinema 4D* (C4D from here on out) has been included on the CD bundled with this book. It's a first-class modeling application and, like few others, it combines substantial power and flexibility with an easy to learn users' interface. Let's get your journey started.

 goals

In this chapter you will:

- **Explain, in broad terms, the process of producing an animated 3D model**

- **Demonstrate an understanding of the 3D modeling and animation workspace**

- **Demonstrate an ability to use the C4D graphical users' interface for creation and manipulation of simple objects**

AN INTRODUCTION TO 3D

The last ten years have seen great strides in 3D modeling and animation. Hardware capabilities have increased substantially. Coinciding with faster CPUs, dedicated graphics processors, more available memory, and increases in storage space, the 3D modeling and animation software available to hobbyists, enthusiasts, and computer graphics professionals has come to be especially capable, with costs plummeting in the last few years. With C4D and a fairly capable computer, today's aspiring artists and animators can produce breathtaking images and short animated videos on a very modest budget. It all comes down to motivation, time, dedication, and understanding.

Workflow in 3D Modeling and Animation

Work in 3D is often presented as a five-stage process: modeling, texturing, lighting, animating, and rendering. However, this leaves out what might be the most important stage of all: planning. It's easy to forego the time and effort required to think through your work in advance and, instead, go straight to the computer. Sometimes you can get away with that and, if you have no particular outcome in mind, it can be fun to start with some object on the screen and push and pull at it until something interesting starts to emerge. However, that's probably the exception rather than the rule, especially if you are trying to turn a profit with your work.

Most often, you'll want to take some time to sketch out your ideas before you launch your 3D modeling software. Even if your drawing skills are limited, the process of putting your ideas on paper—perhaps making a quick sketch of your model or a storyboard for your animation—compels you to think through what you're trying to accomplish. At the very least, make some notes or find examples of whatever it is you intend to model in magazines, photographs, technical plans, or blueprints. Do some research. Get a good feel for the objects you want to build. How do they behave or how do they appear in different situations? What motivates them or what is their intended purpose? Get to know your objects and characters especially well. Then start to model! Of course, plans change but try to start with an end-state in mind.

Modeling

With your plans in hand, you'll typically start by modeling the key elements of your scene. Modeling is the process of building scenes and objects. There's no single way to model; that is, there is no one tool that you'll use for every modeling task. On the contrary, it's a complex process that is sometimes akin to building a house from prefabricated materials, at other times like sculpting an object from a pliable lump of clay, and still at other times like using tools to cut away at solid materials a bit at a time until what is left is your modeled object. Often, it is very slow work that requires careful placement of the tiniest components that influence the shape of a larger object, sometimes only one component at a time. It is an art, and it is a craft. Most of the chapters that follow focus on varied ways to model scenes and objects.

Texturing

In many 3D software applications, modeled objects initially appear neutral-gray in color and smoothly textured. At some point, you'll want to change that. After all, what differentiates a basketball from a beach ball is color and texture. So, as part of the texturing process, you can make objects appear smooth or rough, transparent or opaque, pristine and new or tarnished and well-worn, and of any color. The possibilities are almost endless. Don't underestimate the amount of time you'll need to spend in this phase of the process. All too often, novice 3D modelers spend hours and hours trying to get the finest details of their object just right, only to slap a material onto the object that is so poorly conceived and applied that the desired mood or effect is totally destroyed.

Lighting

Likewise, the difference between a drab, unattractive image and one that evokes strong emotions is often the lighting. 3D software applications typically include a variety of lighting types and colors. In C4D, for instance, your scenes can include spotlights, tube-lights, distant lights, and/or others. You can control the look and feel of shadows. You can generate lens flares and you can even simulate light passing through a smoke-filled room or a stained-glass window. Again, plan on spending lots of time lighting your scenes. Also, immerse yourself in real-world situations and experiences that make careful use of lighting: for example, your local theater

group or a photographic studio. Many people don't realize how little they know about light until they're challenged to light a scene. Your local theater crew or a friendly photographer will be able to give you some great insights. If you're at a college or university, take a course in stagecraft and lighting or a course in studio photography. It's almost certain to enhance your skills in 3D modeling and animation.

Animating

In many instances, animating in 3D is similar to animating in 2D applications like Macromedia *Flash*. You can create keyframes (main frames containing essential waypoints in the animation) and allow the computer to create intermediate frames for you (a process known as *tweening*). You can also create skeletons for your objects and animate those objects by manipulating the bones of the skeleton. You can create paths and animate lights, cameras, and objects along those paths. You have many options, more than could be covered in a chapter or two. Consequently, the especially challenging tasks associated with animation have been left for a second book.

Rendering

With your scene or object completed, you conclude your work by rendering. To render is to output your work as a 2D image or animation. However, the process is a little more complicated than you might think because you have several parameters that you can adjust in order to influence resolution, image size, image quality, file format, and much more. Because everything typically comes together in greatest detail during rendering—it's only when an image has been rendered that you can fully assess the impact of lights and shadows, transparent objects, and reflective materials—it can take a very long time: hours and hours. A little later in the book, you'll read about how to get the most out of the time spent rendering.

Putting It All Together

Now, you may have gotten the idea that 3D modeling and animation is a linear process, but that's certainly not the case. Some of the tools that are most closely associated with texturing can actually be used to influence the apparent structure of an object. For instance, Figure 1–1 shows three spheres. The modeled structure is exactly

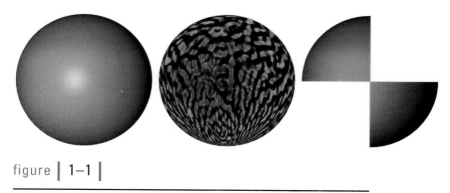

figure | 1–1 |

Using Materials as Modeling Tools

the same for all three. The differences you see are caused solely by applying different materials to the object. Notice that the middle sphere looks quite bumpy and the sphere on the right looks as if parts have been cut away. In both cases, modeling had nothing to do with the appearance, only texturing. You can see, then, that the stages of modeling and texturing can't really be considered in isolation. The same is true of texturing and lighting. Lighting can have a substantial impact on the appearance of a material. Also, modeling can have a pronounced influence on how an object can be animated: for example, whether it will bend smoothly or appear rigid and inflexible. Clearly, the process of modeling and animating a 3D object is not linear, but typically requires you to move back and forth between stages, realizing that work in one stage influences your work in other stages.

Understanding the 3D Workspace

Most computer-based 3D modeling is an illusion. That is, except for those rare times when you might output your work to a milling machine or a rapid prototyping system (expensive systems that create 3D models by cutting objects out of metal, or layering a resin or wax, layer upon layer, to produce a tangible 3D object), you'll output to film, paper, or your computer screen: all 2D output devices! Of course, you'll model and animate at your 2D computer screen, too. But that's not to say that there are no differences between drawing or painting in 2D and modeling and animating in 3D. The third dimension, depth, is often simulated in 2D work through use of, for instance, 1-, 2-, or 3-point perspective and an appropriate

number of vanishing points, but once the work is begun, these points are generally fixed. There's no changing the camera angle or shifting selected objects between foreground and background without starting all over again. You're not nearly so constrained when working in 3D. Perhaps the point can be made clear if you go ahead and get started with C4D.

X, Y, Z Coordinate System

Creating on canvas or on a sheet of paper, you have the two dimensions of height and width to work with. Imagine that you're using a piece of graph paper to plot the relationship between hemlines and the stock market (believe it or not, these two items really do correlate). You might plot the Dow Jones Industrial Average along the horizontal axis, such that a lower average is to the left of a higher average, and hemlines on the catwalks of New York's hottest fashion houses along a vertical axis, such that miniskirts are near the top of your paper and ankle-length skirts are at the bottom of the page. Values from left to right would read in dollars and values from top to bottom would read in inches above the ankle. If you were a statistician, you would most likely label the horizontal line X and the vertical line Y. Well, guess what. This same paradigm is used in 3D modeling. Your two dimensions of left-right and up-down are labeled X and Y. Check it out:

1. Launch C4D.

2. Once C4D is up and running, press the F4 key on your keyboard. This will take you to the front view of your 3D workspace (see Figure 1–2). Near the center of your screen you'll see a window. This window is called a viewport or an editor window. It is comprised of a set of dark gray gridlines. You'll also see a red horizontal line that represents the X axis and a green vertical line that represents the Y axis. The point where the red and green lines intersect is called the *origin*. The gray gridlines represent distance away from the origin. At the origin, both X and Y equal 0.

Notice the arrowheads at the ends of the red and green lines. These arrows point toward increasing values. That is, as you move an object up above the origin along the green Y axis, its position value increases; like the altitude indicated on an aircraft's altimeter increases the higher above the earth's surface it climbs. Moving

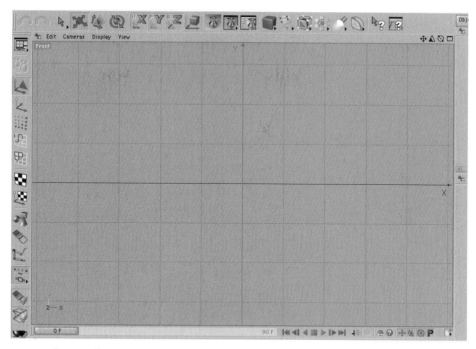

figure | 1–2 |

Front View: X and Y Axes Visible

down below the origin, values are negative and decrease the farther below the origin you move the object.

Also notice how the gridlines run parallel/perpendicular to one another; that is, they do not converge. This means that the front view is an *orthographic* view. Two objects of the same size will always appear the same size in this view, regardless of how close to you they are. Orthographic views are great for aligning objects in your scenes.

3. Press the F3 key on your keyboard (see Figure 1–3). At first, you may not notice much of a difference, but look closely at the colored lines that divide the gray workspace. This is the right view (and you'll see the word "right" in the upper-left corner of your screen). The red line has been replaced with a blue line. This blue line represents depth, the Z axis. Position values along the Z axis increase as an object is moved farther right in this viewport. Of course, left of the origin, values are negative and decrease the farther left an object is moved.

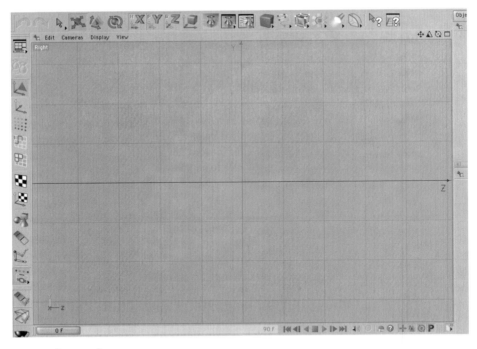

figure | 1–3 |

Right View: Y and Z Axes Visible

So, what has happened to the red X axis? It's pointing straight at you! You don't see it because it is an infinitesimally thin line running perpendicular to your computer's monitor. By the way, remember the arrowhead of the X axis in the front view. It's pointing toward you now, such that X values increase the closer they get to you. Of course, the front view is also an orthographic view.

4. Next, press F2. This brings up the top view. Here, you see the X and Z axes. You are looking straight down the Y axis from above. The top view is also orthographic.

5. Next, press the F1 key (see Figure 1–4). Here, finally, you see all three axes in plain view: X running generally from left to right, Y running bottom to top, and Z running near to far. This is the *perspective* view. The perspective view is unique in that gridlines in this view converge out near the horizon. It is not an or-

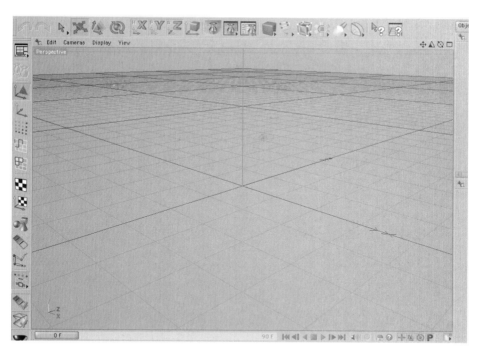

figure | 1–4 |

Perspective View: X, Y, and Z Axes Visible

thographic view and so objects closer to you in this view will appear larger than objects of the same size placed farther back, just as in real life.

6. Finally, press F5. Now, you can see all four views at one time: the perspective view in the top left, the top view in the top right, the right view in the bottom left, and the front view in the bottom right.

C4D allows you to configure the editor windows in a variety of ways but in these early days, you may find it easiest to work with this default arrangement, using the F1 through F5 keys on your keyboard to quickly jump back and forth between views as your work demands. It's in the editor windows that you'll directly manipulate objects: moving them around, pushing and pulling at them to alter their shape, etc.

With that brief introduction to 3D space behind you, you're ready to spend a few minutes studying the C4D workspace and venture even deeper into 3D. Press F1 and then look at Figure 1–5. Hopefully, it looks just like your computer screen.

Problems?

If your screen doesn't look like Figure 1–5, try this. First, press F1 to make sure you're in the perspective view. Next, click on Edit in the set of menus immediately above the editor window you've been studying—not the Edit menu in the main set of menus above the icon bar—and select Frame Default. Finally, click on Window in the main menubar across the top of your screen and choose Layout > Standard. This should return all of C4D's windows and icon bars back to their default settings.

The C4D Graphical Users' Interface

Notice that the C4D graphical users' interface is divided into several components: windows, menus, dialog boxes, and toolbars.

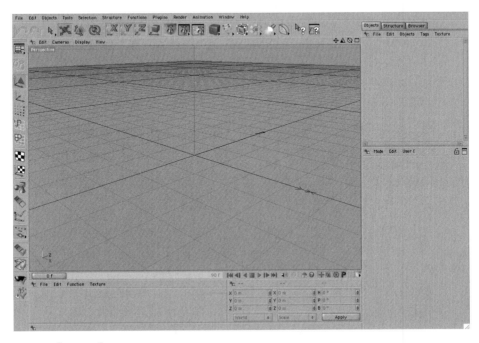

figure | 1–5 |

C4D Graphical Users' Interface

Customizing the C4D Interface

C4D's interface is highly customizable! However, until you have a good bit of experience with C4D, you'll benefit by using the default layout. Later, as you develop a feel for the different tools and decide on a workflow that works best for you, you can modify the interface as you desire. Major interface modifications, although fairly easy in C4D, are beyond the scope of this book. If you're interested, read through the C4D *Reference Manual* on the CD that accompanies this book for details.

Main Menus

Across the top of the screen, you'll see the main set of menus beginning with File, Edit, and Objects (see Figure 1–6). The menu system in C4D works the same way that menus do in most other programs. Do notice, however, that some menu items are followed by

figure | 1–6 |

C4D Menus

arrowheads. Place your cursor over these menu items to reveal submenus and other options. Some menu items are followed by an ellipsis (three dots in a row like this, . . .). When you select these menu items, a dialog box will appear onscreen allowing you to enter parameters or make some selection, such as where you'd like to save your file. Before you move on, notice that this isn't the only set of menus on your screen. Many windows have a set of menus particular to those windows. This can present a few challenges, but you'll get used to it quite soon. These other menu sets will be addressed at a more appropriate time. Table 1–1 lists headings for the main set of menus and briefly describes each of them.

Many of the items available through this system of menus and submenus are also available as icons in the two primary toolbars, sometimes called *command palettes*: one along the top of the screen immediately under the main menu items and one along the left edge of your screen. Here, too, items can be folded or nested, as indicated by a small black arrowhead near the lower-right corner of the icon. Clicking and holding your mouse button down on one of these icons reveals other icons.

Main Toolbar—Horizontal

Many experienced C4D users find accessing the software's features through menus a bit cumbersome. Instead, they find the process of creating or modifying objects via C4D's keyboard shortcuts and toolbars a much faster way to work.

Undo/Redo. At the far left of the horizontal row, you see a set of arched arrowheads. Clicking the one on the left undoes your last manipulation of an object. The right arrowhead redoes the last manipulation. By default, C4D gives you 10 levels of undo.

Live Selection Tool. Click and hold to reveal four selection tools. These allow you to select (make active) objects, polygons, points, etc.

Move, Scale, Rotate Tools. These icons establish the course of action to be executed in an editor window. For example, using the Move Tool when a cube is selected, and then clicking and dragging in the window, will cause that cube to move around in your 3D space.

Axis Lock/Unlock. Axis Lock/Unlock allows you to constrain the movement, scaling, or rotation of a selected element to specified

table | 1–1 | **Main Menus**

File	As with most other software applications, the File menu is where you'll go to open, save, and close files.
Edit	Use menu items under Edit to cut, copy, and paste objects or parts of objects. Also notice that this is where you set preferences for the current project or for the C4D application itself.
Objects	You will use the items and subitems under the Objects menu to create models and scenes.
Tools	Under the Tools menu, you'll find items that allow you to move, scale, or rotate the currently selected object or element; a magnify feature that allows you to zoom in on your work; items that allow you to work with entire objects or just their polygons, edges, or points; and items that allow you to constrain movement, scaling, and rotation to particular axes.
Selection	Under the Selection menu, you'll find options that allow you to alter your current selection. For instance, if you have a group of points selected, you can invert that selection such that those points are no longer selected, but all other points are.
Structure	The Structure menu provides tools that allow you to alter the structure of an object or selected elements. Here, you can add points; bevel a polygon; move, scale, or rotate polygons; and cut/subdivide polygons with a knife.
Functions	Items under the Functions menu allow you to duplicate objects, align objects, create multiple copies of objects and arrange/distribute them at the same time.
Plugins	C4D is extensible. That is, its power can be extended through the use of plugins: applications that add new features and capabilities. You can access plugins through the Plugins menu.
Render	As mentioned earlier, at some point you'll want to see your scenes and objects not as they exist in the editor, but as they'll look when you output them as high-resolution graphics or animations. The Render menu allows you to render all or part of a view, render a view in an editor window or in an external window, and alter render settings.
Animation	The Animation menu is where you'll go to build and play animations.
Window	The Window menu allows you to make different windows active (bring them to the forefront) and change the screen layout.
Help	In its current configuration, the Help menu refers you to Maxon's documentation for assistance. You'll also use this menu to enter your C4D serial numbers.

axes. For example, with the Move Tool selected, the Y axis disabled, and the X and Z axes enabled (as illustrated), clicking and dragging in a window will move the selected object along the X and Z axes only. Its position along the Y axis will not change.

World/Object Coordinate System. This item allows you to move, scale, or rotate objects along specified axes relative to either the 3D world or the object itself. That is, sometimes an object's alignment will be changed such that its axes are not aligned to the 3D workspace axes. When you choose to move, for instance, that object along the X axis, you will want to decide if it should be moved along its own X axis or that of the 3D workspace.

Render. These icons allow you to render the active view in the editor window, render to an external window, render parts of an active view, and set parameters for rendering.

Object Creation Tools. The next six icons, all of which can be expanded to reveal other icons, allow you to create parametric primitives, spline-based objects, NURBS objects, modeling objects, lights and cameras, and deformations. These are the building blocks of 3D.

Main Toolbar—Vertical

While you'll turn to the horizontal toolbar to create and manipulate objects, you'll use the vertical toolbar to set your mode of operation; that is, the level at which you want to edit objects and their associated materials.

Layout Selection. Click and hold the Layout Selection icon to select from a variety of pre-established interface configurations: modeling, animation, standard, etc.

Make Object Editable. Make Object Editable makes an object that is defined by mathematical parameters editable, such that it can subsequently be modified on the level of polygons, edges, or points.

Use Model Tool. You'll select this tool when you want to manipulate (for example move, scale, or rotate) an object.

Use Object Axis Tool. The Use Object Axis Tool allows you to move or rotate an object's axis without moving or rotating the object itself.

Use Points Tool. Rather than make large-scale changes to an object, you'll often want to select the Use Points Tool to edit the object's smallest components, its points, for careful refinement.

Use Edge Tool. The Use Edge Tool allows you to edit an object by manipulating the edges of its polygons.

Use Polygon Tool. The Use Polygon Tool allows you to modify an object's polygons.

Use Texture Tool. This tool is used when you want to manipulate (for example, move, scale, or rotate) the material that you've applied to an object.

Use Texture Axis Tool. You'll use the Use Texture Axis Tool when you need to move or rotate a material's axis without moving or rotating the material itself.

Macs vs. Windows

C4D runs great on either the Mac or the Windows operating system. Generally speaking, the most noticeable differences will be in the appearance of a few interface elements, and most of those are more closely associated with the operating system itself, rather than C4D. These include items such as the close window icon, minimize window icon, and maximize window icon. Of course, the dialog boxes that appear when you, for instance, open or save files will differ but again, these are operating system differences and not really C4D differences. So, provided that you are familiar with your operating system, the instructions provided in this book should be very easy to understand regardless of which operating system you're using. It's worth noting that Mac users may find using a two (or more) button mouse helpful, but even that isn't a necessity. Should you come across any instructions that require you to "right-click," you can simply hold down the Command key to simulate the second mouse button.

C4D Interface in Action

The following short exercise will allow you to come to grips with the 3D workspace as well as C4D's essential commands:

1. If it's not already running, launch C4D.

2. From the vertical toolbar, click and hold the Layout Selection icon (uppermost icon in the toolbar) and move your cursor to the right to select Standard. This resets the interface to its factory defaults.

3. Press the F1 key on your keyboard to see the perspective view.

4. Click once on the Cube Primitive icon (looks like a blue cube) in the horizontal icon bar and a cube appears in your scene (see Figure 1–7). Notice that new objects, like your cube, initially appear at the origin of your workspace (where X, Y, and Z all equal 0). You can confirm these values by referring to the Coordinates Manager located near the bottom of your screen (see Figure 1–8).

Notice the three sets of axes in the editor window: one in the bottom-left corner of the perspective view, one that seems to sit flat on the grid space defined by the X and Z axes, and one centered inside the cube. The first two orient you to the workspace. The third displays the axes of the object itself, which may or may not be aligned with the workspace axes depending on whether you have, for instance, rotated the object.

It's easy to remember which axis is which. You're probably familiar with the abbreviation RGB that stands for red, green, blue, a color mode used in many digital paint programs and the color standard

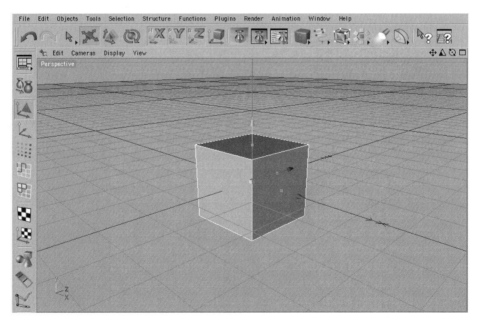

figure | 1–7 |

A Cube at the Origin of Your 3D Workspace

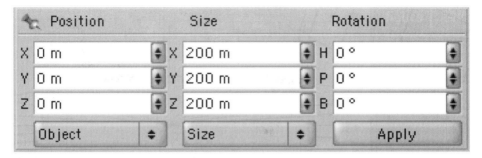

figure | 1–8 |

Coordinates Manager: Cube Is Positioned at X, Y, Z of 0, 0, 0

for display systems. The X, Y, and Z axes in C4D are colored red, green, and blue, respectively. So, just remember that XYZ equals RGB.

5. Next, click once on the Move Tool in the horizontal command palette. It's the fourth icon from the left and looks like a small blue cube with red arrows running through it. If necessary, re-fer to the preceding pages that addressed the horizontal and vertical icon bars.

6. Click and hold the bright red arrow extending out from the right side of the cube that you added to your perspective view and drag your mouse to the right. There's a lot going on here, so stay alert! Notice that the arrowhead turns yellow when your cursor is over it. This lets you know that it is ready to be clicked and dragged. Also notice the changing values for the cube's position along the X axis annotated in the Coordinates Manager. You'll see that as you drag to the right of the origin, X values are positive and they increase the farther to the right you go. Notice the numbers that appear approximately mid-screen (see Figure 1–9). These numbers are part of C4D's heads-up display or HUD (a name borrowed from the similar display of information in advanced aircraft, which allows pi-lots to keep their "heads up" instead of looking down at instru-ments in the cockpit). Because the HUD data is reset each time you release your mouse button, it indicates the amount of movement from the cube's last location instead of its true po-sition in your 3D workspace.

figure | 1–9 |

HUD Indicates
Movement

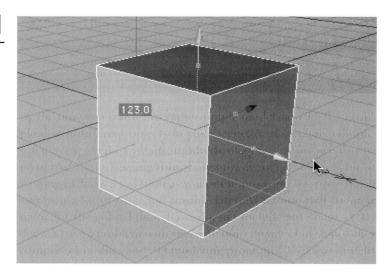

7. Continue to drag the mouse but this time move the cube to the left of the origin and notice that the X values in the Coordinates Manager become negative (less than 0) and that they get smaller and smaller the farther left you move the cube. If you should accidentally deselect the cube such that its axes indicators are no longer visible, simply click on it to reselect it.

8. Next, click and drag the bright green arrow pointing out the top of the cube. What happens to the Y values in the Coordinates Manager as you move the cube above and below the origin? Notice that as you click and drag the bright green Y axis indicator for the cube, you can move the cube only along the Y axis; you cannot alter its position along the X or Z axes. This is similarly true for the other axis handles.

9. Now, click and drag the cube's bright blue Z axis arrowhead and notice the changing position values in the Coordinates Manager.

10. Next, click and drag—not on the cube's X, Y, or Z axes indicators, but—anywhere in the gray space outside the cube. Notice that now you can change the cube's X, Y, and Z values simultaneously! Again, if you accidentally deselect the cube, just click on it to make it active again.

Novice C4D modelers sometimes struggle to move objects around in 3D space, laboring to first get hold of the object they are trying to move by clicking on it. The cursor does not need to first be placed over an object, polygon, edge, or point to move it. As a matter of fact, doing this can often cause problems. For instance, you can accidentally alter the size or shape of the object. Remember, once an object or component is selected, you can then click and drag anywhere in 3D space to move it. As you'll see later, the same is true when you are trying to scale or rotate an object.

11. One or two last points before you move on to something different. First, press F2 so that you are looking into your workspace from above. Click and drag the X and Z axes indicators to reposition the cube. Click and drag anywhere in the workspace to reposition the cube along the X and Z axes simultaneously. Notice that the cube's position along the Y axis, as indicated in the Coordinates Manager, doesn't change.

12. Press F3 and reposition the cube along the Y and Z axes.

13. Press F4 and reposition the cube along the X and Y axes.

14. Now press F5. Click and drag in one editor window and then another.

15. Finally, return the cube to the origin. The easiest way to do this is to enter 0, 0, and 0 for the X, Y, and Z values under Position in the Coordinates Manager and then hit Return on your keyboard or click the Apply button below. As you can see, you can precisely position an object anywhere in your 3D workspace by entering the desired values into the Coordinates Manager.

Scaling objects in C4D works very much like moving them. So, take a moment now, select the Scale Tool (a blue pyramid with two red arrows: one pointing up and one pointing right) from the horizontal toolbar, and click and drag the small boxes at the ends of each of the cube's X, Y, and Z axes to see how things work.

| NOTE |

You'll probably find that, after you've been modeling for a while, you spend most of your time moving back and forth between this view (F5) and the perspective view (F1). Learn to mouse around with your right hand and keep your left hand on the keyboard, moving from editor window to editor window until things are arranged the way you want. If you have a small computer monitor, you might discover that the four-view layout provides too little detail for precise work. In that case, you may find that the best approach is to work with one editor window at a time, moving back and forth between each.

When you've finished, select Close All from the File menu in the main menubar and if you're asked if you'd like to save your work, say No.

Heading, Pitch, and Bank: Rotating Objects in C4D

While the ability to move objects around in 3D space is pretty impressive, if that's all you could do you'd find creating complex scenes and models quite a challenge. So, take a moment to see how you change the heading, pitch, and bank of objects.

1. Under C4D's File menu, select Open and open the JustPlane.c4d file in the Chapter_01 folder on your CD-ROM. This is a little toy airplane created to help explain heading, pitch, and bank. When the file opens, you should be in the perspective view with the airplane selected.

2. Make sure that the Rotate Tool (a blue sphere with two red arrows curved around it) is selected in the horizontal toolbar. Now, three bands—one red, one green, and one blue—seem to encircle an invisible sphere at the aircraft's center (see Figure 1–10). You will use these bands as handles to rotate the aircraft.

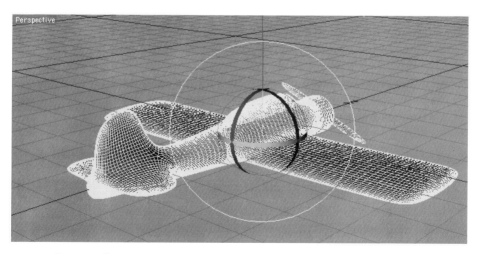

figure | 1–10 |

Rotation Bands

3. When an aircraft's heading changes, the aircraft rotates around the Y axis running straight down through the middle of the aircraft, in this case, down through the canopy and out the bottom of the cockpit. So, to alter the aircraft's heading, click and drag the bright green band around the airplane's Y axis. As you drag the mouse back and forth, notice the changing values under Rotation in the Coordinates Manager at the bottom of your computer screen next to the letter H, for Heading. Reset the airplane back to its original starting point by typing 0 into the heading rotation field in the Coordinates Manager and hitting Return on your keyboard.

4. When an aircraft alters its pitch, the nose of the aircraft rises or falls. That is, rotation in pitch takes place around the X axis: the axis running through the wingtips. So, click and drag the bright red band up and down to change the aircraft's pitch. Once you understand pitch, reset the rotation value next to the letter P, for pitch, back to 0 and hit Return.

5. When an aircraft banks, one wing rises while the other wing falls. So, rotation takes place around the Z axis that runs through the tail of the aircraft and out its nose. Click and drag the bright blue band up and down to change the aircraft's bank, then reset the bank value next to the letter B, for Back, back to 0, and hit Return.

6. Now take a moment to rotate the aircraft around first one axis and then around another without resetting rotation values back to 0 between each rotation. Alternatively, simply click and drag anywhere in the open gray area of the perspective viewport and move the mouse in any direction you'd like. Notice how the X, Y, and Z axes of the airplane are soon quite out of alignment with those of your 3D world. This will become important later on.

7. Go ahead and select Close All from under the main File menu. If you are asked if you want to save changes, say No.

Essential Elements: Objects, Polygons, Edges, and Points

You'll return to C4D in just a few minutes. Before you do, however, you need to know a bit about the underlying form of 3D objects. Imagine that you have created an office scene using C4D. Included

in the scene are a desk, a lamp, a trashcan, chairs of varying styles, and a coffee table. Any one of these might be an object in and of itself, or it might be composed of several objects in C4D. A trashcan would be easy enough to craft from a single C4D object, but you would probably create, for instance, a chair from multiple objects: perhaps one object to serve as the chair's back, another for the seat of the chair, another for a seat cushion, and others for the legs depending, of course, on the style of the chair. As mentioned earlier, modeling in 3D calls for many different approaches, and so it is here. Sometimes you'll use several objects to create a model, just like a builder would use several boards—2 × 4s, 2 × 6s, 2 × 8s, etc.—to create a house. At other times, you'll fashion a model from a single object, like a sculptor would use a single object—a lump of clay—to create a model. This will become clearer with time, but for now just keep in mind that a model might consist of a single object or of very many, depending on the characteristics of the model and your approach to working in 3D.

Frequently, as you wish to move from rigidly structured objects to something a little more pliable, you begin to deconstruct objects and think in terms of polygons. A *polygon* is a multi-sided patch. Take a look at Figure 1–11. This is a closeup of the top of a sphere. Notice that this sphere is comprised of three- and four-sided polygons. The active polygons—that is, those that have been selected—are light gray in the figure.

Sometimes you don't want to move, scale, or rotate polygons but, instead, only a few of their edges. An edge runs along one side of a

figure | 1–11 |

Polygons

figure | 1–12 |

Edges

polygon. In Figure 1–12, you can see that several edges have been selected. The selected edges appear dark in this illustration; in C4D they're colored red.

Figure 1–13 shows points. Points are the smallest definable elements in an object. By default, points appear dark brown until selected, at which time they appear orange. Of course, moving points alters the edges of the polygons to which they are attached, but this

figure | 1–13 |

Points

ability to modify models at the point level—often slow and tedious work—provides very fine control over the look of objects and, consequently, can produce very rewarding results.

Economic Modeling

You won't work with points, edges, or polygons until a little later in the book, so why present this information here? First of all, even the most simple-looking scenes can mask enormous complexity. That is, there's a lot going on behind the scenes in 3D modeling and this hidden complexity can influence render times, the way materials adhere to your objects, file size, and much more. Although you'll really get into this increased complexity later on, you need to be sensitive to it now.

Also, everything eventually resolves to polygons, which are essentially flat patches. The problem arises, then, of how to define smoothly rounded objects from flat patches. There are a number of tricks that you can employ to achieve this but for the sake of discussion let's just say that when the flat patches are small enough and there are enough of them, you can create what appears to be a rounded surface. Take a look at the two spheres in Figure 1–14. The sphere on the right is comprised of 72 polygons. Note that it appears rough and angular. The polygon on the left, which appears

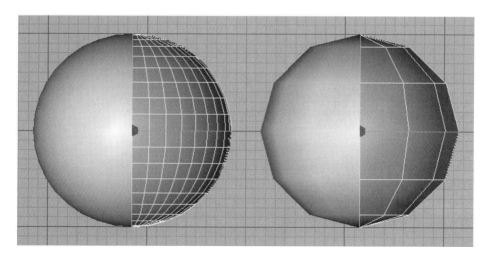

figure | 1–14 |

Relationship of Polygon Count to Smoothing

much smoother, is made up of 648 polygons. So, using more polygons often means a smoother surface.

At this point you might be asking yourself, then, why don't we model everything with thousands of polygons in order to keep things looking clean and smooth? Well, remember that in order to simulate 3D, your computer has to track every object, polygon, edge, and point in your scene. That's no simple task! It requires lots of memory and a fast processor. Often, while working with very complex scenes comprised of dozens of objects and perhaps hundreds of thousands of polygons, things may slow down significantly. Your computer may take several seconds to redraw the screen each time you change your perspective or modify an object. That is not good. You would like your computer to be as responsive as possible. Also, the more detail you build into your work, the longer it will take to render. So, your goal is to use only as many polygons, or only model with enough complexity, as necessary to achieve the desired effect: no more and no less. This is called *economic modeling* and it requires careful planning and a disciplined approach. Objects that will be in the background or partially obscured by other objects don't need the detail of objects in the foreground. Spend your time, and your complexity, on the stuff that really matters.

Other Elements in the C4D Workspace

Editor windows, sometimes called *viewports,* were introduced during the earlier discussion on 3D space, but there's a lot more you'll want to know about them, so let's continue that discussion here. Viewports are the windows into your 3D workspace. Given that you are unable to truly work in 3D, but must view your workspace through the constraints of your 2D computer display, viewports allow you to see several sides of a model simultaneously.

Editor Window Icons

You've seen that you can jump from viewport to viewport by using the F1 through F5 keys on your keyboard. You can also modify your view into any viewport by using a set of viewport-specific icons:

1. Press F5 to see the four-view layout and notice that each viewport has its own set of four menu items and four small icons in its upper-right corner.

2. Press F1 to return to the perspective view.

3. Next click once on the blue cube in the horizontal toolbar at the top of the screen to drop a cube into your 3D workspace.

4. Now you'll use the first three of the four icons in the viewport's upper-right corner to change your view.

Move. Click on this icon and hold your mouse button down while you drag the mouse around. It might appear that you are moving the cube or the 3D workspace around but in fact, you are moving the camera that looks into the workspace.

Zoom. Again, click on this icon and hold your mouse button down while you drag the mouse around. Now, you are moving the camera in and out, closer and farther from your cube.

Rotate. Click on this icon and hold your mouse button down while you drag the mouse around to rotate the camera around the selected object, in this case, the cube.

5. Now try this. Hold down the 1 key on your keyboard (not the F1 key but the number "1" key just above the Q key).

6. Without releasing the 1 key, click and drag your mouse around in the gray open space of the perspective window. This is the same as clicking and dragging the Move icon.

7. Hold down the 2 key and click/drag in the editor window, same as using the Zoom icon.

8. Now, the 3 key, same as using the Rotate icon.

Again, you probably want to keep your left hand poised over the left side of your keyboard all of the time so that you can quickly change editor windows and move, zoom, and rotate your view into your workspace.

Toggle Editor Windows. This icon toggles between the current view and, by default, the four-view layout. Try it and see. Click on it once to return to the four-view layout, then click on this same icon in the perspective window to bring it to full screen again.

Editor Window Menus

One of the things that sets C4D apart from many other computer graphics software applications is that it has not only a main set of

menus across the top of the screen, but it also makes use of several other sets of menus located in several different windows elsewhere in the application. You should be back in the perspective view (if not, press F1) and you should have a cube in your 3D workspace. It may be that because you've been rotating and moving the camera, your view into the workspace is a bit different than what you started with. That's fine.

Take a look at Figure 1–15 to see the options available under the viewport Edit menu. The first two, Undo and Redo View, can be especially confusing for beginners. Follow me through this brief exercise and you'll be fine:

1. Select the Move Tool and click on the cube to make it active.

2. Using the bright red arrowhead extending from the cube, move the cube slightly along the X axis.

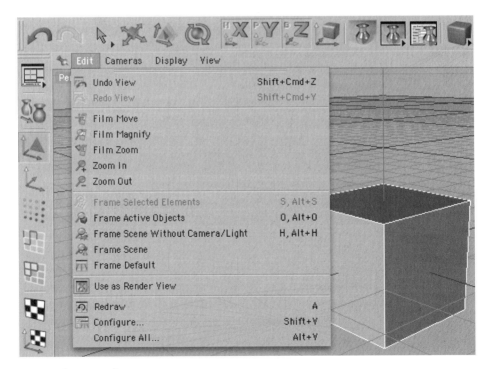

figure | 1–15 |

Viewport Edit Menu

3. Using the Zoom icon in the upper-right corner of the viewport, move the camera a bit closer into the scene.

4. Using the bright green arrowhead extending from the top of the cube, move the cube up slightly along the Y axis.

5. Using the Rotate icon in the upper-right corner of the viewport, rotate the camera a bit to skew your view.

6. Now, from the main menu at the top of the screen (not the editor window menu), select Edit > Undo and pay close attention to what happens. You might have expected to undo the camera rotation, but that didn't happen. Instead, the cube moved back down the Y axis.

7. Repeat step 6 a couple of times and notice that only the movement of the cube is undone and not the movement of the camera.

8. Next, select Edit > Undo View from the menu set in the editor window.

9. Repeat step 8 a couple of times and notice what you are undoing now: only the movement of the camera and not the movement of the cube.

So, Edit > Undo in the main menu set undoes modeling actions while Edit > Undo View in the editor window menus undoes camera actions. You'll find that Edit > Undo and Edit > Redo menu items also appear in other menu sets in C4D, and in each case the influence of that particular Edit > Undo/Redo is limited to the specific set of actions associated with the particular window.

The next five menu items under the viewport Edit menu also influence your look into the 3D workspace:

1. Once again, move the cube around a bit and move, zoom, and rotate the camera.

2. From the Edit menu of the viewport, select Film Magnify. A magnifying-glass cursor appears onscreen. Click and drag a rectangle around the cube, from its upper-left corner to its lower-right. When you release the mouse button, the cube fills the viewport. While this seems to function in a similar manner to the Zoom icon in the viewport's upper-right corner, it is quite different. The Zoom icon moves the camera

nearer to or farther away from the cube. Using Film Magnify leaves the camera in the same position but changes the focal length of its lens. The next few steps should help clarify the concept.

3. From under the viewport's Edit menu, select Zoom Out. Then Zoom Out again and then once more. Notice that the gridlines seem distorted and stretched out.

4. Now click and drag on the Zoom icon and pull the cube close to the screen. Note that the cube is terribly distorted. That's because repeated use of the Zoom Out command leaves you with a fisheye lens. Clicking and dragging the Zoom icon doesn't remedy that but, instead, moves the camera closer and closer to the cube.

5. Under the editor window Edit menu, choose Frame Default. This brings you back to the default view into the viewport.

6. Under the viewport Edit menu, choose Frame Scene. This zooms in (or out, if appropriate) to bring all of the objects of the scene into view.

Often, cameras and lights are placed well outside the main area of action in a scene. For this reason, C4D also allows you to choose Edit > Frame Scene Without Camera/Light. This adjusts the camera such that only those items typically of greatest interest—your modeled objects—fill the viewport. At present, because you have not added cameras or lights to your scene, there's no difference between Frame Scene and Frame Scene Without Camera/Light.

Sometimes, you'll want to focus your attention on a specific object rather than an entire scene composed of many objects. To do this, select the object and then choose Frame Active Objects.

As mentioned earlier, you'll often want to work at the level of polygons, edges, or points. To do so, you can select the elements you wish to concentrate on and then choose Edit > Frame Selected Elements to zoom in the camera on those elements.

Unless your computer is especially slow, available memory is quite limited, and you're working with a complicated scene of many detailed objects, C4D updates viewports automatically. If C4D cannot do so, you may need to select Edit > Redraw.

The next set of options is under the viewport's Cameras menu (see Figure 1–16). You won't spend a lot of time here now, but take a moment and check out the available commands. In many instances, especially when you're new to 3D, you'll work with a single camera, which is usually the editor camera. It's the one there at the start of a new project in C4D; the one framed by your perspective viewport. That said, C4D allows you to add cameras, which will be accessible under Cameras > Scene Cameras.

Also under the Cameras menu, notice that the viewport's view is set: Perspective for the perspective viewport, Top for the top viewport, etc. Although all the exercises in this book assume you're using the default views, feel free to experiment with different views later as your 3D skills develop. You may come across a situation where a top view is of less value than a bottom view. You can always

figure | 1–16 |

Cameras Menu
Options

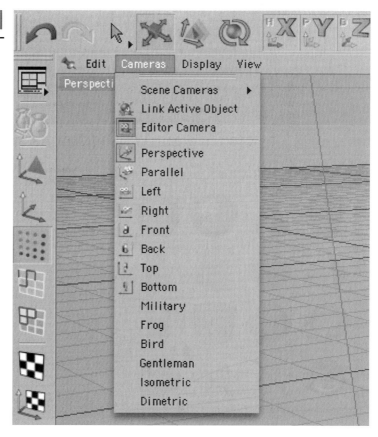

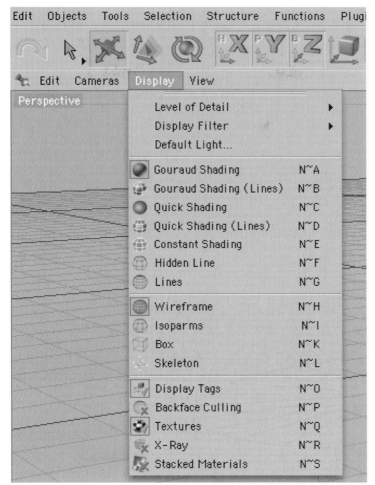

figure | 1–17 |

Editor Window
Display Menu

make that change here, under the Cameras menu, and switch back later as appropriate.

An understanding of the next menu, the Display menu (see Figure 1–17), is especially important. First of all, it's important to keep in mind, as mentioned earlier, that rendered graphics can take quite a while to generate. Consequently, if you had to wait for the computer to fully render each and every viewport every time you nudged an object, tweaked a light, or moved your camera, you wouldn't get anything done. Therefore, all of the work you do in the editor window is done in less than fully-rendered detail. How much less is up to you.

figure | 1–18 |

Default Light

7. Skip over the first two items in this menu and select Default Light (see Figure 1–18). C4D adds a light to your scene so that you can see to model. This light sits slightly high and a bit to the left of the camera, always moving as the camera moves. If you'd prefer that the default light sit somewhere else in your scene, simply click on the sphere to set the new point onto which light will most directly fall. Fill free to experiment, but click on the upper-left corner of the sphere in the dialog box to return the light to its default setting before proceeding.

In Table 1–2, the image in the upper-left corner is a final rendering of two simple objects. Notice the smooth shading on the objects. Also, notice that, as the light source is to your upper-left, the sphere casts a shadow on the ring below and to the right. You can also see a hot spot where the light is brightest on the upper-left side of the sphere. So, when a scene is rendered, you see smooth lighting, materials, textures, bumps, shadows, and everything else built into your scene.

In the upper-right corner of Table 1–2, you see an example of Gouraud Shading, the highest quality available to you while editing in a viewport. Notice that you see a rough approximation of shading that takes into account the lights you've built into your scene, but notice that the shadow of the sphere does not appear on the ring.

If Gouraud Shading proves too much for your computer, you might want to try Quick Shading mode. Here again, object shading is displayed, but notice that the shading isn't true to your light

table | 1–2 | **Display Modes**

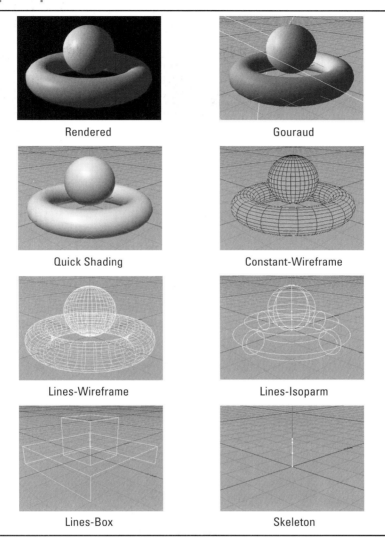

Rendered	Gouraud
Quick Shading	Constant-Wireframe
Lines-Wireframe	Lines-Isoparm
Lines-Box	Skeleton

source. Instead, C4D's default lighting system is used. Notice that the lights and shadows for Gouraud Shading reflect the fact that a light source is positioned in the upper-left of the scene, while the lights and shadows for Quick Shading seem to come from almost straight on from the viewer's perspective. Even when you change your perspective and look at the scene from a different angle, the light source will still appear to come from your direction as if the light were permanently affixed to your camera.

With Constant Shading and Wireframe selected, all shading disappears. If a colored material has been applied to the object, only that color remains. Were you to make the object editable, the system of lines you see indicate where the object's polygons would exist.

The next image demonstrates the Lines mode with Wireframe selected. This configuration has several advantages. It allows the computer to react to editing very quickly, it allows you to see the shape of your objects, and it shows the general polygonal structure of the objects. And even in Lines mode, color information can be seen in that the lines of the object will appear in the color of the applied material.

The next image in the sequence shows Lines mode with Isoparms. Think of Isoparms as a subset of wireframes. These are the lines that define the shape of an object on the broadest scale; very fast, but only the most basic information about shape.

As you might have guessed from the next image in the table, Lines mode with Box selected displays even less information about your objects. The sphere and torus are depicted in this mode simply as boxes that only give you some indication of the space that these objects occupy.

In Skeleton mode, each object is represented only as a small white dot. When objects are grouped, this grouping is indicated with a white line connecting the dots, as is the case with the objects in the lower-right corner of Table 1–2.

To summarize, the varied display modes available to you in C4D allow you to model as efficiently as possible. You can set each viewport to a different display mode. You can choose display modes that approach reality (final rendering) with shadows, color, and specular highlights or you can choose display modes that minimize the workload on your computer and, consequently, allow for rapid development.

Two other options under each viewport's Display menu come in handy from time to time. Take a look at the two images in Figure 1–19. The one on the left is with the viewport's display mode set to Lines and Wireframe, but with Display Backface Culling checked. The image on the right shows the same object in the same display mode but with Backface Culling unchecked. With Display Backface Culling checked, you no longer see through the objects to the lines that make up the back side of those objects. That is, those polygons,

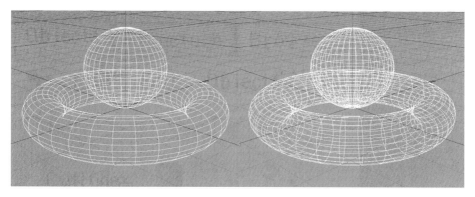

figure | 1–19 |

Backface Culling

edges, and points on the far side of objects, away from the camera, don't appear. Of course, you can still see through to objects farther back in the scene. Checking Backface Culling is a great way of reducing the clutter in a scene.

X-ray mode, the option near the bottom of each viewport's Display menu, allows you to see through an active object. The active object takes on a semitransparent look. This is useful for positioning objects and seeing through objects to other objects on their far side.

View is the last menu item in each viewport's menu set (see Figure 1–20). One of the things you really have to love about C4D is its flexibility. If the default views—available with the function keys, F1 through F5—don't suit your needs, you can always choose some other configuration. The first item under the View menu is Panels. Select it and several options appear to the right: Single View, 2 Views Stacked, 2 Views Side by Side, 3 Views Top Split, etc. The easiest way to learn how these work is to simply select each option one at a time and see what happens. As you sample the various options, notice that your F1 through F5 keys no longer work exactly as they did earlier. That is, they are constrained by the Panels option you select. For instance, if you select the Single View setting, F1 and F5 present that single view and F2 through F4 don't appear to work. Experiment with it a bit and you'll get the hang of it quickly. If you want to return to the default setup, with four views and the function keys working as you are used to, select View > Panels > Four Views.

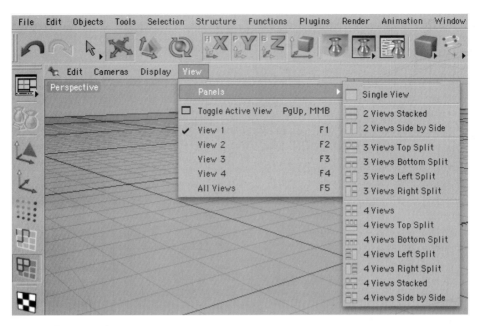

figure | 1–20 |

Viewport View Menu

Managers

The last components of the C4D interface you'll look at in this chapter are its managers. *Managers* are the controlling structures in C4D. Each can sit in its own window or exist as a tab alongside other managers. Notice in Figure 1–21 the highlighted Objects tab next to the Structure and Browser tabs. Each of these is a manager. The selected manager—that is, the one you've made active by clicking on its tab—appears on top of the others. In Figure 1–21, the Objects Manager is active and therefore, the information in the Structure and Browser Managers is hidden. Of course, you could click on any of those tabs to make that manager and its information visible.

When a manager is not grouped with others, it doesn't appear tabbed, as is the case for the Materials Manager (see Figure 1–22), the Coordinates Manager (see Figure 1–8), and the very important Attributes Manager (see Figure 1–23). Each of the managers is briefly described in Table 1–3.

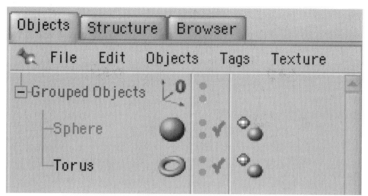

figure | 1–21 |

Objects Manager
Active

figure | 1–22 |

Materials Manager

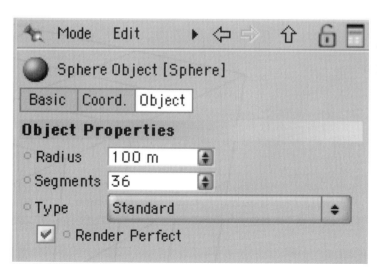

figure | 1–23 |

Attributes Manager
with Sphere Object
Selected

table │ 1–3 │ **Managers**

Object Manager	All of your scene's objects are listed here. From within this manager, you can select objects and make them active; cut, copy, paste, and delete objects; group and rename objects; and much more.
Structure Manager	From within the Structure Manager, you can view and modify an object's points and polygons. You can select, cut, copy, paste, and delete them or precisely reposition them in your 3D workspace.
Browser Manager	The Browser Manager becomes especially helpful as your experience with C4D grows. You can import your older C4D files into the Browser Manager and then drag and drop materials or objects from those older projects into the scene you're working on now.
Attributes Manager	The Attributes Manager displays properties for the selected object, texture, and tool. The details listed will change depending on the type of item selected. For instance, if an object is selected, the Attributes Manager will show the object's size and location. If a light is selected, details of the type of light, its luminance, the types of shadows it will cast, and similar properties are displayed. Notice that the Attributes Manager will frequently include more information than can be displayed in a single screen, and so small buttons may appear (for example Basic, Coord., and Object in Figure 1–23) that must be selected to view specific sets of information.
Materials Manager	All textures and materials for your project are stored here. Using the Materials Manager, you can copy, cut, paste, delete, edit, and group materials, and much more.
Coordinates Manager	The Coordinates Manager allows you to precisely position, scale, or rotate the active object or group of objects.

SUMMARY

In this chapter, you learned a bit about the process of creating 3D objects and scenes. It is especially important that you understand that the process is not linear. Instead, you can expect to move back and forth between the stages of modeling, texturing, lighting, animating, and rendering as you work in 3D.

Given that modeling and animating in 3D draws from a number of other creative paradigms—set design, storytelling, carpentry, sculpting, mechanical assembly, directing, painting, videography, theater, and others—it comes as no surprise that the work, and consequently the tools, can be quite complex. C4D is one of the very best tools to use as you learn 3D, but even its interface can be a bit daunting. You have only scratched the surface here, but you have established enough of a foundation to get you going.

in review

Launch C4D and drop a cube into your 3D workspace:

1. You want to be able to move from one view in your 3D workspace to another effortlessly. Which viewport are you looking at now? How can you change the view such that you see the cube from a top-down view? How about a front view? How do the views (perspective versus orthographic) differ? What clues do the visible axes give you regarding which viewport is open? If, given limited screen space, you'd like to see a two-viewport view rather than the standard one- or four-viewport views, how would you set that up?

2. How can you move, zoom, and rotate the camera? Once you've altered the view, how do you return to the default view? How do you frame the scene such that, in this case, the cube fills the active viewport?

3. What is the difference between the rendered view of your scene and the display presented in your viewport while editing? If your scene includes lights and you want to get a rough idea of how the shading might look, which display mode would you select? If your computer seems to be struggling with the enormous amount of detail in a complex scene, how might you change the display modes of the various viewports to speed up redraw and response?

4. If, in Wireframe display mode, the polygons on the far side of an object are making it difficult for you to see and work with polygons nearer you, how can you hide those far side polygons? If, in Gouraud or Quick Shading mode, you'd like to be able to see through an object to the polygons on its back side, how would you do that?

5. Early in your work with 3D modeling, you're likely to find that the Object, Structure, Attributes, Materials, and Coordinates Managers are the most important. Briefly describe the kind of information found in each.

↗ EXPLORING ON YOUR OWN

1. Remember, if you make changes to the C4D interface, you can always reset the interface by choosing Window > Layout > Standard from the main menu set. You can also reset any viewport to its default view by selecting Edit > Frame Default from the viewport's menu set. So, by all means, experiment! Play with the C4D interface until you know it fairly well. Get to where you can anticipate responses given your selection of this menu item or that icon.

NOTES

Animation Window Help

| parametric primitives |

2

 charting your course

With an introduction to the 3D workspace and the C4D graphical users' interface behind you, it's time to start modeling! You'll begin with *parametric primitives*. These are the simplest forms available to you: the basic building blocks of 3D. You might have played with Lincoln Logs, Lego blocks, or Tinker Toys as a kid. In spite of the fact that the shapes available to you were rather limited, you were probably able to build fairly elaborate objects. The same is true for parametric primitives. You have a limited set of shapes to work with. Still, you'll be amazed at what you can do with only these basic shapes. And later, you'll see that you can make these primitives editable and deform them in interesting ways. Often, the most elaborate objects begin as a simple parametric primitive.

 goals

In this chapter you will:

- Explain the benefits of modeling with parametric primitives
- Recall the types of parametric primitives bundled with C4D
- Demonstrate basic modeling skills using parametric primitives
- Use non-destructive deformers to reshape parametric primitives
- Manage objects in the Object Manager: rename, group, duplicate, etc.

PARAMETRIC PRIMITIVES

In Chapter One, you learned key concepts of 3D modeling and briefly examined the C4D users' interface. In this chapter, you will build on that knowledge and craft a simple model using parametric primitives. Keep in mind that the exercise presented here is a means to an end and not an end unto itself. That is, your goal is not simply to complete this exercise, but to understand modeling with parametric primitives and appreciate their value as essential components in your modeling arsenal. Take your time and think about what's happening in each and every step.

You'll find that every 3D modeling program comes with a fairly unique set of parametric primitives for you to work with. In C4D, this set includes cubes, spheres, cones, and cylinders; polygons, planes, discs, and pyramids; capsules, oil tanks, platonic objects, and tori; tubes, landscapes, humans, and relief primitives (see Figure 2–1).

figure | 2–1 |

C4D's Set of Parametric Primitives

If you are a student of the arts, you may recall that the 2D equivalents of these shapes—squares, circles, and triangles—were considered to be the basic shapes from which all other 2D renderings could be composed. This was a foundational assumption for those who employed the Cubist style of painting: Cézanne, Picasso, Braque, Léger, and others. And just as learning to see these 2D shapes in all other forms was considered essential to any good artist's education in the very late 1800s and early 1900s, you will also want to learn to see the world around you as it is composed of 3D parametric primitives: cubes, spheres, cones, etc.

MODELING WITH PARAMETRIC PRIMITIVES

What makes these primitives *parametric* is their defining parameters. That is, parametric primitives aren't freeform. They can't be shaped into smooth-flowing objects such as faces or flowers. Instead, each primitive has only a few parameters that are alterable. For example, you can modify only the sphere's diameter; you can modify only the pyramid's height, width, and depth; you can modify only the cone's top radius, bottom radius, and height; etc. Consequently, the primary disadvantage of modeling with parametric primitives is that they are somewhat limited in their utility. Regardless of its radius, a sphere is pretty much just a sphere; regardless of its height or the diameter of its base, a cone is still a cone; and so on. Still, a lot of our constructed world utilizes these essential shapes. Look around you! Stereo speaker enclosures are cube-shaped, as are cinderblocks, houses, and televisions. Planets, basketballs, beach balls, marbles, and the globes atop many lampposts are spherical. So, you certainly don't want to dismiss parametric primitives altogether! Besides, parametric primitives aren't without their advantages. Because parametric primitives are relatively simple, mathematically-defined shapes, they don't demand as much processing power from your computer as more complex objects. They are quick and easy to use and modify. Modeling a sphere from scratch, one polygon at a time, would be a time-consuming and tedious task. The same is true for cones, cylinders, and capsules. Having these shapes as ready-made building blocks and as a starting point for other modeled objects is a great timesaver! So get to know how they work. You'll use them often.

Modeling with parametric primitives is more akin to building something with prefabricated materials, such as bricks, cinderblocks, and wooden boards, than molding a shape with clay. If you've done a lot

of 2D work in computer graphics, you might find that working with parametric primitives is more like some of the vector-based artwork you've created with Adobe *Illustrator* or Macromedia *Freehand*, where shapes are generally defined based on certain parameters, while other more complex objects created with C4D are more akin to raster-based (bitmapped) artwork created with Adobe *Photoshop*, in which images are defined at the pixel-level.

One last point: In this chapter, you'll be using parametric primitives in their raw forms. Later, you'll make them editable and/or use them in conjunction with HyperNURBS. Then you'll see that their power and utility can be greatly multiplied. So, again, don't discount parametric primitives. They are a starting point for a great many objects you will model.

Modeling a Wooden Toy Train

Assume for the moment that you have been tasked with creating a wooden train for a toy-store advertisement. Of course, you would like to base your modeling on sketches, plans, blueprints, or some other form from which to work. The inspiration for the model created here was discovered in a woodworking magazine. Take a look at Figure 2–2. You can see that the modeled wooden train created here—using the woodworking magazine as a reference—is composed entirely of parametric primitives: cubes, cylinders, cones,

figure | 2–2 |

Toy Train

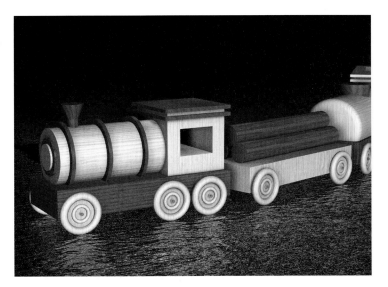

and tori (by the way, in case you are unfamiliar with *tori*, they're the primitive that looks like a donut). Spend a few minutes and think about the shapes there. The cab of the engine is composed of a cube-like structure. The wheels are made of tori. The steam tank is a cylinder sitting atop another cube. You'll work through the process of building this model from scratch. You should find that sufficient detail to get you through with few problems has been included but if you need to, don't hesitate to go back and review the discussion of C4D's interface in Chapter One.

Model Proportions

Where to begin? Take a look at the toy train in Figure 2–2 again. The cornerstone for the model is the base of the train's engine. That is, it is the centerpiece that, once built, everything else will attach to. So, that's probably the best place to start the modeling process. And what about its size? The cab appears to be a cube, the same length along every edge. The base appears to be about three times the length of the cab. The cab is also a little narrower than the base, which tells you that the base is only about two and a half times as long as it is wide. If you keep these rough proportions in mind and periodically come back to Figure 2–2 for reference, you can probably do quite well as you try to make everything fit into place and look appropriate.

Cube Primitives

1. Launch C4D.

2. Press the F1 key to bring up the Perspective view.

3. Drop a Cube into your 3D world by selecting Objects > Primitives > Cube or alternatively by clicking once on the Cube in the folded pallet of parametric primitive icons in the horizontal toolbar (see Figure 2–1).

Now, pause for a minute and look at what has happened. Some of this was covered in Chapter One, but greater detail will be provided here. A cube has appeared at the origin of your 3D universe, its center at 0, 0, 0 along the X, Y, and Z axes. A cube object has also appeared in the Objects Manager at the right side of your screen. You can see the editable parameters for the cube in the Attributes Manager (just below the Objects Manager). With Object selected in the Attributes Manager (see Figure 2–3), you'll see that you have X, Y, and Z dimensions that can be adjusted. You can increase the

figure | 2–3 |

Editable Parameters
for a Cube Primitive

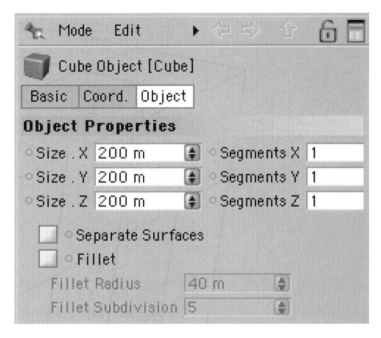

number of segments (more on segments later), you can select Separate Surfaces (only important if you plan to make the cube editable or deform it), and you can add fillets to the cube. That's it! That's all you can do to a parametric primitive cube. Now you can see why they're called *primitives*.

Play with the cube a little bit before you return to the exercise. First, click in the Fillet check box. Notice that the cube in the viewport now has rounded edges, called *fillets* (see Figure 2–4). You'll probably use fillets a lot. Few things in our world have razor-sharp edges. Besides, a small fillet can really add a lot to an otherwise boring cube. And when you light and animate a scene, the fillet on a cube will often pick up a glint of light that wouldn't appear on a cube with a perfectly sharp edge. You can alter the size of the fillet by changing the number in the box next to Fillet Radius or by using your mouse: clicking and dragging one of the tiny orange dots (they appear black in Figure 2–4) on the corner of the cube in the perspective viewport. Reduce the fillet radius to 5m. That looks better. The Fillet Subdivisions setting refers to the number of surfaces (polygons) between one side of the cube and the adjacent side. If you set the Fillet Subdivisions to 1, you get a very hard, angular edge. A higher number, like 5, smoothes the rounding a bit. Feel free to experiment with the

figure | 2–4 |

Cube with Fillets

Fillet Radius and Fillet Subdivisions and see how different settings produce different results.

As useful as fillets are for creating realistic objects, you're going for a different look here. You want your toy train to look quite simple, as if it were made from basic wooden shapes with well-sanded sides. So, uncheck the Fillet box to return the cube to its original shape, and then you can continue with the exercise.

4. This cube will serve as the support for other modeled elements such as the steam tank and the engineer's cab, so the default parameters of 200m, 200m, and 200m for the X, Y, and Z dimensions won't work. You'll fix that now. In most situations, you can generally discount the fact that C4D defaults to measurements in meters and try to think, instead, solely in terms of proportions. With the Cube selected in the Objects Manager and the Object button selected in the Attributes Manager, change the X, Y, and Z measurements to 200, 125, and 500, respectively. Once you enter 200 in the X input box, you can Tab to move to the other boxes and hit Return when you've entered all three values. These settings roughly correspond to your estimates established earlier. Leave all of the Segment settings at 1.

5. Go ahead and rename this cube with a meaningful name. Double-click on the word "Cube," just left of the cube icon, in the Objects Manager. A dialog box appears. Change the object's name from Cube to EngineBase, and then click OK.

By the time you finish this rather simple model, you'll have a couple dozen different objects in your scene. A moderately complicated scene could contain hundreds of objects. You need to be proactive about keeping things organized. So, get in the habit of naming each object as soon as you put it into your 3D space. It will save you a lot of time and trouble later. Also, note that the new name for the cube, EngineBase, doesn't include any spaces. C4D doesn't have a problem with spaces in object names but some other computer graphics and 3D modeling programs do, so you might want to stick with a convention used by many 3D animators and name all of your objects without spaces or special characters.

Tube Primitive

1. Drop a Tube primitive into the universe and name it EngineCab. You're going to use the tube in a rather curious manner. Note that the tube looks like a donut with hard, angular edges and, of course, a donut hole. That hole will soon become the window into your cab.

2. First, you need to reorient the tube. Change the Orientation setting from +Y to +X (see Figure 2–5). This sets the tube up on its side.

3. Change the Inner Radius to 150. You won't leave it there long, but this will give you a better look at the shape of the tube primitive.

4. The Rotation Segments setting indicates the number of subdivisions used to give the tube its rounded shape. You want to square the tube off, so change that value to 4.

5. One last change before you can begin to adjust the size of the cab. Select the Rotate tool from the horizontal toolbar, grab the red rotation band, and drag upwards until you have rotated the tube 45 degrees so that it sits flat on the base. You can type −45 degrees into the pitch input box in the Coordinates Manager if you'd prefer. Now, you can see the cab of the toy train taking shape.

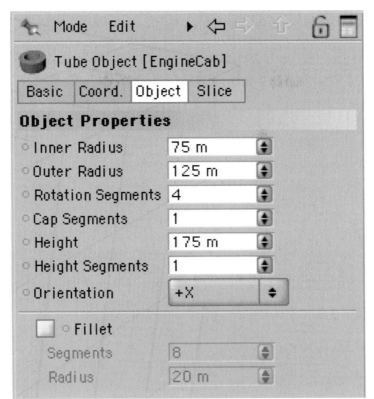

figure | 2–5 |

Editable Parameters
for a Tube Primitive

6. The EngineBase object is 200m across. Remember, the cab was to be slightly smaller than the base. So, make sure the EngineCab is still selected in the Objects Manager (it should be highlighted in red text) and change its Height to 175, its Outer Radius to 125, and its Inner Radius (the cab window) to 65 in the Attributes Manager.

7. Now comes the tricky part. Select the Move Tool. You need to pull the cab straight up along the Y axis, but notice that the Y axis of the tube no longer points straight up. Grab the green arrowhead at the end of the tube's Y axis, and drag. Yech! That's not working at all. Choose Edit > Undo from the main menu.

8. With the Move Tool still selected, click once on the X and Z locks so that only the Y remains enabled. This will constrain your movement to the Y axis only. Also, click once on the Use World/Object Coordinate System icon (see Figure 2–6). This way, when you drag, you'll be dragging up along the world's Y

figure | 2–6 |

X and Z Axes Locked, Use World Coordinate System

axis, and not the object's rotated Y axis. Click and drag in the gray open space of the perspective viewport, moving the cab up to a position of about Y = 150. You'll probably want to move back and forth between the perspective view (F1) and the right view (F3) as you do this to get things set just right. You also might want to experiment with the display modes under the viewport's Display menu to find a display that suits you best. Try setting the perspective view to Gouraud Shading and the right view to Lines and Wireframe.

9. Click off the Y axis lock and click on the Z axis lock. Drag the cab back along the Z axis until 150 shows for the Z value in the Coordinates Manager. Of course, you could just type 150 into both the Y and Z position indicators in the Coordinates Manager and click Apply. Again, switch back and forth, F1 to F3, as needed.

You'll come back to the cab later. You've modeled and positioned it now because positioning of the cylinder, that will be your engine's steam tank, depends on positioning of the cab. The cab is really a rather simple part of the model and so, just as you would like to work from foundational parts of a model to surrounding elements, you'll also find it helpful to work from simple to increasingly complex.

Cylinder Primitive

1. Drop a Cylinder into the scene and rename it SteamTankOuter. Of course, it appears at the origin of your 3D world, right in the middle of your EngineBase object. Its length runs along the Y axis, which isn't what you want either. So, you need to edit its parameters and move it into place.

2. The engine base is 500m long and 200m wide. The engine cab is over 200m front to back. A cylinder 300m long (high, given

its current orientation) and with a radius of 75m (150m diameter) would be just right. So, set the radius to 75 and the height to 300.

Height Segments refer to the number of subdivisions along the length of the cylinder. Figure 2–7 shows two similar cylinders in wireframe mode. The one on the left has only one height segment while the one on the right has eight. As was mentioned earlier, segments aren't usually of a particular concern to you unless you plan to make the object editable, deform it, or use it as part of a Hyper-NURBS object.

Rotation Segments refers to subdivisions around the cylinder. Set Rotation Segments to 6. Notice that the cylinder now has six distinct sides. Of course, this won't do for your purposes. You want a smoothed cylinder. As a matter of fact, even the default setting of 36 shows a tiny bit of edginess, so you need a setting that's even higher.

3. Leave Height Segments set to 8. Change the Rotation Segments setting to 48.

4. Now you need to reorient the cylinder so that instead of running along the Y axis, it runs along the Z axis. Change orientation to +Z.

figure | 2–7 |

Height Segments
along a Cylinder

5. Next move the SteamTankOuter object up and toward the front of the train engine, so that it sits down only slightly into the EngineBase cube and slightly behind the front of the train. The rear of the cylinder will stick into the engine's cab just a small amount. If you aren't comfortable simply moving it into place with the move arrows, you can set its X, Y, and Z coordinates to 0, 130, and −75 in the Coordinates Manager. At this point, your train should look like the one in Figure 2–8.

Before you move on, you need to save your work. Select File > Save As. As noted earlier, it's assumed that you are fairly familiar with your operating system, such that you understand the need to keep your files neatly organized in properly named folders. You'll probably find it best to create a folder inside the Documents folder on your Macintosh or the My Documents folder on your Windows-based machine and save your work there.

figure | 2–8 |

Train Engine's Base, Cab, and Steam Tank in Place

Notice that there's a file in the Chapter_02 folder of your CD-ROM called Base_Cab_Tank.c4d. It includes all of the work done to this point in the exercise. If you've had problems, feel free to open it now and continue the exercise using that file.

Adding Detail to the Steam Tank

Often, it's the little details that make a model attractive. So, next you'll try to improve on the rather stark look of some toy trains by adding additional detail around the steam tank; nothing out of the realm of possibility for an average woodworker, but just enough to warrant a second look at your toy train advertisement. Look at the close-up of the cylinder in Figure 2–9 and take note of the front of the tank and the supports that seem to encircle the tank. These are all parametric primitive cylinders.

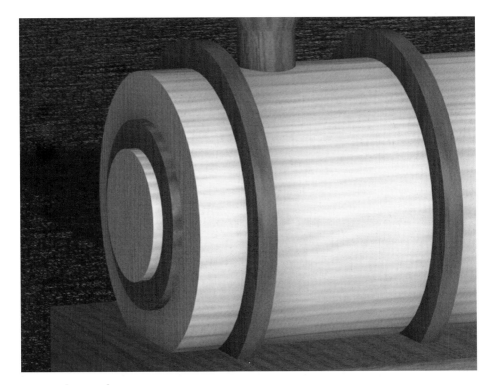

figure | 2–9 |

Close-up of Steam Tank

1. Create another cylinder. Name this object SteamTankMiddle.

2. As before, change its orientation to +Z and set its Rotation Segments to 48. Leave the Height Segments at 8. Make sure the radius is set to 50 and the height to 200.

3. Position this cylinder inside the larger cylinder with the end closest to the front of the steam engine protruding just a bit. You might remember that you positioned the outer cylinder along the X axis at 0 and the Y axis at 130. If you do the same for this cylinder, it will be perfectly centered inside the larger one. Only the Z axis setting will be different. If you prefer to enter a setting directly into the Coordinates Manager, try −135.

4. Add a third cylinder. Name it SteamTankInner. Proceed just as you did in the previous steps, but set the radius to 35. Position it so that it protrudes a bit beyond the middle cylinder: Z = −145.

5. Now create the three steam tank braces. Again, create a cylinder. Orient it to the +Z axis. Although the height will be quite a bit smaller than your first cylinder, the radius needs to be a bit larger. Set the Radius to 90 and the Height to 10. Set Rotation Segments to 48 and leave Height Segments at 8.

6. Again, this cylinder's location along the X axis will be 0 and along the Y axis 130, just like all the other cylinders. Rename the cylinder RingAft. Slide the RingAft cylinder back, toward the train engine's cab: Z = −10.

Working in the Objects Manager

1. Duplicating objects in C4D is easy. In the Objects Manager, click on RingAft and hold the mouse button down. At the same time, hold down the Control (Ctrl) key on the keyboard, and drag down slightly until the arrowhead cursor changes into a white arrowhead cursor with a "+" beside it and a left-pointing arrow. At this point, you can release the mouse botton and the Control key and the RingAft object will be duplicated. Double-click on this new object in the Objects Manager and rename it RingMiddle.

2. You won't see the second object in the viewport yet because it occupies the exact same space as the original. Simply slide this new ring forward to about the middle of the steam tank: Z = −85.

3. You need to create a third ring but you'll use yet another technique. By exposing you to as many ways of getting things done as possible, you can subsequently choose a method that suits you best. Make sure that RingMiddle is selected (red) in the Objects Manager. Using the set of menus there in the Objects Manager, choose Edit > Copy. Then Edit > Paste. A new object named RingMiddle.1 will appear. Rename it RingFront and slide it near the front of the steam tank: Z = −190. At this point, your train engine should look like the one in Figure 2–10.

4. It's time to clean up a few things so that the Objects Manager is a bit more manageable. In the Objects Manager, shift-click RingFront, RingMiddle, RingAft, SteamTankOuter, SteamTankMiddle, and SteamTankInner. Then, under the Objects menu in the Objects Manager, select Group Objects. A new

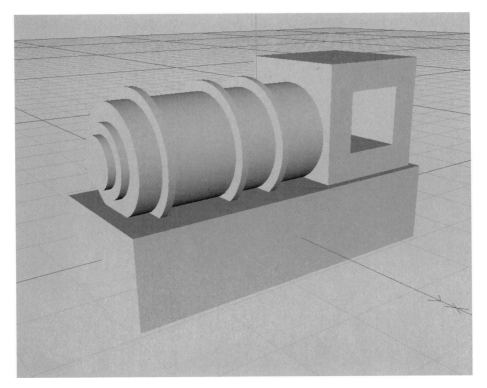

figure | 2–10 |

Steam Tank Completed

object appears in the Objects Manager: Null Object. Rename it SteamTank. Note the "+" to the left of the name. This tells you that SteamTank is a *parent* for—that it contains—other objects. Click on the "+" to reveal its *children,* that is its contents (see Figure 2–11). Not only does this clean up the Objects Manager, but it also groups objects together such that when the parent is moved, all of its internal objects move together. Try it and see, and then select Edit > Undo to move the SteamTank group back into place.

This would be a good time to save your work. If things haven't gone very well for you and you'd like to continue with a file created for your use, open the Tank_Complete.c4d file from Chapter_02 on the CD-ROM.

figure | 2–11 |

The SteamTank
Group: Parent and
Children

Adding Detail to the Cab

Take a couple of minutes and add a roof to the cab.

1. First, create another cube and rename it CabRoofUpper. Resize its X, Y, and Z dimensions to 200, 10, and 200, respectively.

2. To position this new cube, first go back in the Objects Manager, and select the Engine Cab object to determine its precise location. Make note of its X and Z coordinates. Now, set these same coordinates (0 and 150, respectively) into the X and Z coordinates of the new cube object. That centers it perfectly on the cab.

3. Now, drag the green arrow above the cube to pull it up on the Y axis, or using the Move Tool and appropriate axis locks, move the cube into position on top of the cab. Don't hesitate to rotate your view into the perspective viewport (hold down the number 3 key on the keyboard while dragging the mouse) or switch to multiple viewports as necessary to line up your objects : Y = 240.

4. Duplicate CabRoofUpper. Rename this new object CabRoofLower and slide it down the Y axis until it is only slightly below the upper part of the roof: Y = 220.

Wheels: Tori, Disc, and Capsule Primitives

You'll want to add wheels to your toy train. This necessitates the use of a few different primitives. Each wheel will be composed of an inner ring, an outer ring, a disk connecting the rings, and an axle.

1. Add a torus primitive to your scene. A *torus* looks like a donut. Its Ring Radius (see Figure 2–12) refers to the distance between the center of the torus (center of the doughnut hole) and the center of the pipe that composes the body of the torus. The Pipe Radius refers to the diameter of the pipe itself and, therefore, indirectly determines the size of the hole in the middle of the torus. Understandably, the Pipe Radius cannot be greater than the Ring Radius. Change the torus' orientation to +X. Set the Ring Radius to 45 and the Pipe Radius to 10. Name this object OuterRing.

2. At this point, the OuterRing is hidden by the EngineBase in the Perspective viewport. Pull the torus out along the X axis so that it sits outside the EngineBase object. Make note of its position on the X axis. That is, check its coordinates so that as

figure | 2–12 |

Torus Primitive
Parameters

Torus Object [OuterRing]

| Basic | Coord. | **Object** | Slice |

Object Properties

○ Ring Radius 45 m
○ Ring Segments 36
○ Pipe Radius 10 m
○ Pipe Segments 18
○ Orientation +X

you create other bits of the wheel, you can center them on these same coordinates. The Y and Z axes should be set to 0 since new objects are positioned at the origin (0,0,0) when they are added to a scene, and so far all you have changed is the X location. Move the Torus to X = 135.

3. Next, create an inner hub for the wheel. Create another torus, set its Ring Radius to 20 and its Pipe Radius to 5. Change the orientation to +X. Position it at the same coordinates as the other torus. Name it InnerRing.

4. Now you need to create the hub that runs throughout the wheel. You'll use a disc primitive for this. Drop a disc primitive into the 3D world by selecting the disc icon from the folded palette of parametric primitives in the horizontal toolbar (see Figure 2–13), or select Objects > Primitive > Disc from the menubar.

5. Your OuterRing has a Ring Radius of 45 and so, of course, this new hub should also have an Outer Radius of 45. Set the Orientation to +X and leave all other parameters as they are. Rename the object Hub and set it at the same X, Y, and Z coordinates as the OuterRing.

figure | 2–13 |

Select the Disc Primitive from the Toolbar

The Inner Radius setting for a disc allows you to create a disc with a hole in it: a perfectly flattened doughnut of sorts. Disc Segments refers to the number of concentric rings running from the center of the disc to its outer edge. Rotation Segments refers to the number of cuts running from the center out to the edge: slices of the pie, if you will. Note that a low setting for Rotation Segments—below about 10—results in a disc that doesn't appear especially round at all, but has a faceted edge. Again, segments aren't of particular concern at this point. Still, to make sure you understand the concept, Figure 2–14 shows a disc, in wireframe mode, with an inner radius of 50, and outer radius of 100, 4 disc segments, and 8 rotation segments.

6. You need to add an axle to the wheel. To do this, you'll use a capsule primitive. Drop a capsule primitive into the 3D world by selecting the capsule icon from the folded palette of parametric primitives in the toolbar across the top of the page (see Figure 2–15), or select Objects > Primitive > Capsule from the menu.

7. Pull the capsule primitive out along the X axis until it is in plain view outside the other objects that comprise your train engine. Height refers to the length along what is currently the

figure | 2–14 |

Sample Disc Primitive: 4 Disc Segmentsand 8 Rotation Segments

figure | 2–15 |

Capsule Primitive

Y axis. Radius refers to the distance halfway across the circular part of the capsule. A capsule's radius can never be more than half its height. When it is exactly half, the capsule looks like a sphere. Change the orientation to +X, set the radius to 5 and the height to 15. Rename the capsule Axle and position it at the same coordinates (135,0,0) as the other wheel objects.

8. That's it. Your first wheel is complete. Shift-click to select the OuterRing, InnerRing, Hub, and Axle and group them. Rename this group Wheel_FL (as in front left).

9. Move the Wheel_FL group into a position near the front edge of the train: X = 115, Y = −55, Z = −185. You can probably do this in the Perspective viewport alone, however you may find it much easier working in four views mode (see Figure 2–16).

10. Of course, your train won't get very far on only one wheel, so you need to make a copy of this first wheel, paste the copy into your scene, and move it into place. Remember, you can quickly and easily duplicate an object by control-clicking on it and, while holding the mouse button down, dragging

figure | 2–16 |

Positioning the Wheel in Four Views Mode

vertically in the Objects Manager. Rename this new wheel group Wheel_RL (rear left) and move it into place: X = 115, Y = −55, Z = 195.

11. Repeat this process to create a Wheel_ML (middle left) group and place it slightly forward of the left rear wheel: X = 115, Y = −55, Z = 70.

12. Now, shift-click Wheel_FL, Wheel_ML, and Wheel_RL so that they are all selected (text is red for all three). As before, control-click and drag to duplicate, but note that this time all three wheels are duplicated.

13. With all three of these new wheel groups still selected, move them along the X axis until they sit next to the engine base on its right side: X = −115. Of course, you'll want to rename these objects to reflect their new location (for example, Wheel_FR for front right).

14. Now, shift-click to select each of the six wheel groups plus the engine base. Group these and name the new group Base.

If you haven't done so in a while, save your work. Feel free to continue with your model or, if things aren't working out, open Wheels.c4d from Chapter_02 on the CD-ROM.

Smokestack: Cone Primitive

1. Create the smokestack. Add another cylinder to your scene and rename it StackLower. Set the Radius to 20 and the Height to 50.

2. Move the stack so that it is just aft of the foremost steam tank support: X = 0, Y = 215, Z = −155.

3. Now, add a cone primitive to the scene and name it StackUpper. Change its orientation to −Y such that the wide end of the cone points up.

4. Set the Top Radius to 0, Bottom Radius to 35, Height to 70, and position on top of the bottom part of the stack: X = 0, Y = 235, Z = −155.

5. Group these two items together and rename the group Smoke-Stack.

Adding Cars

That's it! You've created a toy train engine from parametric primitives. Save your model so that you can apply textures to it later on. But don't quit C4D just yet.

1. Create another copy of the Base group.

2. Now, shift-click all of the other groups—all but this new base—and group them. Rename the group Engine.

3. Select the new Engine group and drag it along the Z axis until it is out of the way of the second base group: Z = −550.

4. Open the new Base group and click on Wheel_ML. Then hit the Delete key on your keyboard to delete it. Also delete the Wheel_MR group.

5. Rename the Base group LogCarBase.

6. Save your work.

This new LogCarBase will serve as the base to other cars you will build on your own, starting with a log car. Think about it for a moment. There's really nothing to it. The logs will be simple cylinder primitives, resized and stacked.

NON-DESTRUCTIVE DEFORMERS

Non-Destructive Deformers add flexibility to objects such as parametric primitives. They allow you to bend, twist, and/or otherwise distort objects.

Structure and Application of Deformers

When you add a deformer to your scene, it appears as an empty cage: a cube with blue outlines. You'll want this cage to surround the object you intend it to deform, or at least that part of the object you want deformed. The deformer's parameters can be set in the Attributes Manager, just a you would set the parameters for a primitive. The deformer can also be moved around in 3D space to influence only certain parts of an object. When deforming primitives, you'll want the deformer to be a child of the primitive in the Objects Manager.

Bend Deformer

1. Choose File > New from the main menus.

2. Add a cylinder primitive to your scene. Set the Radius to 50, Height to 400, Height Segments to 1, Rotation Segments to 36, and Orientation to +Y.

3. Add a Bend Deformation to your scene. The Deformers are folded into a group in the horizontal toolbar. The Bend Deformation is in the upper-left corner of the folded group (see Figure 2–17)

4. Make the Bend Deformation a child of the cylinder. That is, select the bend in the Objects Manager and drag it onto the cylinder. When you do, the cursor will change into a white arrowhead with a small white box and a down-pointing black arrow next to it, indicating that you can now release the mouse and the bend will become a child of the cylinder (see Figure 2–18).

5. Make sure the bend is selected in the Objects Manager. Look carefully into the perspective viewport and notice the blue box that represents the bend deformation. Along its Y axis, at about the top of the blue box, you'll see an orange dot (see Figure 2–19). This is the handle for the deformation. Click and drag the orange handle and you'll notice that the cylinder bends, but not very well. It appears stiff and inflexible. If

figure | 2–17 |

Selecting the Bend
Deformation

figure | 2–18 |

Making the Bend
Deformation a Child

figure | 2–19 |

Bend Deformation
Control Handle

you pull the handle to the right, such that the bend parameters in the Attributes Manager read Mode as Limited, Strength at 80 degrees, and Angle at 25 degrees, you'll see something like Figure 2–20.

6. Select the cylinder in the Objects Manager so that its editable parameters show up in the Attributes Manager. Set Height Segments to 4. That's better! Now the cylinder really appears to bend. Set the Height Segments to 8 and see how that influences the bend. Finally, set 16 for a nice, smooth deformation.

So, segments influence the ability of an object to be bent or otherwise deformed. Remember, however, that you always want to model as economically as possible. Use only as many segments as necessary to achieve the desired look.

7. There are several other things you need to know about deformers. Select the Bend Deformation in the Objects Manager and, in the Attributes Manager, change the Mode from Limited to Within Box. Notice that the top of the cylinder, the part that was above the blue bend deformation box, is now sheared off. It sits where is originally sat.

8. Now set the Mode to Unlimited. Now the entire cylinder bends. Change the Mode to Limited and then back to Unlim-

figure | **2–20** |

Inflexible Bend

ited again. See the difference? Select the cylinder and increase its Height to 600. Now the difference between Limited and Unlimited can be clearly seen. Limited bends the cylinder within the bend deformation box only, such that those parts of the cylinder outside the box remain straight. Unlimited bends the cylinder along its entire length; it continues to curve from one end to the other.

Why do they call these non-destructive deformers? Well, the changes to the, in this case, cylinder are not permanent. You haven't altered its essential structure by bending it with a deformer. If, later in your project, you decided to get rid of the bend, all you would need to do is delete it. Try it and see.

9. Select the Bend in the Objects Manager and hit the Delete key on your keyboard. The cylinder snaps back to its original shape. If you had created a curved tube using some other method such that the true nature of the tube was curved, un-doing that would be difficult at best.

Twist Deformer

1. Open a new scene in C4D: File > New.

2. Add a Pyramid primitive to the scene.

3. Add a Twist Deformation to the scene and make it a child of the pyramid.

4. Set the Segments of the pyramid to 16.

5. Grab the orange handle of the twist deformation and pull it right until the Angle setting in the Attributes Manager reads about 225.

Bulge Deformer

1. Open a new scene.

2. Add a Cube primitive to the scene and set its size, in the Attributes Manager, to 100, 500, 100.

3. Add a Bulge Deformation to the scene and make it a child of the cube.

4. If you pull on the orange deformation handle now, nothing happens: there are too few segments. Set the Y segments of the cube to 24.

5. Grab the orange deformation handle and pull left to suck in the middle of the cube: Strength of about −60%.

6. Now select the Move Tool in the horizontal toolbar. Make sure the X and Z axis Locks are locked so that you can drag the bulge only up and down the Y axis.

7. Click in the gray open space in the perspective view and move the bulge up and down the Y axis.

8. Change the Mode for the bulge to Unlimited and drag up and down the Y axis again. Pull the bulge down near the base of the cube to create a rather interesting table.

Make sure that all three axes are unlocked before continuing.

Combining Deformers

1. Add an Oil Tank primitive to a new scene at set its Radius at 100, Height to 400, and Height Segments to 24. All other settings can be left at their defaults.

2. Add a Bulge Deformer and make it a child of the oil tank. Move it up on the Y axis to 30m and drag its orange deformation handle left until the strength is at about −50%. Set the Mode to Unlimited. It looks like one of those old Stromberg Carlson wall-mounted telephone receivers from the late 1800s: the part you would hold to your ear (see Figure 2–21).

3. Next, add a Bend Deformation to your scene, make it a child of the oil tank, and make sure it sits below the bulge in the hierarchy (see Figure 2–22).

4. With the bend selected in the Objects Manager, pull the orange deformation handle right until Strength is about 100 degrees and Angle is about 30 degrees. Set Mode to Unlimited. Hey, it's a 1960s telephone handset (see Figure 2–23).

5. Now drag the bend up in the Objects Manager so that it sits above the bulge in the hierarchy. That looks quite a bit different, doesn't it? The point is, you can use multiple deformers but their order as children under the deformed object is quite important.

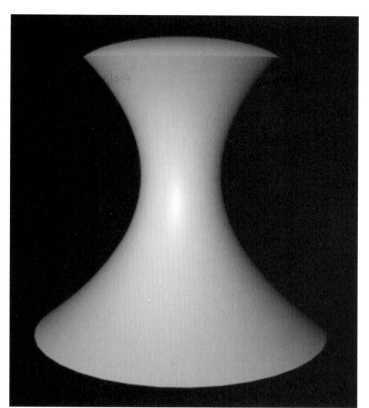

figure | 2–21 |

Telephone Earpiece

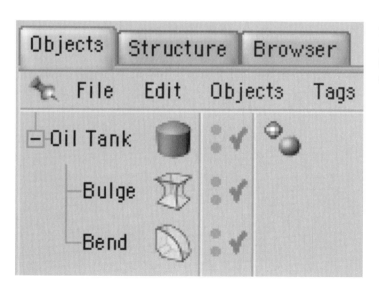

figure | 2–22 |

Oil Tank with Deformers as Children

figure | 2–23 |

Telephone Handset

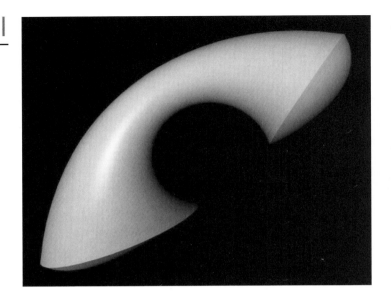

SUMMARY

Parametric primitives are objects defined by mathematical parameters. Although very easy to modify—simply change the value for any available parameter—they can be modified only in rather basic ways. Still, much of our world is comprised of objects that can be deconstructed into these simple primitive shapes.

Non-destructive deformers allow objects to be twisted, bent, sheared, bulged, tapered, and more. One of the especially great things about non-destructive deformers is that they do not alter the underlying geometry—that is, the constructed shape—of the deformed object. They can always be removed, in which case the deformed object snaps back to its original shape.

in review

1. What is meant by parametric primitives?

2. What set of parametric primitives are shipped with C4D?

3. What are the benefits of modeling with parametric primitives?

4. What are their limitations?

5. How are objects renamed in the Objects Manager?

6. How are objects duplicated in the Objects Manager?

7. How are objects grouped in the Objects Manager?

8. What is meant by making one object the child of another?

↗ EXPLORING ON YOUR OWN

1. Complete your train by finishing the log car and by adding other cars. The log car should be quite easy to build: three cylinders oriented to the +Z axis for logs. Build a tank car. Build a caboose. Use your imagination and build an entire train from parametric primitives only.

2. Build other models using parametric primitives only: Lego™ blocks, a Christmas tree, a log cabin, a set of barbells, or a toy robot. Be creative and don't worry about being a bit abstract. Build a parametric primitive (pseudo-cubist) character.

3. There are several parametric primitives you didn't use in your train model. Load each into a scene and play with its parameters.

4. Experiment with non-destructive deformers to see what types of objects you can create.

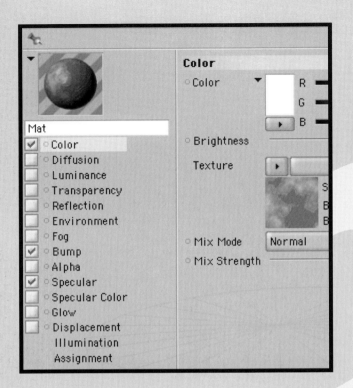

basic texturing

3

 charting your course

It's amazing how important texture is in your interpretation of the world around you. For instance, think of an orange. When you can't make out the wrinkles and creases of its skin, and surface features seem to run together in a rather homogenous blend of the color, your brain tells you that the orange is farther away. When every bump and crevice is clear and easily seen, your brain tells you that the orange is close by. A basketball and a beach ball are nearly the same size, but there's no mistaking one for the other given their different colors and textures. We live in a world of textures. Everything around us is pitted, scratched, polished, rusted, sanded, painted, worn, bumpy, shiny, dull, or somehow characterized by a set of surface features that help us differentiate one object from another or a close object from a distant one. Consequently, it's only when you apply textures appropriately that your scenes and models come alive and seem real.

 goals

In this chapter you will:

- Describe the characteristics of materials editable in C4D
- Use the Materials Manager to create new materials and manipulate their properties
- Apply materials to modeled objects

AN INTRODUCTION TO MATERIALS

This chapter is called *Basic Texturing*, but the goals address "materials." Obviously, an explanation of terms is in order. Some software applications use the terms one way, while others use them another; as do many 3D professionals.

In C4D, *material* generally refers to the broader set of surface attributes that might be applied to an object: things like color, reflection, luminosity, and specularity. However, C4D allows you to have a much greater impact on the look of your objects through the use of textures: applied images, features, and patterns that might appear as rust spots on an old trashcan, deformations in a car's tire, or the unique pattern of pores, blemishes, and dirty smudges on a character's face.

Materials and Textures in C4D

The best way for you to see how C4D implements these concepts is to create and modify your own materials.

1. Launch C4D.

2. Open the Objects.c4d file in the Chapter_03 folder. It's a fairly basic scene with a torus and a sphere—grouped together under a parent—and a light so that you can see how light influences the look of materials and textures.

3. Make sure you are looking into the perspective viewport and render that view by clicking once on the Render Active View icon in the horizontal toolbar (the first of the three render icons, it appears immediately to the right of the World/Object Coordinate System icon and looks like a shiny blue vase). After just a second or two, the scene renders revealing a black background and the two gray putty-colored objects with highlights and shadows. This is how rendered objects look with no materials applied (see Figure 3–1).

4. You'll find the Materials Manager in the lower-left corner of your screen. Select File > New Material from the set of menus in the Materials Manager and a small sphere will appear below (see Figure 3–2). This sphere shows you a preview of the material.

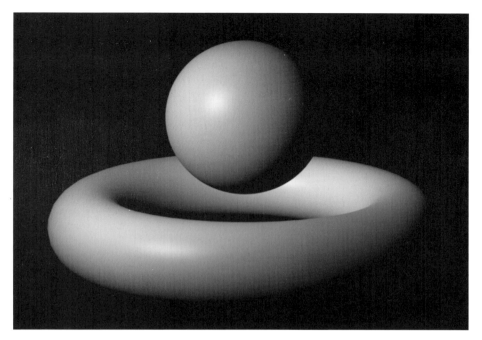

figure | 3–1 |

Scene: No Materials Applied

figure | 3–2 |

Material Preview in the Materials Manager

5. Finally, double-click on that preview sphere to open the Material Editor dialog box (see Figure 3–3). Notice that you can also manage materials' characteristics and settings in the Attributes Manager. Either way is fine although, you'll notice that the Material Editor dialog box is used in most of the examples in this book.

Notice the 13 checkboxes along the left side of the Material Editor dialog box. These are called *channels* in C4D, and include color, diffusion, luminance, transparency, etc. To the right of this list, you'll see a set of parameters. The parameters on the right vary with the channel you've selected on the left and, generally speaking, the set of parameters includes two main components: color and texture.

So, for the material's characteristic of color, you can set either a color (top half of the dialog box) or texture (bottom half of the

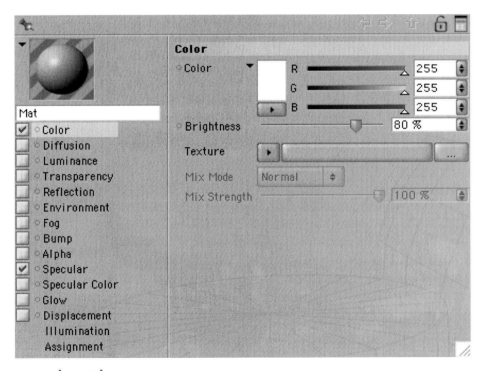

figure | 3–3 |

Material Dialog Box: Channels and Settings

dialog box). In most instances, it's not exclusively color or texture but you have the ability to blend the two. If you were to click on the word Luminance on the left side of the dialog box, the area on the right would show Luminance Color and Texture; for Reflection, Reflection Color and Texture; for Environment, Environment Color and Texture and so on. In some cases, there are a couple of other options, but most channels follow this same general structure: a color and/or texture for each channel.

A word of caution: Clicking on the text for a particular channel does not add it to the material. You can, for example, click on the word Luminance along the left side of the Material Editor dialog box and even alter the parameters for that characteristic but those alterations do not take effect until you have checked the checkbox to the left of the text. Why? Actually, this is a pretty nice feature. You can make several alterations to a material and simply check/uncheck the checkbox to quickly see the material with/without the alterations.

Back in Figure 3–3, notice the ellipsis to the far right of the word Texture. This indicates that while a material might be comprised of basic color elements, it could also be textured with an image such as a jpeg or tiff. To the immediate right of the word Texture, you'll see an arrowhead. If you click on it, you have the option of applying a *shader* to your material instead of an image. Shaders supplied with C4D include Brick, Checkerboard, Cloud, Cyclone, Marble, and Rust (see Figure 3–4). Shaders are sometimes called *procedural shaders* because, unlike images, they are generated mathematically based on a set of parameters.

In summary, a material is applied to an object to add surface detail and color. Most basic to a material is a set of color parameters: surface color, luminance color, reflection color, etc. You can go beyond basic color to apply a texture in combination with, or instead of, any of these color characteristics. A texture can be in the form of an image or a shader. Images are just that: images created in Photoshop, downloaded from the Internet, or supplied with your 3D modeling application. Shaders are mathematically generated textures, typically defined based on a set of adjustable parameters.

figure | 3–4 |

C4D Shaders

In C4D, materials are defined by the attributes set in the 13 channels: color, diffusion, luminance, transparency, reflection, environment, fog, bump, alpha, specularity, specular color, glow, and displacement. In this chapter, you'll examine all except alpha and displacement. You'll be introduced to these last two along with several other related topics in a later chapter.

Earlier, the importance of naming all of your objects was stressed. The same is true for materials. Notice that the default name, "Mat," appears in the upper-left corner of the Material Editor dialog box. To rename a material, type a new name into this textbox and hit enter on your keyboard. You can also name or rename a material by double-clicking on its name just below the preview sphere in the Materials Manager and entering the new name in the small dialog box that pops up.

Color

Color is the most basic surface property. You create your colors in C4D by positioning a set of color-mixing sliders and then setting a brightness value (see Figure 3–5). By default, the mixing system uses RGB and a range of possible values for each of the three between 0 and 255 and for the Brightness, 0% and 100%. This works well for many 3D designers because this is the same color designation system used in other computer graphics applications. You have several other options, however. If you prefer to work with hue, saturation, and brightness, or if you prefer to work exclusively with percentages, or if you prefer to work with a color table, all of these options, and several more, are available to you in C4D. Simply click and hold the small arrowhead under the color swatch and make your selection. Note, however, that examples and instructions in this book assume RGB, 0 to 255, and Brightness, 0% to 100%.

If you type a number greater than 255 into the box to the right of a color slider, the value automatically decreases to 255. For brightness values, on the other hand, you can exceed 100%. Values well above 100% yield a super-saturated look.

1. Experiment a bit. The Material Editor dialog box should still be open. Drag the sliders back and forth and notice how the spherical preview changes color to reflect your settings. Notice that the preview icon under the Materials Manager also reflects the color changes you have made.

2. Set a deep purple color. Slide the red and blue color sliders to the far right and the green slider all the way to the left. Set the brightness value to 64%.

figure | 3–5 |

Setting a Material's Color and Brightness

3. Close the Material Editor dialog box.

There are a couple of ways to apply a material to an object. The easiest is to click on the material's preview in the Materials Manager and drag it onto the desired object in the viewport. The only problem with this approach is that sometimes the viewport becomes so cluttered with objects that you can't easily position your cursor over the desired object. So, you can also click and drag the material from the Materials Manager onto the name of the desired object in the Objects Manager.

4. Drag the spherical preview of the material from the Materials Managers and drop it (release your mouse button) when it's over the sphere primitive in the viewport. The sphere turns purple and the sphere object in the Objects Manager now has a material icon to its right (see Figure 3–6). Go ahead do a quick render by clicking on the Render Active View icon in the horizontal toolbar.

5. Open the Material Editor dialog box once again by double-clicking on the preview in the Materials Manager.

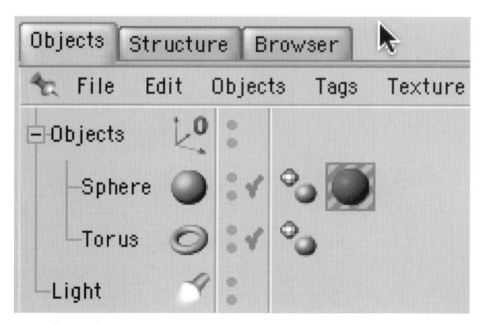

figure | 3–6 |

Icon Indicates a Material Assigned to the Sphere Object

6. Now, click on the ellipsis to the far right of Texture. This brings up your Open File dialog box. Navigate to the CD, open the Chapter_03 folder, and select the OrangeCheckers.jpg file. This is a simple bitmapped image created with Photoshop.

7. A dialog box may appear: "This image is not in the document search path. Do you want to create a copy at the document location?" If so, click Yes. Now notice the preview of the material in the dialog box. It's no longer purple, but orange-checked (see Figure 3–7).

8. As mentioned earlier, you're not limited to either color or image map, but you can blend the two. Look for the small Mix Strength slider low in the Material Editor dialog box. When it's set to 0%, the sphere appears completely purple and when it's at 100%, the purple is completely obscured by the image of the checkerboard pattern. Set it anywhere between these two extremes and you have a mixing of the color and the texture image. Drag the slider left and right to see how the preview changes and then set it to 100% before you move on.

figure | 3–7 |

Using a Bitmapped Image as a Texture in the Color Channel

> ### Keeping Textures in Their Place
>
> When you apply an image to a material in C4D, that image doesn't become a part of the file but, instead, becomes linked to the project. This is a very important point. If, later, you move the C4D file to another computer and fail to bring the image files along with it, the materials will not render properly. That's why, in the previous step, C4D might have presented you with a dialog box that said, "This image is not in the document search path. Do you want to create a copy at the document location?" C4D was trying to help you out by creating a copy of the OrangeCheckers.jpg file to be stored in the same location as the C4D file itself. The best approach to take is to keep each of your C4D files in its own folder, create another folder inside the first and name it "Tex" (as in texture), and store all of your image files there. C4D automates this process for you: after you have used an image in building a material, if you select File > Save Project instead of File > Save, C4D will create the Tex folder automatically and save your C4D file along with associated texture files.

9. Assume that the OrangeCheckers texture map isn't going to give you the look you were going for and now you have decided to experiment with a shader. In the Material Editor dialog box, click and hold on the small arrowhead immediately to the right of Texture (immediately to the left of where it currently says OrangeCheckers.jpg). Drag down to Surfaces and then choose the Rust shader.

Immediately, your sphere takes on a different look: blue with dark, fuzzy splotches here and there. Remember, this is not an image but a procedural shader: that is, a mathematically defined texture. Just as different parametric primitives had different parameters you could manipulate to change their form, each procedural shader has a set of features you can adjust. For the rust shader, that will include rust gradient colors, percentage, and frequency. Next, you'll change these parameters and see what you end up with.

10. In the Material Editor, click on the square shader preview swatch to bring up the adjustable parameters shown in Figure 3–8.

11. Make sure that Shader (and not Basic) is selected. A gradient appears below Shader Properties.

12. Double-click the small blue color chip immediately below the left end of the gradient preview to bring up a color picker.

figure | 3-8 |

Editable Parameters for the Rust Shader

Color pickers vary greatly from computer to computer but they are usually pretty intuitive. Select a bright orange; then close the color picker. Notice the change in the Material Editor and in your viewport.

13. At present, your gradient has only two colors assigned to it. Click somewhere about midway along the gradient and slightly below it to add another color swatch.

14. Double-click the new color chip and select a very dark red, almost black, and then set the chip at the far right to black.

You can always delete a color chip by clicking on it and dragging it away from the gradient line. You can also click and drag a color chip left or right along the gradient line to alter the transition between colors. At any time in the process you can click on the Render Active View icon and see what your sphere looks like. You don't have to close dialog boxes first. Go ahead and render the perspective view to see how this works.

Let's assume that you want a sphere with a bit less rust and smaller areas of rust: a more pitted look. The Rust percentage refers to the area of sphere covered with the dark-colored splotches. Frequency determines how large or small the patches are.

15. Lower Rust to 30% and increase the Frequency to 3; then render the active view again (see Figure 3–9).

figure | 3-9 |

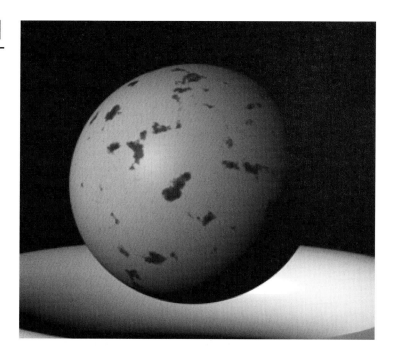

This example has shown how the Material Editor's color channel works. You can set surface color, use an image as a texture, or apply a shader and manipulate its parameters to determine surface color for a material. The remaining channels work in much the same way. Now it's time to change channels.

Specular

Anytime you create a new material, two channels are automatically activated for you: Color and Specular. So, you will address Specular next. Your rusty orange sphere looks okay at this point, but there is one serious flaw you probably want to address right away. There's a bright spot there on the left side. That highlight is called *specularity*, or the specular highlight. Specularity tells you a lot about an object. Highly polished objects reflect light especially well and so they often have a small, very bright specular highlight. Dull, marred surfaces absorb lots of light and redirect the reflected light they don't absorb, resulting in a broad, poorly defined specularity.

1. Select the Specular channel (its checkbox should be checked already).

You'll see a graphic representation of the highlight, a Mode drop-down menu, and four sliders (see Figure 3–10). The Mode drop-

down box allows you to choose from three options: Plastic, Metal, and Colored. Plastic works best for wood, glass, painted surfaces, organic surfaces, and, of course, plastics. With Plastic selected, the specular highlight will be white unless a different specular color is selected. This is in contrast to the Metal and Colored modes for which the specular highlight is influenced by the color of the material and other properties set in the Material Editor dialog box. For the time being, you'll work with the Plastic mode.

2. Width and Height define the size and shape of the specular highlight. Set the Width to 25% and the Height to 100% and render the active view. Notice that the object appears polished with a tight, bright highlight.

3. Next, set the Width to 100% and the Height to 25% and render the active view. The result is quite different. Now the sphere appears a bit dull and flat, which is what you'd expect if it were old and worn.

Try a few different settings, rendering the active view between changes, until you understand how this works. The preview in the upper half of the Material Editor dialog box and the graphic representation of the highlight should prove helpful.

The next two options, Falloff and Inner Width, impact the distribution of light around and within the specular highlight.

4. First, set both the Width and Height to 75% and render the active view. Notice how the highlight transitions fairly smoothly from bright white to a hazy mix of white and orange near its edge.

figure | 3–10 |

Editable Parameters
for the Specular
Channel

5. Next, set the Falloff to 20% and render the active view again. Notice that the transition is different, staying brighter longer but still with a fairly smooth transition at the edge.

6. Now set the Falloff to 90% and render the active view. There's almost no transition from bright to darker at all.

7. Next, set the Falloff to −30% and render the active view. The center of the highlight is now quite tiny, almost a pinpoint of intense light.

As Falloff values increase above 0%, the transition from the hot spot at the center of the specular highlight to its edge grows smaller and smaller until at 100%, you have a very distinct, round spot with no fringe. This is represented in the preview by the vertical sides of the distribution curve. Below 0%, as values grow increasingly negative, only a spindle of light remains in the center and available light outside the center grows steadily weaker, finally disappearing. Figure 3–11 shows your sphere with Falloff set (from left to right) at −30%, 0%, 20%, and 90%.

8. Inner Width also influences the area of brightness at the center of the highlight. Leave Width and Height set to 75%, Falloff set to 0%, and now set the Inner Width to 10%. Render the active view, paying particular attention to the transition from bright light at the center of the specularity to less intense light at its edges.

9. Reset the Inner Width to 100% and render the active view again. The center of the highlight is large and intense, but you still have a small area of transition at the edge.

Changing the Inner Width may yield results that look similar to those obtained with certain Falloff settings, but the two character-

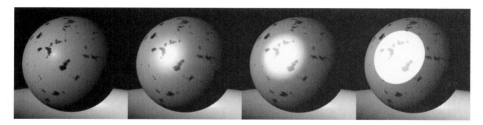

figure | 3–11 |

Specular Falloff: −30%, 0%, 20%, and 90%

istics really are different. Falloff influences the slope of the curves around the center. Inner Width defines the size of that center. Pay close attention to the pink area at the center of the Specular preview and the slope of the curves to each side of that pink area and things should be fairly clear.

10. Set the Width to 75%, the Height to 25%, the Falloff to 0%, and the Inner Width to 10%. This should result in a specular highlight that is fairly broad and flat, giving the impression that our sphere is old and worn.

Bump

Imagine that you are in the hill country shortly before dusk. Peaks are lightly colored where the setting sun strikes them from the west, while valleys are dark, filled with shadows. If you were to try to capture this scene on canvas, you'd use a mix of light and dark colors, bright in spots and muted in others, and thereby bring the illusion of ridges and valleys to your work. Roughly speaking—sorry for the pun—the Bump channel employs a similar scheme to create the illusion of texture on your objects. Specifically, C4D uses the grayscale values of an image you link to your material to simulate the appearance of texture. The bright pixels in the image will appear as raised areas, while dark pixels will appear as depressions.

▶ Understanding Grayscale

It's especially important that you understand that the Bump channel works with *grayscale values*. What does that mean? Well, it doesn't mean that you have to use grayscale images. That said, you're encouraged to do so. Why? You might be surprised at how little grayscale values differ in a color image. Try this in Photoshop sometime. Open a new file, click on the Foreground color swatch to open up the Color Picker. Using the HSB settings (hue, saturation, and brightness) create a medium red: H = 0, S = 75%, and B = 75%. Fill the image with this red. Now use the Rectangular Marquee to section off a large rectangle in the middle of the image. Again, click on the Foreground color swatch to open the Color Picker and this time simply change the Hue setting to something like 180, leaving Saturation and Brightness at 75%. Fill the rectangle with this new blue. The colors look remarkably different but their grayscale values are exactly the same. Don't believe it? Desaturate the image and you'll see a homogenous field of gray. So, if you'll bring the image you plan to use as a Bump map into Photoshop and desaturate it, you'll have a much better estimation of how it's going to impact the bumpiness of your material. Only then can you get a true feel for the grayscale values in the image.

1. Still in the Material dialog box, check the checkbox for the Bump attribute. Notice that Color is not an option here (see Figure 3–12). Instead, you can adjust the bump strength and apply a texture. That's about it. Bump causes areas of the material to appear raised or depressed. If you want the rust spots to appear like paint that has corroded and bubbled up, you can use the same shader you used for the Color channel in order to align your eroded bumps with your rust color. Select the Rust shader just as you did earlier, set Rust to 30%, Frequency to 3, and leave everything else as it is. Again, the color makes no difference here, only grayscale values influence the texture.

Again, light areas of the image appear as raised areas, while darker areas appear as indentations. The magnitude of the effect is influenced by the Strength setting. The higher the setting, the more pronounced the effect. You can exceed values of 100% by typing a larger number into the textbox to the right of the slider. Negative values result in a reversal of the effect, with light areas sinking and dark areas rising.

2. The Strength slider disappeared from view when you clicked on the Rust swatch. To bring it back into view, simply click on

figure | 3–12 |

Editable Parameters for the Bump Channel

the Bump channel in the list along the left side of the Material Editor.

3. Adjust the slider a few times and render the active view between each change until you get an idea of how the bump channel works. At −100%, the surface looks pitted. At 100%, the surface looks bubbled-up.

4. Finally, set the strength to 20%.

Specular Color

As mentioned previously, the color of the specular highlight defaults to white or the material's surface color depending on settings in the Specular channel. Specular Color allows you to override those defaults. The effect is fairly straightforward and results are easily predictable.

1. Check the Specular Color channel checkbox.

2. Push the R and G color sliders far right, each to 255, and the B slider far left to 0. Render the active view and note the yellow highlight.

3. Click the ellipsis and load the OrangeCheckers.jpg file into the channel. Render the active view and notice that the image appears projected onto the sphere, much as you might project a video or a 35mm slide onto a wall.

4. Select the Marble shader (black arrowhead > Surfaces > Marble) and render the active view. You'll have to look closely, but you'll notice the marbled highlight on your sphere.

5. The Specular Color is of little use in this particular project, so deselect the effect by un-checking the channel's checkbox. That will re-establish the default white highlight.

Diffusion

The Diffusion channel allows you to add a dirty, worn look to a material. Like the Bump channel, it works with the grayscale values in an image, discarding color information.

1. Check the checkbox next to Diffusion (see Figure 3–13). Of course, you could create your own diffusion map in Photoshop and determine, quite specifically, how the wear and tear on your sphere ought to look but for the sake of time, you'll just use one of C4D's built-in shaders again.

figure | 3–13 |

Editable Parameters for the Diffusion Channel

2. Click the arrowhead to the right of Texture to reveal your shaders, select Surfaces, and then select Cyclone. Render the active view and notice that the sphere looks streaked and dirty, an interesting effect.

3. Try some of the other shaders. Whenever you select a new one from the menu, the previously selected shader disappears and has no impact on the look of your object. Venus produces an interesting effect, as does Noise (Noise isn't under Surfaces but, instead, sits above it in the menu), but I think my favorite is Cloud, so set that and render the active view again.

4. Notice the Affect settings under the Brightness slider in the Material Editor dialog box. You won't be using the Luminance or Reflection channels on this object, so you want to leave those boxes unchecked. Do make sure that Affect Specular is checked. This applies the diffusion map not only to the surface color but also to the specular highlight of the object. That is, you'll notice that the specular highlight on the object is now irregular, very dirty in some areas and less so in others.

The slider to the right of Mix Strength allows you to influence the intensity of the effect, sort of like mixing an image or shader with a surface color in the Color channel, as you saw earlier. Set the slider to 0% and the effect of dirt and grime disappears. At 100% it is very pronounced.

5. Set the Mix slider to 35% and the Diffusion Level Brightness slider, near the top of the dialog box, to 65% to get a nice rough, dull, and dirty look.

6. That should just about do it for the sphere. Rename the material RustyOrange and close the Material dialog box.

Materials Manager Options

The Materials Manager is much more than a simple storage facility for materials. So, before you begin to work on a material for your torus, spend a few minutes with the Materials Manager.

1. Make sure that the RustyOrange material is selected in the Materials Manager. You can tell that it's selected when its name is highlighted as red text. If it is not selected, click on it once.

2. Under the Materials Manager Edit menu, select Copy.

3. Then, under this same menu, choose Paste. A copy of the RustyOrange material is created in the Materials Manager.

It can be a bit difficult telling which is the original and which is the copy, as the names are truncated when viewed this way. One way to see the full name of each material is to select Material List under the Materials Manager Edit menu. This presents much smaller preview icons but the full name of the material is visible. Notice that your new material was named RustyOrange.1. Also under the Materials Manager Edit menu, you can change the size of the preview icons. Try the different sizes: mini, small, medium, and large. Notice that each combination of settings has its pros and cons. With a moderately-sized monitor, the standard Material view with either small or medium icons works well. Although the full name of the material may not be viewable when the Materials Manager is set up that way, you can always see the full name by clicking once on the material preview and then looking to the Attributes Manager.

As noted earlier, many C4D users prefer to configure materials via the Material Editor dialog box. You may prefer to use the Attributes Manager. Click once on a material in the Materials Manager and then look at the Attributes Manager (see Figure 3–14). The full name of the selected material appears in the upper-left corner. Notice that the attributes manageable in the Material Editor dialog box are also accessible here. Click once on the Basic Button in the Attributes Manager and notice that this is where you select

figure | 3–14 |

Accessing Material
Parameters Using the
Attributes Manager

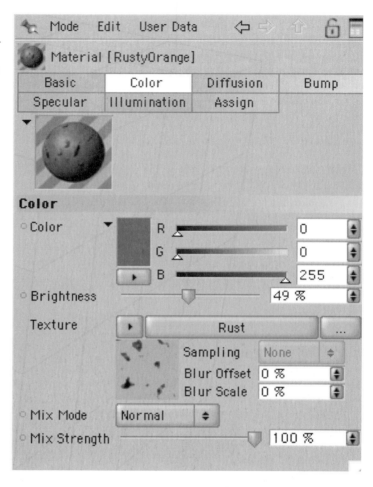

different channels. As you check the various channel checkboxes,
buttons are added or removed from nearer the top of the Attributes
Manager. As you work with C4D, find out which approach works
best for you: Material Editor or Attributes Manager.

Back in the Materials Manager, take a look at the Function menu.
There, you can sort materials in the Materials Manager alphabeti-
cally, rename materials, group materials, remove unused or dupli-
cate materials, and even highlight the material associated with the
currently selected object in the Objects Manager. Before you move
on, click once on RustyOrange.1 to select it and then either hit the
Delete key on your keyboard or choose Edit > Delete from the
Materials Manager menu set. You won't need this extra copy of
RustyOrange so this gets rid of it.

More Material Attributes

Next, you'll create a bright blue material for the torus, and experiment with a few of the other material channels in the process.

1. Create a new material and name it ShinyBlue.

2. In the Color channel, set the red and green values to 0, the blue value to 255, and the Brightness value to 100%.

3. In the Specular channel, set Width to 33%, Height to 75%, Falloff to −20%, and Inner Width to 20%.

4. Apply this material to the torus.

5. Render the active view and you'll see that the torus looks clean and polished in contrast to the sphere (see Figure 3–15). Notice how the specularity almost looks like a reflected studio light.

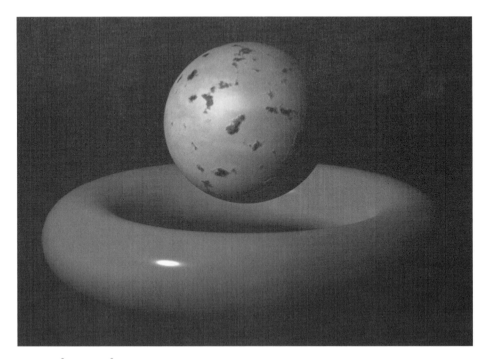

figure | 3–15 |

Rusty Orange Sphere and Shiny Blue Torus

Environment

There are a couple of ways to achieve a highly polished and reflective look in a material: environment and reflection. Environment has a number of benefits, as you'll see here. First of all, in a scene where there are few objects to reflect, environment allows you to simulate reflected objects easily. Also, environment usually renders a bit more quickly than a true reflection.

1. Check the checkbox to activate the Environment channel.

2. Click the ellipsis in the Texture section of the dialog box and load the Auditorium.jpg file from the Chapter 3 folder on the CD-ROM.

3. Render the active view and you'll see that the torus appears almost as chrome reflecting an auditorium scene (see Figure 3–16). So what's missing? Notice that the sphere isn't reflected onto the torus at all. That won't do. Uncheck the Environment checkbox to deactivate that channel.

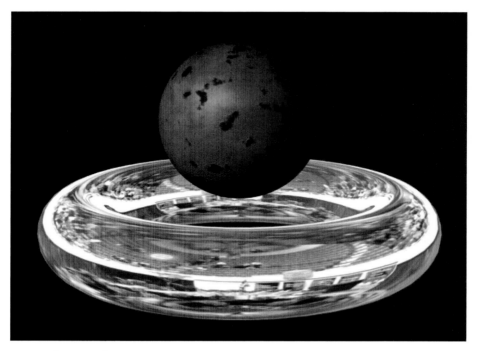

figure | 3–16 |

Environment Channel: a Simulated Reflection on the Torus

Reflection

The other way to create a reflection is to use the Reflection channel.

1. Check the Reflection channel checkbox.

2. Make sure all the color sliders are set to 255 and the brightness to 100%.

3. Render the active view. Notice the torus reflecting itself inside the ring and the sphere reflected on the top of the torus on the side closest to you.

You can use both the Environment and Reflection channels together. Try it and see. Remember, you can adjust the Mix Strength slider in the Environment channel to alter the intensity of the apparent reflection. You can get some pretty fair results that way, but let's explore a couple other options. Uncheck the Environment channel checkbox, leave Reflection checked, and let's continue.

Fog

Fog gives your material a slightly cloudy, transparent look.

1. Activate the Fog channel. Stick with the default settings for now.

2. Render the active view. The cloudy appearance and the multiple images of spheres and specularity that are produced (see Figure 3–17) are very impressive, but uncheck the Fog channel for now.

Glow

Rendering with Glow is a two-step process. Your image is rendered as usual, and then the glow is subsequently applied.

1. Just for fun, check the Glow channel.

2. Keeping the default settings, render the active view (see Figure 3–18). The torus appears almost iridescent.

Inner and Outer Strength influence the intensity of the glow above the material's surface and at its edges. Radius determines how far from the surface the glow extends. Uncheck the Glow Channel.

figure | 3–17 |

Torus Primitive with
Fog Applied

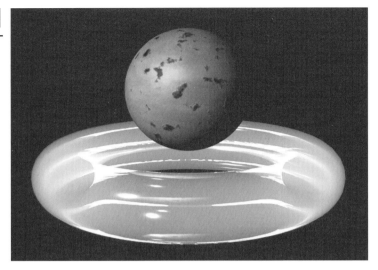

Luminance

Luminance is used to produce self-illuminated objects such as neon lights, television screens, and computer screens.

1. Activate the Luminance channel.

2. With Brightness set to 100%, the effect can be a bit over-powering. However, set the red and green color sliders to 0, the

figure | 3–18 |

Torus Primitive with
Glow Applied

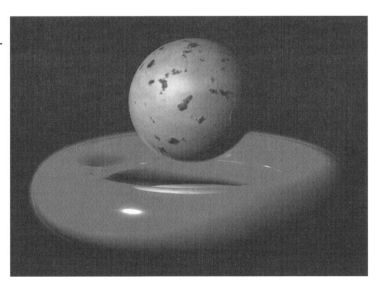

blue slider to 255, and the Brightness slider to 20% and render the active view. The effect is quite pleasing, adding a bit of color and energy to the present scene.

3. Leave Luminance checked.

This is as far as we're going to go with your sphere and torus. If you'd like, take some time to experiment with the channels you've used so far and see how altering settings produces varied effects. Notice that by using the basic options built into C4D, you can produce materials that look aged or new, near or far, clean or soiled, bumpy or smooth, and anywhere in between.

Transparency

Let's end the chapter with a look at transparency. You'll probably find that you use transparency a lot for windows, bottles, glasses, jewels, cockpits, gas clouds, liquids, etc. However, because the transparent properties of objects vary quite a bit from object to object and because we come in contact with transparent materials every day, getting transparency just right and producing a believable appearance can take a lot of time and effort.

1. Open the file Glass.c4d in the Chapter_03 folder of your CD-ROM.

Notice that the file includes a floor object created from a cube primitive, a light, additional illumination supplied with an Environment object, and a glass object. The floor already has a material applied to it: a checkerboard. You will be experimenting with a variety of material settings to be applied only to the glass object.

2. Create a new material and name it Glass.

3. In the Color channel, set all three color sliders to 255 and the Brightness slider to 10%. Why such a low Brightness setting for the glass material? We often think that glass is white because we see white light passing through it. In truth, clear glass has very little color, hence the low brightness setting in the Color channel. For some types of glass, you might even deselect the Color channel altogether.

4. Because your glass will be clear, clean, and polished, set the Specular Width to 20%, Height to 100%, and Falloff to −5%.

5. Activate the Reflection channel and set the Reflection Color Brightness to 15%. Again, clear glass isn't as reflective as you might think.

6. Apply the material to the glass object and render the active view. It looks like a shiny black glass at this point. You need to build in some transparency.

7. Activate the Transparency channel by checking its checkbox.

8. Render the active view. At this point, the glass is so transparent that you can't even see it, only its specular highlight and a bit of its rim. That won't do.

9. Ease off on the Brightness setting in the Transparency Color area of the Material Editor dialog box. Set it to 95% and render the active view. That's a little better. At least you can see the outline of the glass, albeit dimly.

10. Next, still in the Transparency channel (see Fig 3–19), notice the area labeled Refraction. *Refraction* has to do with the way materials distort light. Think about the times you've looked at someone standing in the shallow end of a swimming pool. Their legs seem to be disconnected from their upper body. The same is true for a pencil half submerged in a glass of water. Air has a refractory value of 1.0. Water has a refractory value of

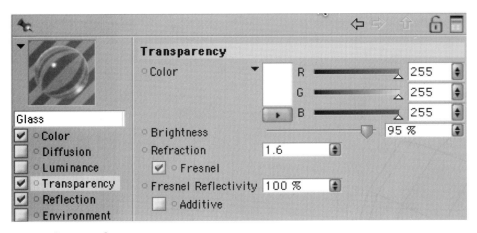

figure | 3–19 |

Transparency Channel

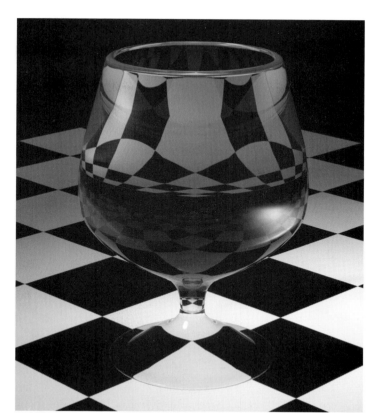

figure | 3–20 |

Completed Glass

about 1.33. Clear glass varies but often runs between about 1.5 and 1.75. So, set the n-value of the refraction to 1.6 and render the active view. You should notice that the tiled floor is now distorted where viewed through the glass.

11. One last change: check the Fresnel checkbox to enhance the look a bit more. *Fresnel* factors in the angular difference be-tween the surface of the glass and the location of the camera. Render the active view (see Figure 3–20). It's looking pretty good now, isn't it?

As we bring this chapter on materials to a close, here are some more glass examples to play with. In the Chapter_03 folder on your CD-ROM, you'll find a file named GlassExamples.c4d. It includes seven different basic glass types. Open the file and examine the settings used in each of the seven glass materials. Spend some time there so that you come to better understand the Transparency channel.

SUMMARY

In this chapter, you learned how to craft materials for your specific texturing needs and how to apply materials to objects. You also learned how to manage materials, duplicate them, delete them, and organize them via the Materials Manager. We will go into more detail in a later chapter, but with what you've learned so far, you should be able to add a great deal of realism and energy to your objects.

There are so many possible configurations for materials that it is impossible to offer cookie-cutter solutions to all your texturing needs. Instead, you'll need to spend a good deal of time and thought piecing together the right materials for your projects. Remember, you have straightforward, quick, and easy solutions to many problems working with only a few channels such as Color and Specular, but you can also develop far more dynamic materials using Environment, Diffusion, Transparency, Reflection, Glow, and Fog channels.

in review

Launch C4D and drop a cube into your 3D workspace.

1. Imagine that you want to make the cube look new and highly polished. Which channels would you most likely use? How might you make the cube look well worn and old instead?

2. What are the two ways to simulate reflection? What are the pros and cons of each? Let's assume that you have your scene with only this one cube in it, but you want the cube to appear to reflect something you've captured in a bitmapped image: perhaps a picture of you or a close friend. How could you do that? Which channel(s) would you most likely use?

3. You want your cube to glow like a chunk of radioactive material in a science fiction movie. Which channels might come in handy as you attempt to do this?

4. The Specular channel can have a lot of influence over the look and feel of an object. How might you vary the characteristics of specular height, width, falloff, and inner width to craft different materials?

5. Which channels are most important as you develop materials such as glass and water? How would you go about producing realistic materials for objects composed of these elements?

↗ EXPLORING ON YOUR OWN

1. In Chapter one, you created a toy train. Open that model now and add textures to it to make it appear more realistic. There is also a copy of the train model in the Chapter_03 folder for you to use. A fire hydrant, created with primitives only, has also been included. Apply textures to the different parts of the hydrant and see if you can come up with a realistic rendering. There's a bottle in there, too.

2. There are several bitmapped images in a Tex folder inside the Chapter_03 folder on your CD. Use those images to build your own materials. Note that some include "bump" in their file name. Use those in the Bump channel. You can also download images for use as textures from the Internet. Simply use your favorite search engine and search for "3D textures." Or visit www.maxon.net/~deepshade/.

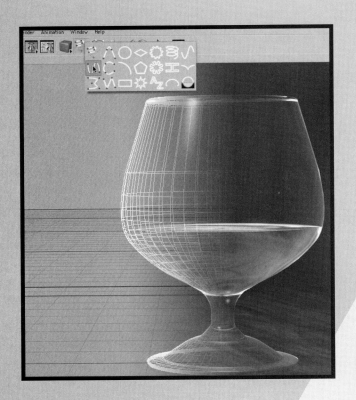

spline-based modeling

 charting your course

After your brief foray into basic texturing, it's time for you to return to modeling concepts and procedures. As mentioned earlier, there are a number of ways to model objects in C4D and similar 3D software applications. In Chapter Two, you used parametric primitives to model a toy train. Using parametric primitives is similar to building a house with prefabricated materials: bricks, cinderblocks, 2 by 4s, 4' by 8' plywood sheets, etc. Clearly, you can do a lot with these materials, but there are a number of constraints and limitations; which is one of the main reasons why most houses look alike, and why deviations from the standard of straight walls, rectangular windows, and a single flat floor cost extra. Different materials and alternative techniques are required.

In this chapter, you'll use a different set of tools: tools that allow you to pull a cross-section along a path, lathe an object, or cover a set of cross-sections with a skin. While not completely freeform, you'll find that these tools provide you with far greater flexibility than parametric primitives, albeit at some small cost in terms of complexity.

 goals

In this chapter you will:

- Identify C4D's spline types and note the unique characteristics and capabilities of each

- Build simple 3D models using hand-drawn splines and spline primitives in conjunction with Extrude, Lathe, Sweep, and Loft NURBS

AN INTRODUCTION TO SPLINE-BASED MODELING

To understand how spline-based modeling works, you need to first understand what a spline is. A *spline* is an infinitely thin line between two or more points. That a spline is infinitely thin is important because that means splines do not render. That is, if you render the active view after creating a spline, you'll see nothing other than apparently empty space. If they aren't rendered, what good are they? Well, when you push or pull a spline through 3D space, perhaps along or around some axis using specific NURBS objects, it leaves an object in its wake.

An analogy will make this clear. You might have played with a Play-Dough Factory as a kid. You could select some shape from a template (a star, crescent moon, rectangle, etc.), fill a chamber with Play-Dough, and then push down on a lever to push the Play-Dough out of the chamber and through the template. That's the way it is with spline-based modeling. The spline is the template that you can move through space. The NURBS object is essentially the Play-Dough left in its path (see Figure 4–1).

NURBS stands for *non-uniform rational b-spline*. You know that a spline is a line in 3D space. A non-uniform rational b-spline is a line in space defined by weighted control points. Basically, *NURBS* are a mathematical construct for defining 3D objects. They utilize other objects, such as other splines, to generate a surface. At this point, it's not important that you understand the math behind

figure | 4–1 |

A Star Spline
Extruded Through
Space

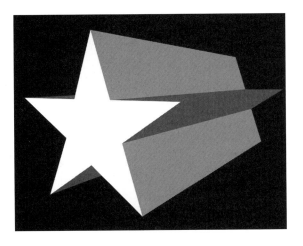

the concept, any more than you need to understand the math behind the curves generated in programs like Adobe Illustrator or Macromedia Freehand. Just know that NURBS are enormously powerful and extremely flexible. They put substantial modeling power into your hands and you'll soon be using them to create fantastic models.

Spline Types

There are five types of splines in C4D: Linear, Cubic, Akima, B-spline, and Bézier. You can select the spline type from the main menus under Objects > Create Spline; use the folded icon in the horizontal toolbar (see Figure 4–2); or, once a spline has been drawn, change its type using the drop-down menu in the Attributes Manager (see Figure 4–3).

Each spline type has its own characteristics and uses. For hard, angular objects, you'll want to draw with the Linear Spline tool. To create especially smooth, flowing lines, use the Cubic Spline tool. For greatest control over multiple curves and the ability to precisely manage the curvature of every segment of the line separately, use the Bézier Spline tool. Table 4–1 shows each type of spline applied to the same set of points.

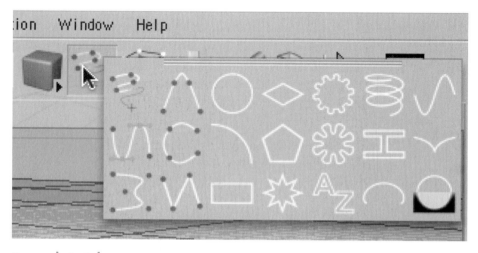

figure | 4–2 |

Setting the Spline Type via the Main Toolbar

figure | 4–3 |

Setting the Spline
Type via the Attrib-
utes Manager

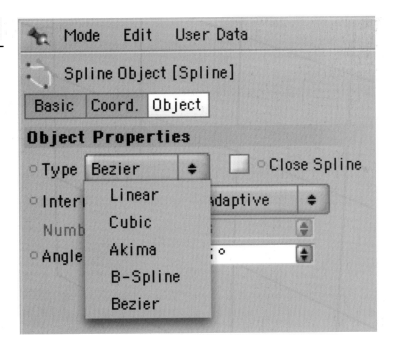

The Freehand Spline tool isn't a spline type per se, but instead a way of drawing a spline. This tool is available under the Objects > Create Spline menu as well as via the main horizontal toolbar. While each of the other spline drawing tools requires you to draw point to point, clicking the mouse button as you go, the Freehand Spline tool allows you to draw just as if you were using a pencil and then it creates points for you. You can control the smoothness of the line you draw with the Freehand Spline tool by first selecting the tool and then, in the Attributes Manager, adjusting the tolerance. Small numbers result in very edgy, angular lines with lots of points. Large numbers result in smooth, flowing lines with few points.

An entire book could be written about splines. There are so many options. The Bézier Spline tool will be the spline tool of choice for much of your work. Less frequently, you'll use either the Linear Spline tool or the Freehand Spline tool. Later in the chapter, you will draw several splines. Try different tools and different settings as you draw those splines. No doubt you'll have your favorite tool but it's nice to know that there are other options available for unusual shapes and peculiar circumstances.

Of course, there will be times when you don't need to custom create a spline. Instead, you might choose to use one of C4D's

table | 4–1 | Spline Types and Uses

Linear

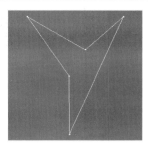

The path of the spline between points is straight and direct. Best used for objects that have hard, straight edges.

Cubic

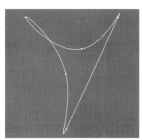

The path of the spline between points is especially loose and free flowing. So much so, that the sweeping curves at the top and left in the example to the left cross one another.

Akima

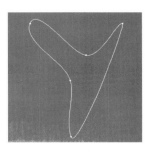

Not as soft as the Cubic spline, an Akima spline has slightly soft curves between points.

B-Spline

Of particular interest, the curved path of a B-spline does not pass through the points that define it. Where points are closer together, the curve is more angular.

Bézier

Points on a Bézier spline have a set of handles that allow you to adjust the smoothness of the curve passing through the point as well as its direction. This spline type gives you the greatest flexibility and control.

built-in Spline Primitives. Just like the parametric primitive objects addressed in Chapter Two, these shapes are mathematically defined. You modify them by altering specific parameters. Look at Figure 4–2 once again. The six splines along the left edge of that unfolded icon are your spline drawing tools. The remaining fifteen icons represent C4D's Spline Primitives: circles, rectangles, cogwheels, arcs, flowers, text, etc.

Creating Splines

Technically speaking, drawing splines is pretty easy. You simply select the spline drawing tool you want to use, make sure you're in the correct viewport, and then click away. That's all there is to it. On a more creative level, however, getting your splines just right can be a lot of work. If you've used similar tools to create shapes in 2D drawing programs such as Adobe Illustrator or Macromedia Freehand, you'll pick up C4D's spline tools quickly. If this is your first opportunity to work with this type of drawing tool, you'll get the hang of it soon. Just plan on putting in a fair bit of time practicing the techniques presented here.

1. Launch C4D and press F4 to see the front viewport.

2. Select Edit > Configure from the viewport's menus.

3. In the Back panel of the Attributes Manager (see Figure 4–4), click the ellipsis (. . .) button, navigate to the Chapter_04 folder on your CD-ROM, and open the Heart.tif file.

figure | 4–4 |

Configure Viewport
Background

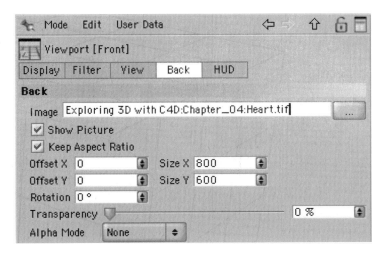

This image was created with Photoshop using the Custom Shape Tool. This file, others included in the Chapter_04 folder, and similar images that you can quickly create on your own in Photoshop, are perfect for learning to draw splines.

Draw Freehand Spline Tool

Select the Draw Freehand Spline tool and trace the heart that appears in your front view. Select a good starting point—perhaps the bottom of the V at the top center of the heart—and then, holding your mouse button down, drag your cursor around the edge of the heart until you finally return to your starting point. Don't release your mouse button during the process or your drawing will end. Don't worry if you don't get it exactly right. Just give it a quick try and then you can come back and clean things up later.

After you finish, take a look at the spline that appears. Notice that the color varies along the spline: bright yellow at the beginning of the spline and bright red at its end. If, later, you add points to the spline, they will be added to the red end unless you specifically control-click somewhere along the spline.

Over in the Attributes Manager (see Figure 4–5), notice the Close Spline checkbox. If your start-point and end-point were quite close, C4D may have closed the spline for you and the checkbox will be checked. If your start and end points were separated by some distance, you will want to check the checkbox so that C4D

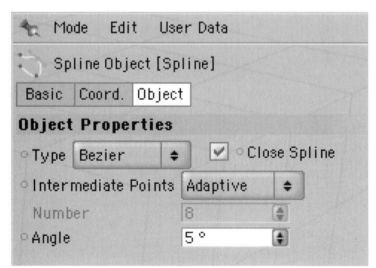

figure | 4–5 |

Spline Type and
Close Spline
Checkbox

connects those points. Also notice that the line Type defaults to Bézier for a spline drawn with the Draw Freehand Spline tool.

Back in the viewport, points along your spline appear as small brown dots. Select the Move Active Elements tool, click on a point, and notice that you can move it around and position it wherever you'd like. You'll also notice that as you click on each point, small magenta-colored lines appear out of each side and the lines have small boxes at their ends. As was mentioned earlier, you can control the shape of the spline between adjacent points by moving these control handles around. Click and drag one of the small magenta dots to try it out. Notice that as you drag the control handle on one side of the point, the control handle on the opposite side moves in the opposite direction. If you want to restrict your manipulation of a spline's curvature to only one side of a point, shift-click and drag the control handle. Then, its twin will not move. Try it and see.

As a brief aside, take a look at the Structure Manager (see Figure 4–6). You may have to scroll to see all the data, but the Structure Manager shows you where each and every point for the selected object lies in 3D space. The first three columns indicate the X, Y, and Z coordinates for each point. In this example, all of the points have 0 for their Z value because you're drawing flat against the front view. If you have one of the points selected in your viewport, the row for that point will be highlighted with a blue gradient behind the data for that point. In Figure 4–6, this is point number 0. Also notice that points are numbered beginning with 0 and not 1. Columns 4

Point	X	Y	Z	<- X	<- Y	<- Z	X ->	Y ->	Z ->
0	8.954	113.145	0	0	0	0	17.971	35.943	0
1	215.504	178.671	0	-75.681	34.477	0	58.574	-65.306	0
2	263.53	0.001	0	4.188	8.376	0	-7.376	-14.752	0
3	93.097	-115.795	0	49.93	31.832	0	-16.351	-10.424	0
4	13.838	-201.056	0	3.66	11.8	0	-0.444	-1.433	0
5	-95.237	-105.004	0	41.332	-21.137	0	-45.208	23.12	0
6	-233.615	-2.442	0	15.352	-15.352	0	-7.881	7.881	0
7	-251.523	46.397	0	1.093	-10.931	0	-3.73	37.304	0
8	-194.544	181.52	0	-29.992	-22.494	0	14.461	10.846	0
9	-83.841	191.288	0	-19.424	9.712	0	2.673	-1.337	0
10	-44.769	176.636	0	-3.596	0	0	0	0	0

figure | 4–6 |

Structure Manager Showing Location of Points and Their Control Handles

through 9 locate each point's control handles. You can change the location of any point or of its control handles by double-clicking the value you want to change in the Structure Manager, entering the desired value, and then pressing enter. Try it and see. You will frequently use this technique to precisely position points in space.

Generally speaking, having fewer points is better than having many when working with a Bézier spline. You'd really prefer to manage the curvature of your shape—not with lots of points—but instead with a few well-placed points and appropriate manipulation of their control handles. You can delete points along your spline by clicking on them and hitting the Delete key on your keyboard. You can see in Figure 4–7 that all but six points have been deleted and then their control handles used—often dragging with the Shift key depressed to control one handle at a time—to end up with a fairly smooth heart shape.

How do you decide which points to delete and which to keep? There's no simple answer to that question. In broad terms, however, look for prominent points along the curve of an object and also points where the direction of the spline moves off in an opposite direction. Look at Figure 4–7 again to see this concept in action. Actually, you could probably recreate the heart shape with only four points: one at the bottom of the V near the top of the heart, one at the very bottom of the heart, and then one at each of

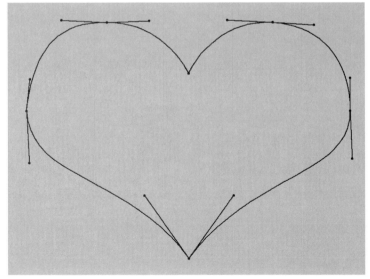

figure | **4–7** |

Six Points Define
the Heart Shape

the extremes on the left and the right. It's always a best guess and, of course, you can always add or remove points as needed. Practice and you'll get a feel for it.

Draw Bézier Spline Tool

Use the heart image once again, this time with the Draw Bézier Spline tool.

1. Delete the spline you created a moment ago.

2. Select the Draw Bézier Spline tool from the folded spline icon or from the main menus under Objects > Create Spline > Bézier.

When using this tool, you will click to create a point with no control handles—sometimes called a hard point—or click and drag to create a point with handles—a soft point that produces curvature. Use Figure 4–7 as a guide if you wish. You'll be creating points in the same locations as indicated there.

3. First, click once at the bottom of the V near the top of the heart.

This creates a hard point with no handles.

4. Next, click near the top of the arc along the upper-right side of the heart but don't release the mouse button. Instead, continue to drag to your right.

A set of control handles will appear and the spline will begin to curve. Continue dragging to the right until the curve approximates the curve of the heart shape between these first two points. Release your mouse button when you are fairly happy with the curve of the spline.

5. Now click and drag at the far right of the heart where the curvature of the heart stops moving farther right and begins to pull back toward the left. This time, however, drag down, not to the right.

Again, match the curvature as best as you can but keep in mind that you can always come back later and edit points.

The point at the bottom is toughest.

6. Click and drag down about an inch.

You won't get a good match to the curve of the heart, but don't worry about it. The same is true on the next point at the far left side of the heart.

7. Drag up about an inch from a point on the far left of the heart where the outline stops moving left and begins to move back right.

The control handles of the previous point cause the line to go wide to the left but don't worry about that now.

8. Click another point at the top left of the heart and drag to the right.

9. Finally, check the Close Spline checkbox in the Attributes Manager.

Now clean up your spline as you did with the spline you created earlier.

10. Select the Move Active Element tool and move each point into position.

The curvature for points along the top of the heart probably looks pretty good; it's only the bottom points that need serious attention.

11. Click on that point at the very bottom of the heart to select it. Its control handles appear.

12. Shift-click the control handle that's below the point and drag up and to the left until the curve along the left side of the heart looks good.

13. You'll probably want to shift-click and drag the other control handle for that point up a bit and to the right (see Figure 4–8).

Draw Akima, Cubic, and Linear Spline Tools

As noted earlier, you'll probably use these spline drawing tools far less often than the Freehand and Bézier tools. The Draw Linear Spline tool is great for creating splines composed entirely of straight-line segments. The Akima and Cubic Spline tools are very similar, the main difference being the curvature of spline segments

figure | 4–8 |

Shift-Click and
Drag Control
Handles One at
a Time to Move
Independently

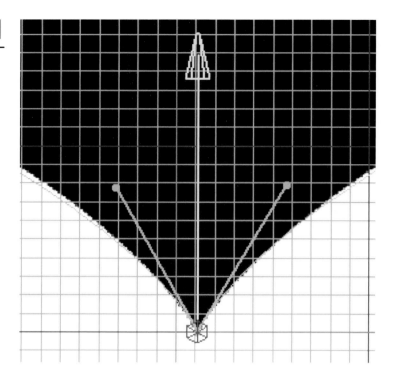

between and around points. In each case, you simply click to create
a point. There are no manageable control handles, so clicking and
dragging doesn't work as it does for Bézier splines. If you look in
the Structure Manager with a Linear spline selected, you'll see that
there are no coordinates for control handles. For Akima and Cubic
splines, there are coordinates but you can't change them.

When using the Linear Spline tool, you'll typically draw from cor-
ner to corner, angle to angle.

1. Create a new scene in C4D, make sure you are in the front
 view, and configure that view to use the Arrow.tif file, on the
 CD-ROM, as a template.

2. Using the Draw Linear Spline tool, click at any corner point,
 then click your way around the shape one corner point at a
 time.

3. Work your way around and then click on the starting point to
 close the spline, or click the Close Spline checkbox when one
 point away from the starting point to complete your work.

You've just added a point to your spline. As is always the case, X, Y, and Z axes indicators appear, centered on the point you just entered. If the point isn't positioned exactly where you want it, you can click and drag on one of these indicators to move it. That's the good news. The bad news is that if you are trying to lay down a new point but one of these axis indicators gets in your way, you have a problem. If you click, C4D assumes that you are trying to grab the axis indicator and so your new point doesn't get created. You'll probably find it easiest to simply create the new point a bit offset from the axis indicator that's in your way, and just come back later to reposition it.

When drawing with the Akima or Cubic Spline tools, you'll often find yourself drawing just a bit at a time; slowly working your way around an object.

1. Create a new scene in C4D, make sure you are in the front view, and configure that view to use the WholeNote.tif file as a template.

2. Using either the Draw Akima or Draw Cubic Spline tool, click somewhere on the outside surface of the note, and then click again and again every inch or so to outline the note. You'll find that you need to position points closer together where your shape curves most.

If you click and drag, you do not produce control handles but, instead, simply adjust the location of the point. Try it and see.

Remember, you can always click and drag the axis indicators for any point you've just created and move the point into place.

Drawing Splines and the Active Viewport

It is especially important that you be mindful of which viewport is active when you create your spline. A brief demonstration may help make the point.

1. Create a new scene and press F2 so that you are in the Top view.

2. Select the Freehand Spline drawing tool and quickly draw a rough circle.

3. Now press F1 to return to the Perspective view.

Notice that the spline you drew is flat on the plane defined by the X and Z axes.

4. Still working with this same scene, press the F4 key so that you are working in the Front view.

5. Quickly draw another rough circle using the Freehand Spline drawing tool.

6. Return to the Perspective view once again.

Notice that the new spline lies flat on the plane defined by the X and Y axes. The same is true when you add Spline Primitives to your scenes. They are inserted flat against the plane defined by the active viewport, with one exception.

7. Delete the spline objects you've created so far.

8. In the Perspective view, draw a circle using the Freehand Spline tool.

9. Now rotate your view a bit and you'll notice that the spline was drawn flat, in two dimensions, parallel to your view when drawn.

10. Rotate your view substantially and draw another spline. Again, it appears flat on the screen; and it is. It's parallel to your view.

11. Now delete those splines and add a Spline Primitive to your scene: perhaps a star, rectangle, or cowheel.

Notice that the Spline Primitive isn't drawn parallel to your view but, instead, flat against the plane defined by the X and Y axes (the front view). Okay, so there appears to be a bit of an anomaly in the Perspective view. Just remember, splines appear in your scenes flat against the screen on the plane defined by the active viewport for all views except the Perspective view; and flat against the screen in the Perspective view when the spline is created with drawing tools, but on the plane defined by the X and Y axes when a spline primitive is used.

NURBS

As we mentioned earlier, NURBS can be used to create surface area—that is, geometry—when used in conjunction with some other modeling tool: splines, for instance. So, in this next section, you'll take the skills you've acquired drawing splines, combine that with a new understanding of NURBS, and find that you can model especially interesting objects.

C4D offers you six different NURBS objects for use in modeling, accessible via either the main menus or the horizontal toolbar (see Figure 4–9). HyperNURBS will be covered in a later chapter. Bézier NURBS are useful, but in a rather limited set of circumstances, so we won't address them here either. The other four types—Extrude, Lathe, Loft, and Sweep—are foundational. You'll probably use them frequently and so you need to understand them especially well.

figure | 4–9 |

Accessing NURBS Objects

Extrude NURBS

The Play-Dough Factory analogy referred to earlier best describes Extrude NURBS. Using one of the spline drawing tools or one of C4D's Spline Primitives, you create a template to be moved straight through 3D space to leave an object behind.

1. Choose File > New from the main menus to open a new scene.

2. Make sure you are in the Perspective view.

3. Using either Objects > Spline Primitive > Flower from the main menu or the Add Flower Spline icon under the folded spline icon set, add a flower spline to your scene.

4. Now, add an Extrude NURBS object to your scene. Either choose Objects > NURBS > Extrude NURBS from the main menus or select the Add Extrude NURBS Object icon from the horizontal toolbar.

5. Next, make the Flower spline primitive a *child* of the Extrude NURBS object.

That is, in the Objects Manager, drag the Flower spline primitive on top of the Extrude NURBS object. As you do, your cursor will change into a small white box with a downward-pointing arrow (see Figure 4–10). Now, you can release your mouse button and your Objects Manager will look like the one in Figure 4–11. Notice that the Flower spline icon is indented below the Extrude NURBS object. Also notice the minus sign to the left of the Extrude NURBS object. Clicking on this minus sign closes this group and hides its children. When you do this, the minus sign changes to a plus sign. Next click once on the plus sign to open the group and reveal its children.

Of particular interest, however, is what has happened in the perspective window. Notice that your Flower spline has now been

figure | 4–10 |

Drag the Flower onto
the Extrude NURBS
Object

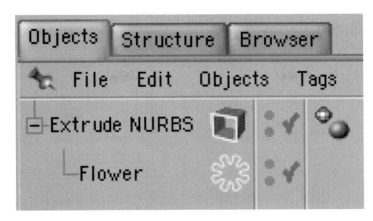

figure | 4–11 |

The Flower Has
Become a Child of
the Extrude NURBS
Object

pulled along the Z axis to form a flower shape that has depth. Also of interest, the Flower spline is still a primitive and so its parameters are still editable.

1. Click once on the Flower spline primitive in the Objects Manager to make it active.

2. In the Attributes Manager, change the number of petals to 3 and then look at your extruded flower in the viewport.

3. Now, set the number of petals to 15.

4. Change the Inner Radius to 150 and look at the flower in the viewport.

5. Change Inner Radius again, this time to 50.

Sometimes, extreme settings produce rather disappointing results. With the Flower spline primitive, whenever the Inner Radius goes much below about half the Outer Radius, the curvature of the spline that forms the petals begins to cross over itself. You could increase the Inner Radius. Or, you might take the curvature out of the spline. Try the latter and see what happens.

6. In the Attributes Manager, change Intermediate Points to None to do away with the curves (see Figure 4–12).

7. Reset Inner Radius to 100, Outer Radius to 200, Petals to 8, and Intermediate Points to Adaptive.

8. Now, click once on the Extrude NURBS object in the Objects Manager to make it active.

figure | 4–12 |

Flower with Interme-
diate Points set to
None

The Attributes Manager now presents parameters for the Extrude NURBS object instead of the spline (see Figure 4–13). Notice that the Extrude has run for 20 meters along the Z axis. It is not clear that this is the Z axis. You just need to remember that the first box is X, the second box is Y, and the third box is Z.

9. Change the distance in the Z axis box to 150. See the difference?

10. Go ahead and change the X and Y values to 150.

Notice that the flower now runs to the right, up, and to the back along the X, Y, and Z axes, respectively. And while you're here experimenting with Extrude NURBS, enter a negative number as the value for X, Y, or Z. Then reset the values for X, Y, and Z to 150, 150, and 150.

figure | 4–13 |

Editable Parameters
for the Extrude
NURBS Object

| Mode Edit User Data | ⇦ ⇨ ⇧ | 🔓 ☐ |

🗋 Extrude Object [Extrude NURBS]

| Basic | Coord. | Object | Caps |

Object Properties

○ Movement 0 m ↕ 0 m ↕ 20 m ↕
○ Subdivision 1 ↕
○ Iso Subdivision 10 ↕
 ☐ ○ Flip Normals
 ☐ ○ Hierarchical
 ☑ ○ Untriangulate

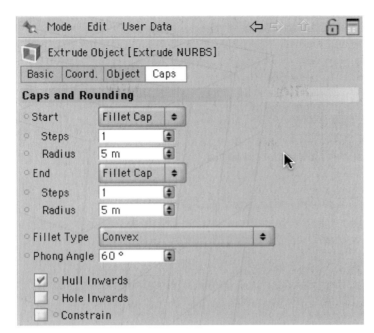

figure | 4–14 |

Cap Options in the
Attributes Manager

11. Next, click once on the Caps button in the Attributes Manager to see cap settings for the Extrude NURBS object (see Figure 4–14).

12. Set the Start and End dropdown boxes to None and render the active view.

Notice in the perspective viewport that both ends of your extruded flower are now open.

13. Now, set the Start setting to Cap.

If you'll render the active view, you'll see that this closes off the previously open extrude at the end where the extrusion started, but you haven't capped the far end yet. You may want to rotate your view in the perspective viewport so that you understand how this works.

14. Set End to Cap, too.

Notice that the edges of the cap, where the cap and extrude come together, are very sharp and angular. You can change this.

15. Set the Start and End to Fillet.

This rounds the ends of the extruded object, but the cap has disappeared.

16. Finally, set Start and End to Fillet Cap.

Now, when you render the active view, you can see that the caps are in place and the transition between each cap and the extrude is smooth.

Steps and Radius refer to the transition between the cap and the extrusion. Increasing Radius to, for example, 10 extends the transition over a larger distance. A smaller number, for instance 1, yields a smaller area of transition. Steps helps define the smoothness of the transition. Fewer steps results in a quick, direct, and angular transition. Increasing the number of steps results in a smooth, rounded transition.

17. Set the Start Steps to 1 and the Radius to 10 and render the active view.

Notice that the transition from cap to extrude is hard and angular.

18. Now set the Steps to 10 and notice the difference (see Figure 4–15).

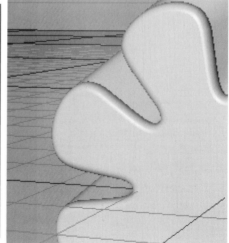

figure | 4–15 |

Fillet Steps: 1 (left) versus 10 (right)

Also, notice in the Attributes Manager that you can select from a number of Fillet types: Linear, Convex, Concave, Half Circle, 1 Step, 2 Step, and Engraved. Table 4–2 shows the difference between the different types, but you're encouraged to experiment with the different settings and see what you can come up with. Notice that Concave and 1 Step are very similar, the main difference being that Concave curves inward while 1 Step uses straight edges. Likewise, Half Circle and Engraved look a lot alike, again the difference being rounded versus straight edges.

Before you leave the Cap and Fillet options, turn your attention to Constrain. When Constrain is unchecked, the overall size of the extruded object grows to accommodate the size added by the fillet. For example, imagine an extruded circular spline with a diameter of 200 meters. Adding a 10-meter fillet increases the diameter of the resulting cylinder to 220 meters: 10 meters out in each direction away from the center. With Constrain checked, the diameter is not allowed to grow but instead remains at 200. Check and uncheck the Constrain checkbox a few times using your current flower object and you'll get the idea.

Before you move on, consider an earlier point by way of an example.

1. Open a new scene and press F2 to see the Top view.

2. Add a Flower Spline Primitive to the scene, add an Extrude NURBS object, then make the Flower a child of the Extrude NURBS object.

3. Now, press F1 to enter the Perspective viewport and render the active view.

What's wrong? Why doesn't the flower appear extruded? Remember, earlier it was noted that a spline is added into the open viewport flat against the plane that is facing you, in this case the plane defined by the X and Z axes. So, when the Flower spline is extruded, it slides along the Z axis by default to produce a flat, slightly stretched object. It's easy enough to fix.

4. Either click on the spline in the Objects Manager to make it active and change its Plane from XZ to XY in the Attributes Manager, or click once on the Extrude NURBS object in the Objects Manager and set its Z value to 0 and its Y value to 20 (or any number other than 0).

table | 4–2 | Fillet Types

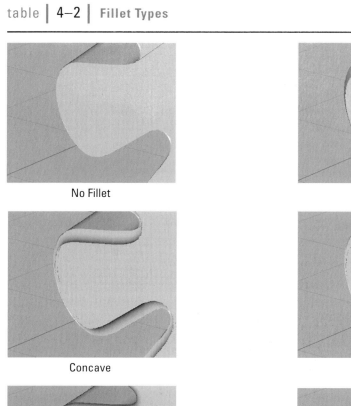

No Fillet

Linear

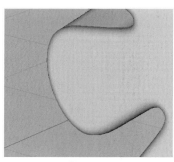

Concave

1 Step

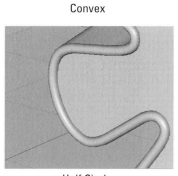

Convex

2 Step

Half Circle

Engraved

One last bit of fun with Extrude NURBS.

1. Create a new scene, add a Text Spline, and then add an Extrude NURBS object.

2. Select the Text Spline primitive in the Objects Manager and then, in the Attributes Manager, enter your first name in the textbox.

3. Now, make the Text spline a child of the Extrude NURBS object (see Figure 4–16).

There are several options in the Attributes Manager to experiment with, including Font, Height, and Spacing. The Separate Letters checkbox could be important if you intend to later make the Text Spline primitive editable and position or animate letters individually. Feel free to experiment with these settings before moving on.

figure | 4–16 |

Extruded Text Spline Primitive

Lathe NURBS

Using Extrude NURBS allows you to move a spline straight through space. Conversely, Lathe NURBS allow you to rotate a spline around an axis. It's similar to the lathe a carpenter might use to fashion table legs or the spindles used in chair backs. First, a bit of theory, and then you'll have an opportunity to put the theory into practice later in the chapter.

1. Choose File > Close All from under the main menubar.

If asked if you'd like to save changes to the work you did earlier, say no.

2. Make sure you are in the perspective view.

As was the case with Extrude NURBS, the plane that your spline is created in is especially important. Because you're going to use a spline primitive, the perspective view will work fine.

3. Add a Profile Spline to your scene.

In the folded icon containing splines, it's the one that looks like an "H" lying on its side.

4. Next, add a Lathe NURBS object to your scene and make it a parent of the Profile Spline; that is, make the Profile Spline its child.

What happens? You end up with something that looks a little like a spool that thread or wire might be stored on (see Figure 4–17). Why? The Profile Spline, which appears in your scene as an uppercase letter "I," is spun around the Y axis of the Lathe NURBS object.

figure | **4–17** |

Profile Spline
Primitive Lathed
360 Degrees

Perhaps the point can be made clearer if you spin the Profile Spline only halfway around the axis.

5. Make sure the Lathe NURBS object is selected in the Objects Manager so that you can see its settings in the Attributes Manager.

6. Then, in the Attributes Manager, change the Angle setting from 360 degrees (a complete circle) to 180 degrees (a half circle) and render the active view.

Now, you can see how the Profile Spline has been lathed around the Y axis (see Figure 4–18).

You're not done yet. Changing a couple of settings will better illustrate how Lathe NURBS work.

7. Select the Profile Spline in the Objects Manager.

8. Make sure the Move Active Element tool is selected and lock the Y and Z axes so that the Profile Spline can be moved along the X axis only.

9. Now, move the spline right—in the positive direction—along the X Axis.

figure | 4–18 |

Profile Spline Primitive Lathed 180 Degrees

The result is what appears to be a bent I-beam; something like a steel girder that might be used to support an arch (see Figure 4–19). Why? Remember that the spline is being rotated around the Y axis. You have moved the spline out along the X axis, further from the Y axis, and so the lathe takes into account that distance.

Take a few minutes and experiment with other spline primitives as children of Lathe NURBS objects. Vary the parameters in the Attributes Manager for both the spline and the Lathe NURBS object. Try altering the caps and fillets settings, too. Also, use the spline drawing tools to create a spline in the front viewport and then lathe it. You'll have an opportunity to practice this later in the chapter. At this point, just make sure you have a handle on the basic concepts and operations.

figure | 4–19 |

Increasing the Distance between the Profile Spline and the Y Axis

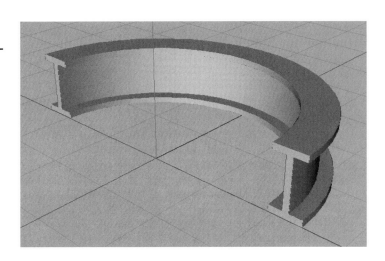

Sweep NURBS

While Extrude NURBS drag a spline along a straight path and Lathe NURBS pull a spline around an axis, Sweep NURBS pull a spline along some other spline. You have almost infinite control over both the shape of the cross section and the path it's pulled along. For the time being, you'll stick with spline primitives, but later you'll create the splines yourself.

1. Open a new scene in C4D and press F1 to utilize the perspective viewport.

2. From either the Objects > Spline Primitive menu or the folded icon group of splines, select the Helix (it looks like a spring).

3. In the Attributes Manager, change the Helix's Start Radius to 300, End Radius to 100, End Angle to 1080, and Height to 300.

The resulting spline starts large (300 m), gets smaller at its end (100 m), and consists of three complete coils (1080 degrees).

4. Next, add a Star Spline to the scene.

Clearly, this star is far too large to drag along the helix spline.

5. Change its Inner Radius to 25, Outer Radius to 50, and Points to 6.

6. Now, add a Sweep NURBS object to the scene.

Getting this next step right is crucial to the effect.

7. First, drag the Helix object onto the Sweep NURBS object so that the Helix becomes a child of the Sweep NURBS object.

8. Then, drag the Star object onto the Sweep NURBS and it will also become a child.

The Objects Manager should then look like Figure 4–20. Notice that the contour—the object to be dragged along the path—appears in the list of children above the path. If you get them in the wrong order, the results can be quite horrendous! Try changing the order of the children by dragging one above the other. However, if everything is in order, Figure 4–21 should be the result.

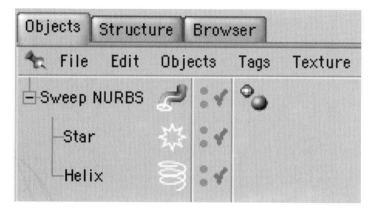

figure | 4–20 |

Getting the Children
in the Correct Order
Is Essential

figure | **4–21** |

The Star Spline Primitive Swept Along the Helix

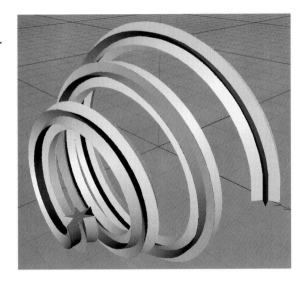

Loft NURBS

When I was a kid, my father was quite a model airplane enthusiast. I'm not talking about the little plastic kits you'd assemble with glue and then slap a couple decals on. I mean those time and labor intensive radio-controlled or fly-by-wire systems with three-foot wingspans. He was a master at that sort of thing and I really enjoyed watching him work. He would cut a few dozen cross-sections out of balsawood for the wings and fuselage, set them in place with several hardwood spars, and then cover the whole thing with a special kind of tissue paper. After the paper was glued into place, he would lightly spray it with water and the tissue would shrink a bit to form a tight skin around the cross-sections and spars. That's how Loft NURBS work. You use as many splines as you'd like as cross-sections and then drop them, in order, into a Loft NURBS object and a skin automatically appears between each. The process is fairly straightforward and, while you probably won't use Loft NURBS as often as you Extrude, Lathe, or Sweep NURBS, they certainly have their place.

1. To a new scene, and in the perspective view, add a Circle Spline and change its radius to 100.

2. Move it along the Z axis until its Z value is about 1000.

3. Add an n-Sided Polygon Spline to the scene, change its radius to 100, and move it to about 500 Z.

4. Add a 4-Sided Polygon Spline to the scene, leave it at $Z = 0$, and do not change any of its parameters.

5. Now, add a Loft NURBS object to the scene and make it the parent of the three spline primitives.

As was the case with the Sweep NURBS object, the order of the children under the Loft NURBS parent is extremely important. It doesn't matter if you go from first to last or last to first, but be sure to go from one extreme to the other; in this case, 4-Side, n-Side, then Circle or Circle, n-Side, then 4-Side (see Figure 4–22). There you have it! What happens when you get the children in the wrong order? The Loft NURBS object draws back upon itself and you end up with a bit of a mess. Try it and see.

Take some time to work through the exercises at the end of this chapter to get a better understanding of how Loft NURBS work.

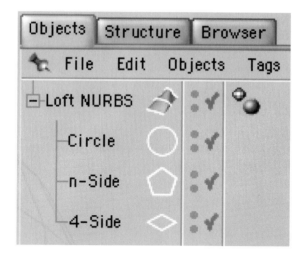

figure | 4–22 |

It's Especially Important to Keep Children in the Right Order

Intersected Shapes from Splines

To this point, you have extruded, lathed, lofted, and swept simple splines only. However, splines can be combined to create increasingly complex shapes and cutouts. It's not a very difficult process, but there are a couple of things you need to keep in mind.

First, spline primitives will not work. That is, before it can be combined with another spline, a spline primitive must be made editable.

figure | 4–23 |

Cogwheel Has Been Made Editable, Rectangle Has Not

To make a spline primitive editable, select it in the Objects Manager and then select Functions > Make Editable from the main menus or click on the Make Object Editable icon near the top of the vertical toolbar. You'll note that the spline primitive's icon in the Objects Manager changes when it has been made editable. Figure 4–23 shows two spline objects: a Rectangle and a Cog Wheel. While both were originally spline primitives, the Cog Wheel has been made editable.

For best results, the splines that you combine must be of the same type. That is, you can combine a Linear spline with another Linear spline or a Bézier spline with another Bézier spline, but you may run into problems when you try to combine a Linear spline with a Bézier spline. The resulting combination will need to be one or the other; it can't be both.

DON'T GO THERE

A word of caution about making primitives editable—either spline primitives or parametric primitive objects—once made editable, you can no longer alter the size, shape, or characteristics of a primitive using the parameters previously available through the Attributes Manager. Instead, you must alter the primitive by manipulating points, polygons, edges, etc. And while you can make a primitive editable, there is no way to make an editable object a primitive. So, before you make a primitive editable, be sure that's what you really want to do.

Give it a try. You'll combine a Rectangle Spline with a Cogwheel Spline and then extrude the combination for a cutout effect.

1. Create a new scene in C4D and add a Rectangle Spline, a Cog-wheel spline, and an Extrude NURBS object to it.

2. Change the Cogwheel spline as follows: number of Teeth to 10, Inner Radius to 50, Middle Radius to 150, Outer Radius to 180, and Bevel to 100%.

3. Now make each of the spline primitives editable.

4. Next, shift-click the two spline primitives in the Objects Manager and from the main menus, choose Functions > Connect.

5. A third spline will appear in the Objects Manager—a combination of the other two—probably named either Cogwheel.1 or Rectangle.1.

6. The other two splines are of no use anymore, so delete them.

7. Now make the new spline a child of the Extrude NURBS object.

The result (see Figure 4–24) is quite interesting. Take a few moments and experiment with the Fillet Cap settings for the Extrude NURBS object. Set Steps to 5, Radius to 5, and check Constrain.

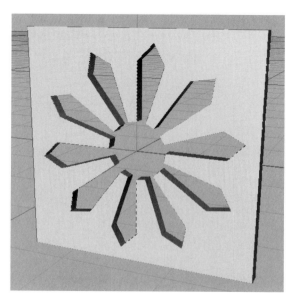

figure | 4–24 |

Combining Splines for
a Cutout Effect

SUMMARY

In this chapter, you learned how to model increasingly complex objects using splines as templates and then extruding, lathing, lofting, and sweeping those splines through 3D space. Although you worked with several different spline types, you'll probably find a few types more useful than others. Some will become your favorites and you'll learn to craft a variety of objects with them. Probably the greatest challenge associated with this type of modeling is getting good at drawing with splines. Take time to practice, practice, practice.

in review

In this chapter, you worked with several spline types:

1. Which spline drawing tools might be best for angular, hard-edged objects? Which might be best for an object composed of several varied curved surfaces?

2. Why is it important to know which viewport is open as you're creating a spline?

3. How do settings for Cap and Fillet impact the area between an extrude and its cap?

4. What important points do you need to keep in mind when combining splines to create complex shapes?

↗ EXPLORING ON YOUR OWN

Take a look at Figure 4–25. It is the spline used to create a chess pawn. Using that figure as a guide, create your own pawn spline, lathe it, and then apply a shiny black or white texture to it to make it look real.

Figure 4–26 is the spline used to create a pear-shaped goblet. Use it as a guide to create your own spline, lathe it, and then apply a semi-transparent texture to it to make it look real.

Although you should be able to see where the points belong for each of the forego-ing splines, you will need to experiment with control handles to get the curves just right. Remember, the Draw Bézier Spline tool works well for objects like these. Click for hard, angular points and click and drag for soft, curved segments. Also, shift-click and drag control points to move them separate from their twins.

figure **|** 4–25 **|**

Profile of a Chess Pawn

figure | 4–26 |

Profile of a Brandy
Snifter

Create a pot or a vase by lathing a spline. Add a rough, earthy, terracotta texture to it to make it look handcrafted. Create a set of dishes, bowls, glasses, and similar tableware.

Experiment with the other project files on the CD-ROM for this chapter. Working in the front viewport, configure the view using the images of the heart, arrow, music note, checkmark, and others and extrude them. Add caps and fillets. Combine splines to create an extruded paw and whole note. Add bright and colorful textures to each.

Open the Wing.c4d file on the CD-ROM. It contains 6 wing spars. Create a Loft NURBS object and drag the spars onto it to make them the Loft NURBS's children. You should end up with a nice-looking wing.

Open the StarsAndStripes.c4d file on the CD-ROM. It contains 6 stars, about half of which have been rotated 90 degrees. Drag them into the Loft NURBS in order to produce a colorful red, white, and blue banner. Create your own banner or windsock.

ADVENTURES IN DESIGN

LOGO DESIGN

A great way to get your start in 3D modeling is with logo design. As companies make the move from print to other forms of media, they often express an interest in taking their corporate logos from 2D to 3D. The work doesn't have to be especially complex. On the contrary, elaborate designs can work against you because, while the company may be interested in a logo suitable to new media, they are likely to want to use the new logo for 2D materials as well. That is, the design needs to translate well across a wide variety of media types.

Working with a 3D modeling application like C4D affords you a great deal of flexibility. You can craft your logo and easily adjust camera angles, change materials, and make adjustments to your model so that you can present your client with several alternatives from which to choose a favored design.

That's not to say that logo design isn't a challenge. While the technical aspects are eased with a 3D modeling application, conveying a company's character in only a few letters or modeled objects can be quite a chore.

Professional Project Example

Letterhead and similar materials for North Educational Group carry a simple text identity (see Figure A–1). They've used this branding for several years and believe it's time to generate a logo that could be used with CD-ROM-based training materials, color brochures, video training films, and other media types. That said, they have a long history in the education and training field and would prefer not to stray too far from their well-established identity.

You brainstorm possible design concepts. Of course, *North* brings to mind things like maps, directions, locations, compasses, the North Star, and the North Pole. After a bit of sketching possible solutions, you settle on the

NORTH
EDUCATIONAL

figure | A–1 |

Company Letterhead

idea of integrating a compass into the existing text identity, replacing the "O" in North with the compass. The look of the compass is important and, mindful of C4D's ability to generate great-looking materials, you decide to go with a traditional compass made of brass. After all, brass conveys ideas like strength and tradition and the compass suggests direction and foresight.

The project is an easy one in C4D. You can craft the compass out of a few parametric primitives and spline primitives. Some work in Photoshop will be required to craft the face of the compass, but other than that, you should be able to do everything in C4D. You can see a possible solution here (see Figure A–2) and deconstruct the C4D file on the CD-ROM.

The first step was to create the compass. A search of the Internet revealed several possible designs. Those were narrowed, with only those that appeared rather conservative and carefully-crafted retained as inspiration for the design of the logo.

The case was crafted from a flattened cylinder and a torus. The number of Pipe Segments for the torus was reduced to four to produce an angular inner ring, surrounding the compass face. The face of the compass was created in Photoshop (see Figure A–3) and applied to a Disc Object in C4D.

The text was especially ease to produce. There are two text elements there: one for the word "North" and a second for "Educational." Text splines

figure | A–2 |

3D Branding for North Educational Group

figure | A–3 |

Photoshop Image of the Compass Face

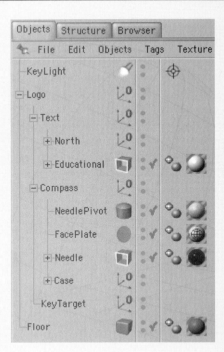

figure | A–4 |

Objects Manager Showing Scene Components

were extruded to the same depth as the compass case. Arial Black was chosen as the typeface because it appears solid and strong. The text was sized to be in scale with the compass. When the word "North" was created, Separate Letters was checked in the Attributes Manager so that once the text was made editable, the letter "O" could be easily deleted. An off-red floor and shadows were added to enhance the character of the piece. The Objects Manager for the completed project can be seen in Figure A–4.

Your Turn

Now, it's your turn to tackle a logo design project. Find a company without a logo or with a logo that's flat or boring. Maybe you'd like to craft a logo for a friend or for the design company you plan to start at some point in the future.

Design Guidelines

● Spend a good deal of time researching the company and thinking about its character. Which would the company most likely value: tradition or innovation; stability or flexibility; technology or craftsmanship? Is the company large or small; old or new; global or local? How can you communicate

the company's character in your design?

- Keep your design simple. Remember, you want your logo to move between media as easily as possible. That's not to say that the version of the logo used for digital media will look exactly the same as the one used for print, but they should share common strengths. Spend some time studying company logos for IBM, Nike, Apple Computer, and others.

- You'll probably find that primitives and spline-based modeling tools are all you need for this exercise. Again, the design ought to be fairly straightforward. Creating your materials, on the other hand, will probably take a good deal of time. Color and texture can convey so very much about a company. Will natural colors and rough textures work best, or does the company's character call for shiny, smooth surfaces?

lighting the way

 charting your course

Now that you're able to model objects with parametric primitives and spline-based NURBS and apply basic textures, it's probably a good time to introduce basic lighting concepts and procedures. In this chapter, you'll learn about three-point lighting and apply that knowledge to a scene using C4D's lighting tools.

Just as the clever use of textures can enhance the realism of objects, the skilled use of lighting can facilitate communication of mood and environment: a dark, terrifying night lit only by the moon's glow, or a bright and beautiful day in the park, the beaming sun reflecting off the grass, sidewalks, and water-filled ponds. This chapter begins with a brief introduction to the theory behind three-point lighting and then introduces C4D's lighting capabilities through a couple of short tutorials. Lighting can be one of the more difficult challenges in 3D modeling and animation, so spend lots of time here, experimenting with settings until you have a good feel for how things work.

 goals

In this chapter you will:

- **Explain the three-point lighting system**
- **Use various light types and settings in C4D to illuminate a scene**
- **Use lights as extensions to modeled objects**

AN INTRODUCTION TO THREE-POINT LIGHTING

Three-point lighting uses three points of light, or three light sources, to illuminate a scene. This is an especially popular approach to lighting used in photographic studios and on many staged film and video sets. It's been proven effective in many situations and environments and so you'll find it a useful starting point for lighting a lot of your 3D work.

Each of the lights in the three-point lighting system has specific purposes and each is typically set into a scene in a fairly standard way. Using three light sources helps you balance light and shadow. As a result, contrast is optimized and depth and interest can be enhanced, breathing life into an image that would otherwise appear flat and dull. This balance is critically important and escapes many beginners who tend to flood their scenes with light. Of course, with practice you may decide to deviate from tradition—and certainly, some scenes call for a different approach—but develop an understanding of three-point lighting now, and you'll be well served in many instances.

Key Light

The *key light* is the main light in your scene. Typically, it will be the brightest light, casting shadows that tell your audience something about the time of day, main light source, and size of objects (as indicated by shadows). Therefore, positioning of the key light is especially important.

Positioning the key light too close too the camera results in a rather flat and unrealistic-looking image, as can be seen with the vase at the top of Figure 5–1. Positioning the key light at a far greater angle to the camera, as in the vase in the center image of Figure 5–1, yields better results but here too, things look a bit extreme. Much of the detail of that second vase is lost in the shadows and the shadow to the right of the vase is very long and drawn out. This might be fine for certain situations—for example, you're trying to set a scene that's dark and mysterious or the only light source is a setting sun, a headlight, or a flashlight—but you won't find this a good choice for most of your work. The bottom image in Figure 5–1 provides the best results. Very little of the detail is lost in shadow.

figure | 5–1 |

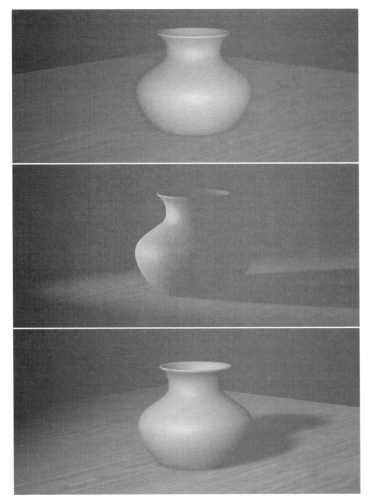

Key light: Straight on (top), 90° Left (middle), 30° (bottom)

If you look closely at the shadow cast by the bottom vase, you can probably figure out where the light source is coming from: slightly high and about 30 degrees offset from the camera. This is where you may want to start with your key light: about 15 to 45 degrees either left or right of the camera and about 15 to 45 degrees above the camera (see Figure 5–2).

Fill Light

In nature, main light sources beam into an environment and then bounce and scatter. Light is reflected off of the floor, tabletop,

figure | 5-2 |

Correct Positioning
of Key Light

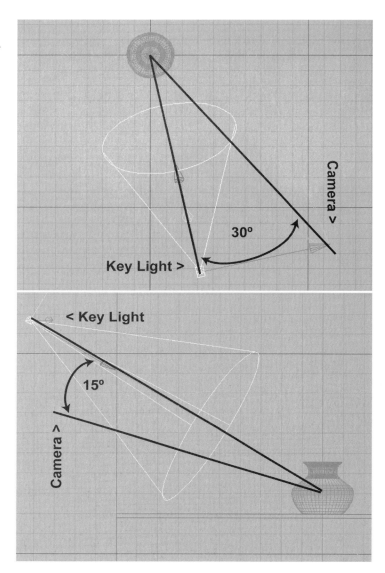

30°

Camera >

Key Light >

< Key Light

15°

Camera >

adjacent walls, the ceiling, etc. Consequently, few areas in a scene are totally blackened by shadows and most shadows have soft, broad edges. To achieve this effect in 3D modeling, you will use a *fill light*, typically positioned opposite the key light. That is, if the key light is high and to the left of the camera, the fill light will generally be lower and to the right (see Figure 5–3).

In some instances, you may find it necessary to use multiple fill lights—perhaps of varying colors—to simulate reflected light. Light reflected off the grass may appear green while light reflected off a brick building may be red. The light reflected off the grass will come from very low in the scene while light from the brick wall may come from abeam your objects. While you'll only use one fill light in the exercises in this chapter, keep in mind that you may need to use additional fill lights in more complex scenes.

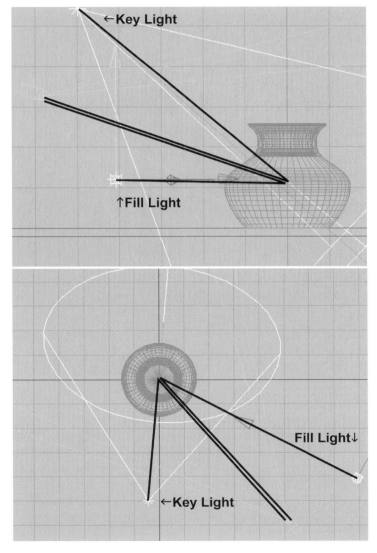

figure | 5–3 |

Fill Light Positioned
Opposite Key Light

figure | 5–4 |

Key Light Only (top) versus Key and Fill Lights (bottom)

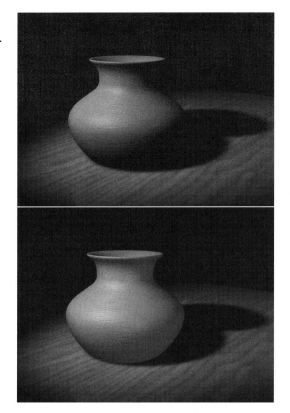

Figure 5–4 shows a vase with a key light only, and then with a fill light added. Pay particular attention to the lower-right edge of the vase as well as the right side of the vase's neck. In both of these areas, the use of the fill light has revealed detail in the object and its texture. Also notice the slightly brighter lip on the top left rim of the vase. What was a very heavy, drab, and partially obscured image has been brightened and balanced.

Backlight

The third light source in the three-point lighting system is the *backlight*. The backlight is typically placed behind the object to be illuminated, opposite the camera, increasing the contrast between the background and the object you want to emphasize in the foreground. Your goal in using a backlight is to create a brighter edge around the object in the foreground such that it stands out as distinct from the background. As is the case with fill lighting, you may want to use multiple backlights in order to achieve the best

results. Again, a backlight is traditionally placed slightly high and opposite the camera.

Figure 5–5 demonstrates the subtle improvements a backlight can make. Notice the rim at the top of the vase, how the contrast has been increased substantially. Notice also that the backlight has been allowed to spill over and illuminate the area around the base of the vase.

Remember, three-point lighting is simply a starting place. It's a great foundation from which to begin thinking about lighting your scenes, but don't feel like you have to use it as described here in every scene. Pointless lighting—lighting that doesn't facilitate communication of your message or support your intended vision for a particular scene—results in unnecessarily long render times and wasted effort. Remember, economic modeling applies not only to the creation of efficient objects but also to lighting.

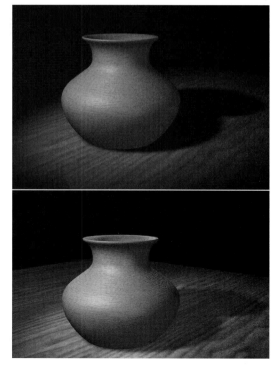

figure | 5–5 |

Key and Fill (top) versus Key, Fill, and Back (bottom)

C4D'S LIGHT OBJECTS AND SETTINGS

With that brief theoretical introduction, it's time to start adding lights to a scene. As you'll see momentarily, you have many lighting options with C4D. You'll make use of some of these options in the vast majority of your scenes. Other options will be used infrequently at best. Ten different pages inside the Attributes Manager are dedicated to lighting parameters, and the parameters selected on one page frequently determine the parameters you'll see on another. So, trying to understand the full range of capabilities built into C4D's lighting system can be a daunting task. You may be best served by learning some basic settings and procedures here at the beginning of this chapter and more advanced information later.

You'll start with a straightforward scene: one that allows you to see the impact of lighting without distracting details that might complicate your work.

1. Launch C4D and the open the file LightMe.c4d, to be found in the Chapter_05 folder on your CD-ROM.

This scene consists of a green sphere and a pink torus sitting above a black and white tiled floor.

2. Render the active view to see what things look like without lights.

Adding a Light to Your Scene

Adding a light to your scene is quite easy.

1. Add a Target Light to your scene by selecting Objects > Scene > Target Light from the main menubar.

Conversely, you can choose the icon that looks like a flashlight with a small black target next to it from the group of folded icons in the horizontal toolbar (see Figure 5–6). It's the fourth (last) icon in the top row.

This is probably an appropriate time to explain the difference between the Target Light (the one you just selected) and the regular (untargeted) Light, the third icon in the top row. When you choose a regular Light, it appears in the scene as an omni-directional light. Light radiates out in all directions from a single point. If, instead, you choose Target Light, a unidirectional light appears in the view-

figure | 5-6 |

Light and Target
Light Icons

port and two new objects are added to the Objects Manager (see Figure 5–7): the light and its target. A Target Light will always shine toward the target. You can move the target around in 3D space, just as you would any other object, and the light will follow it. Conversely, you can move the light around anywhere in your 3D space and the light will always stay fixed on the target. More on regular Lights versus Target Lights in a moment.

Back to your scene. The first thing you'll notice when adding a light to your workspace is that the scene goes quite dark. That's because C4D has assumed, up to this point, that you'd be satisfied with its

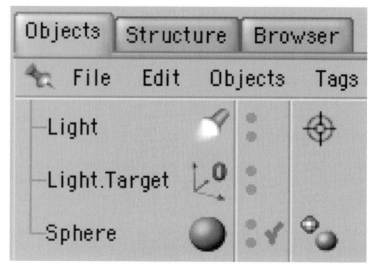

figure | 5-7 |

Target Light in the
Objects Manager

default lighting. Every new scene starts out with this default so as to facilitate your work during the early stages of the modeling process. Can you imagine trying to model in the dark? But this default lighting has some serious limitations. In previous exercises, whenever you rendered a scene, the light seemed to always come from the direction of the camera, even when the camera was repositioned. That's not very realistic. Also, your previously rendered scenes didn't include any shadows. So, the default light in C4D is there to get you started, but isn't sufficient for most of the creative work you'll want to do. When you add your first light to a scene, C4D understands that you're ready to take control of the lighting and, consequently, disengages its default.

2. Select the Light object in the Objects Manager and then take a look at the Attributes Manager (see Figure 5–8).

figure | 5–8 |

Attributes Manager, General Panel, for a Target Light

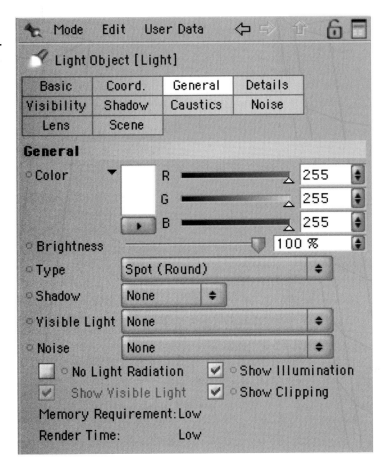

Notice the ten buttons you can select to view different sets of light parameters. At present, General is probably selected. As you'll see in a moment, this is where the light's basic features are set.

3. Rename the Light object as KeyLight.

You can do this either in the Objects Manager, just as you have renamed other objects in the past, or you can click Basic in the Attributes Manager and enter a new name there.

The Coord. page lists the X, Y, and Z coordinates of your light in 3D space. Targeted lights are added at an X, Y, Z of $-500, 500, -500$. The target is added to the scene at 0, 0, 0. If you had added a regular light to the scene—one without a target—that light would have appeared at 0, 0, 0.

4. Rename the Light.Target object as KeyTarget.

5. With the KeyTarget object selected, make sure that the Move Active Element tool is selected and drag the target around your 3D space.

Notice how the light follows the target.

6. Choose Edit > Undo from the main set of menus to return the target to 0, 0, 0.

7. Next, drag the target straight up along the Y axis so that it sits in the center of the sphere at about 0, 150, 0.

8. Make the KeyTarget object a child of the Sphere object.

9. Now, select the Sphere object and drag it around your 3D space.

Notice how the light follows the sphere or, more accurately, its child the target.

10. Choose Edit > Undo to return the Sphere to 0, 150, 0.

11. Finally, select the KeyLight object and drag it around your scene.

Notice that it always points toward its target.

12. Return the KeyLight to its starting point.

13. Render the active view to see what you've got so far (see Figure 5–9).

14. Save the file as LitPrimitives.c4d.

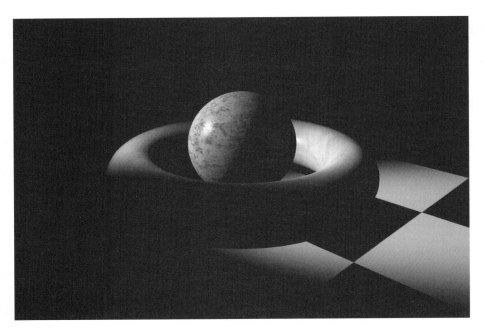

figure | 5—9 |

Sample Scene, Key Light Only

A quick recap: At this point, you should understand how to add lights to a scene, the difference between targeted and regular lights, and the relationship between a light and its target. Next, you'll begin to manipulate your KeyLight's properties. After all, it's not doing very much for your scene right now. You can continue with the file you were working on a moment ago or, if experimenting with the target light and its target left things a bit messy, open a copy of the LitPrimitives_01.c4d file on the CD-ROM.

Light Color and Brightness

Just as you were able to alter the surface color of materials in an earlier chapter, three color sliders and a brightness slider allow you to alter the color of your lights here.

1. Make sure you have the KeyLight object selected in the Objects Manager and the General panel selected in the Attributes Manager.

figure | 1 | *Darts* by Dustin O. Andrews

figure | 2 | *Old World Globe* by Christopher Wilson

figure | 3 | *Velvet Rope* by Jeff Nicholson

figure | 4 | *Light Sword* by Nathaniel Percell

figure | 5 | *Table Setting* by Casey Kudrna

figure | 6 | *Retro TV* by Jeff Nicholson

figure | 7 | *Pots* by Nathaniel Percell

figure | 8 | *Shoehouse* by Dustin O. Andrews

figure | 9 | *Galileo's Thermometer* by Erin Beach-Prather

figure | 10 | *Unicycle* by Geoff Burns, artbygeoff.com

figure | 11 | *Fire Hydrant* by Casey Kudrna

figure | 12 | *Lighter* by Cary Hawkins

figure | 13 | *Museum* by Erin Shorey

figure | 14 | *Drum Set* by Geoff Burns, artbygeoff.com

figure | 15 | *Viva Las Vegas* by Stephen Grassie

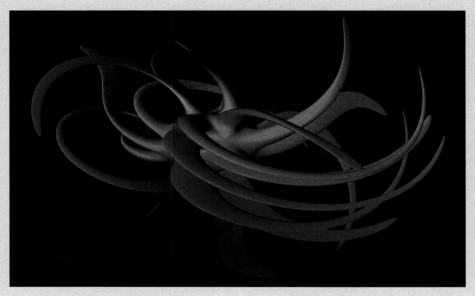

figure | 16 | *Spider* by Tony Alley

figure | 17 | *Teapot* by Tony Alley

figure | 18 | *Conservatory* by Tony Alley

figure | 19 | *University Logo* by Tony Alley

figure | 20 | *Plants in Light* by Tony Alley

figure | 21 | *Toy Train* (Chapter 2)

figure | 22 | *Deformed Parametric Primitives* (Chapter 2)

figure | 23 | *Glass Samples* (Chapter 3)

figure | 24 | *Extrude NURBS Cut-Out* (Chapter 4)

figure | 25 | *Loft BURBS Stars and Stripes* (Chapter 4)

figure | 26 | *Gas Cloud and HyperNURBS Spaceship* (Chapter 5)

figure | 27 | *Surf Gear* (Chapter 7)

figure | 28 | *C4D Puck* (Chapter 7)

figure | 29 | *Cartoon Shader* (Chapter 8)

figure | 30 | *Field of View* (Chapter 8)

2. Slide each of the R, G, B sliders back and forth. As you do, take note of the color changes in the viewport.

Try a few different settings, render the active view from time to time, and then reset the values to 255, 255, 255 for white light.

Light Brightness

The Brightness slider can be a bit confusing. If you look at the Details panel in the Attributes Manager, you'll see another Brightness setting there; and still another on the Visibility panel; and still others on other panels. You might think of it this way: The Brightness slider on the General panel controls the brightness of the light's color while the Brightness setting on the Details panel controls the brightness of the lamp. To use a real-world example, General brightness might establish the type of gel, filter, or lens used with a studio light—light red or dark red for example—while Details brightness might be the power of the lamp itself—perhaps 60 watts or 1000 watts. Both influence the illumination of your objects, but if you'll establish a pattern for thinking about and using these settings, you are more likely to end up with consistent, predictable results.

3. After you've experimented a bit, return the Brightness values on the General and Details panels to 100%.

The Targeted Light Cone

On occasion, you'll want to bring attention to a specific object in your scene or highlight a small area of your stage. One way to do so is use a narrowly focused beam of light. At other times, it may be more appropriate to flood your entire stage with light, which you could do with a broader beam of light. The exercise that follows demonstrates how to make adjustments to a targeted light cone and, thereby, control how your scene is lighted.

1. Select the Details panel in the Attributes Manager.

Notice the Inner and Outer Angle settings. Now, over in the viewport, notice the four orange handles around the far edge of the light cone and a fifth at the end of a straight line along the center of the cone (see Figure 5–10).

2. Click and drag one of the orange handles found on the circumference of the circle and, at the same time, watch what

figure | 5–10 |

Outer Angle Control
Handles

happens to the Outer Angle setting and the illumination of objects in the viewport.

You are changing the outer angle, producing either a wider or narrower cone of light. After you've experimented for a bit, type 45 into the Outer Angle value box and hit Enter on your keyboard.

3. Uncheck the Use Inner checkbox and render the active view.

You'll notice that the light cone, as it can be seen on the checkerboard floor, has a very hard edge: bright to dark in an instant. Also notice that Inner Angle data input field in the Attributes Manager is grayed out such that you can no longer enter a value there.

4. Now check the Use Inner checkbox and render the active view again.

Notice that the transition from bright to dark is now slow and gradual.

5. Enter 44 as the Inner Angle and render the active view.

This results in the transition from light to dark occurring across a very short distance: 1 degree. It's not instantaneous, but it is very quick. Try 42, then 40, then 30, and then smaller and smaller values until you reach 0, rendering the active view between each change. Notice that the greater the difference between the Inner Angle and the Outer Angle, the more gradual the transition from light to dark. Also notice that with any value greater than 0, a second set of orange control handles appears in the viewport to allow you to manually adjust the Inner Angle.

6. Before you move on make sure that, on the Details page, Use Inner is checked, the Inner Angle is set to 0, set the Outer Angle to 60, and then increase the Brightness to 110%.

Configuring Shadows

When a light intersects an object, it can cast no shadow at all, soft shadows, hard shadows, or area shadows. Soft shadows have soft, fuzzy edges. Soft shadows are very common in nature where multiple light sources and an abundance of reflecting surfaces results in a diffuse mixing of light. Hard shadows aren't as common; they are produced when a single, clean light source strikes an object. Area shadows are especially realistic. Next time you're outside on a sunny day, sometime around 10 a.m. or 2 p.m., look carefully at the shadow you cast on the sidewalk. Closest to the sidewalk, the shadow cast by your feet and ankles will be fairly crisp. The shadow cast by your head and neck will be especially soft. The shadow cast by your midsection will be somewhere in-between hard and soft. Area shadows work this way, the shadow's soft edge varying based on a number of factors. Figure 5–11 may help make this clear. Look carefully at the soft shadow (top image) and area shadow (bottom image), paying special attention to the differences in their soft edges.

1. Back on the General page, click on the Shadow dropdown box and select soft.

It's important to remember that you are setting shadow properties for individual lights and not for the entire scene. That is, you may find that you want one light to cast a soft shadow, another to cast a hard shadow, and a third to cast no shadow at all, and C4D makes this easy to do.

figure | 5–11 |

Soft (top), Hard
(middle), and Area
(bottom) Shadows

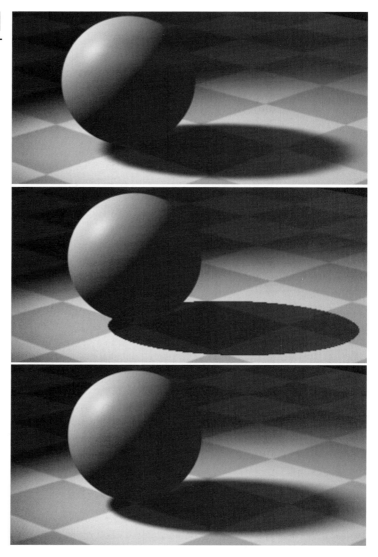

**DON'T
GO THERE**
Although Area shadows often give the most realistic results, that increased realism comes at a price. You'll notice that Hard shadows render very fast, Soft shadows take a bit longer, and Area shadows can take a very long time to render. Always keep modeling economy in mind and limit the use of Area shadows to only those circumstances where it is required.

2. Change the setting to Hard and then Area and with each change, notice the differences of your rendered viewport. Set the shadow type to Soft before continuing.

Visible Light

Often, you see a light's source, for instance a light bulb, but you don't see rays of light streaming out of that source unless smoke, dust, fog, or some other environmental condition makes them visible. Consequently, the default setting for Visible Light is None. However, you have three other options: Visible, Volumetric, and Inverse Volumetric.

Visible makes the light visible from its point of origin out into space. With this setting, however, the intensity of that light doesn't seem to be influenced when objects get in the way. The uppermost image in Figure 5–12 should aid in your understanding. Notice that the intensity of the visible light appears consistent prior to and after passing the sphere. The Volumetric setting results in something a bit more realistic: diminished light on the far side of objects. The bottom image in Figure 5–12 uses the Inverse Volumetric setting. Notice that light is visible only on the far side of the sphere. The sphere seems to be emitting light, an interesting special effect.

1. Select the KeyLight object in the Objects Manager and then in the Atrributes Manager, set Visible Light to Visible and render the active view. You'll notice that you can see a white cone of light in the upper-left corner of your screen. The visible rays of light don't make it all the way to the sphere and torus. Instead, they fade out about halfway there.

2. Back in the viewport, you'll notice that a new orange control handle has been added to the light cone (see Figure 5–13). It's there on the line that defines the center of the cone.

3. Select the Visibility page in the Attributes Manager. Now, select that orange control handle about halfway up the light cone's centerline and drag it back and forth. As you do, notice that the Outer Distance value changes on the Visibility page. After you've moved it back and forth and understand the connection between the handle and the Outer Distance setting, enter 650 for the Outer Distance value and hit the Enter key. Render the active view once more and notice that you have extended the distance of the visible light cone.

figure | 5–12 |

Visible (top), Volumetric (middle), and Inverse Volumetric (bottom) Lighting

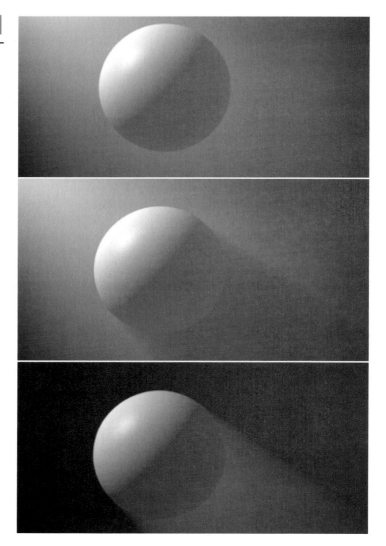

4. Uncheck the Use Falloff and Use Edge Falloff checkboxes on the Visibility page and render once again. Notice that the light's brightness stays steady to the edges of the cone now.

5. As was mentioned earlier; there is also a Brightness setting here on the Visibility page. It controls the brightness of the light within the cone. Lower the Brightness to 25%, render again, and you'll see that the light cone is dull, almost gray. Increase the Brightness to 500%, render again, and you'll see that the cone is very bright.

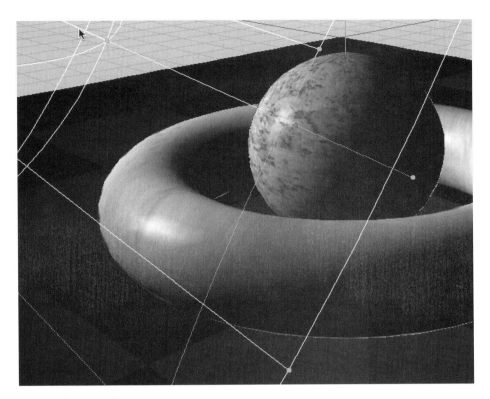

figure | 5–13 |

Control Handle: Outer Distance of Visible Light

6. Feel free to experiment with Brightness, Falloff, and Edge Falloff settings until you understand how these work. Before you move on, make sure that the Use Falloff and Use Edge Falloff checkboxes are checked, Falloff is set to 100%, Edge Falloff is set to 50%, Inner Distance is set to 0, Outer Distance is set to 800, and Brightness is set to 100%. If you'd rather, you can continue with the file LitPrimitives_02.c4d on the CD.

Noise

The Noise settings allow you to simulate inconsistencies in the atmosphere. The Illumination setting results in uneven lighting only on the surface of illuminated objects. Look carefully at the top image in Figure 5–14 and notice that while the light traversing the atmosphere appears smooth and clean, light striking the surface of

figure | 5–14 |

Noise: Illumination (top), Visibility (middle), and Both (bottom)

the sphere appears brighter in some areas but darker in others. The middle image demonstrates the Visibility setting. The surface of the sphere is evenly lit but light in the atmosphere varies in intensity. The bottom image shows the result of choosing Both. Everything appears disturbed and uneven.

1. On the General panel, set Noise to Visibility.

2. Select the Noise panel in the Attributes Manager to see how you can influence the look of the noise in your scene.

The small preview graphic should help you anticipate the look of the noise you'll get in your visible light but generally speaking, selecting noise from the Type dropdown menu yields a look like a smoky café or wispy clouds; Soft Turbulence looks like clouds that are fairly well formed; Hard Turbulence looks like boiling water; and Wavy Turbulence looks like mixed paint.

3. Try each Type and then set Soft Turbulence.

Octaves can be set from 1 to 8. With 1 set, your Soft Turbulence will appear fairly smooth and consistent. With 8 set, there's greater variability and bumpiness.

4. Set Octaves to 8.

5. Adjust the Visibility Scale settings. Set the X, Y, Z values to 10, 10, 10 and render the active view to get something that looks like thin, high stratus clouds. Set 10, 200, 10 to get a pattern that streaks along the Y axis.

Positioning the Key Light

Let's return to building a three-point lighting system for your scene.

1. Select the General panel and set R, G, B to 255, 255, 255; Brightness to 100%; Type to Spot (Round); Shadow to Soft; Visible Light to None; and Noise to None.

Figuring the angular difference between your light, objects, and camera can be a bit tricky in C4D. Shadows certainly give you a clue, and looking at your scene through the different viewports can help, too. For instance, press F1 to view your scene through the perspective viewport, render the active view, and notice that the shadow runs off to the right at about 90 degrees to your view. Next, press F2 to view your scene from above. Select Edit > Frame Scene and Display > Gouraud Shading from the viewport menus. Keep in mind that the camera (perspective viewport) looks into your scene toward the origin, about halfway between the X and Z axes, and from a slightly high vantage point. Again, you can see that your camera and light are at about 90 degrees to one another (see Figure 5–15).

The angle above or below the camera line is a bit harder to discern, so step through the following procedures for some assistance.

2. Make sure you are in the perspective view.

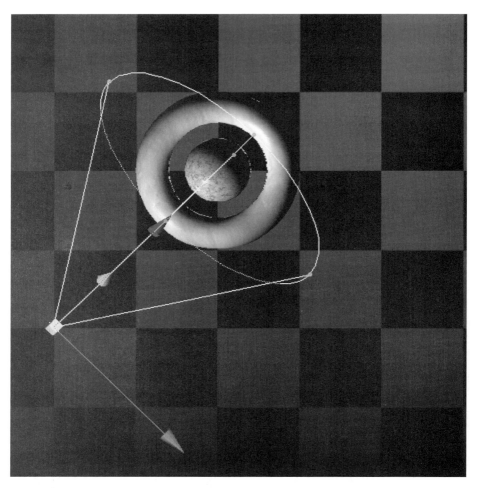

figure | 5–15 |

Determine the Offset Angle between Light and Camera

3. From the same folded menu that you pulled a Target Light earlier, pull a (non-targeted) Camera: the very first icon in the very first row.

Of course, Objects > Scene > Camera in the main menu set will work, too.

If you are in the perspective view when you add a camera, the camera is placed in the scene at the exact same location as C4D's default editor camera. Now, in each of your viewports, you'll see a set of

green lines emanating from a wireframe camera. You'll learn more about cameras in a subsequent chapter. For the time being, you're just using this added camera as a reference.

4. Press F2 to see the top view again.

5. Select the KeyLight object in the Objects Manager.

6. Make sure the Move Active Element tool is selected and then drag the KeyLight into a position slightly left of the green camera (see Figure 5–16).

7. Switch back and forth between the side and front views (see Figure 5–17), pressing F3 and then F4, to position your light slightly above the camera.

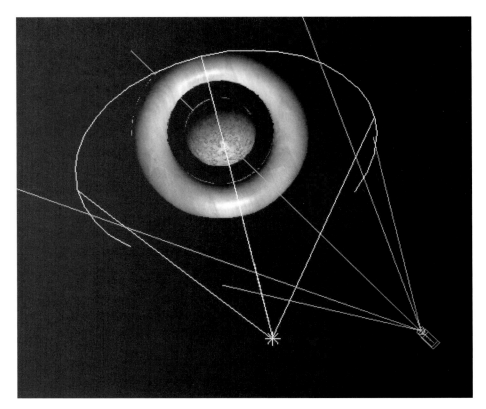

figure | 5–16 |

Seen from the Top View (F2): Key Light in Correct Position

figure | 5–17 |

Switch Between
Views to Position the
Key Light Above the
Camera

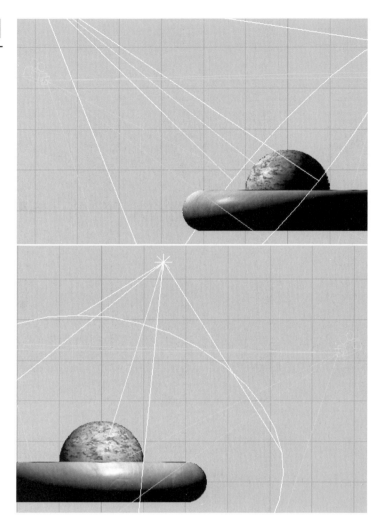

You may have to choose Frame Scene from the Edit menu of each viewport to see the camera, light, and objects. Also, rather than bounce back and forth between the front and side views, you could press F5 and move the light around with a simultaneous view of all the viewports. It comes down to personal preference and the size of your computer monitor.

Remember, you want to drag the light around until it is about 15 to 45 degrees above the camera and 15 to 45 degrees left of the camera. Your KeyLight will probably end up somewhere in the vicinity of an X, Y, Z of 225, 750, −700.

Hopefully, your scene is coming together nicely. If you've run into problems and your work looks substantially different than Figure 5–18, open the LitPrimitives_03.c4d file on the CD-ROM to see where things ought to be. You can continue working with your file in the next exercise, or use LitPrimitives_03.c4d.

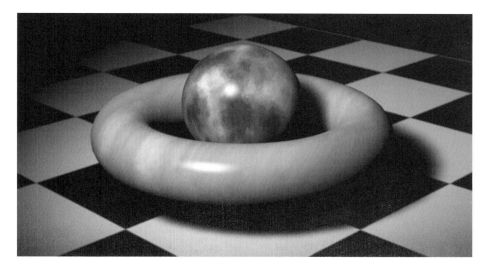

figure | **5–18** |

Scene with Key Light

Positioning the Fill Light

Remember, the fill light is used to fill in heavily dark areas of your scene and reduce contrast. As was mentioned earlier, the fill light should be positioned on the opposite side of the camera from the key light. Looking from above, your key light is left of the camera, so the fill light will be on the right. Looking from the front or side, you see that the key light is above the camera, so the fill light will be slightly below.

1. Add a regular light to your scene: Objects > Scene > Light or the third icon, top row of icons for lights, cameras, and other scene objects.

Note, in the Attributes Manager, on the General panel, that this is an Omni light and, from the Coord. panel, that it has appeared at 0, 0, 0. Also notice, no target was added.

2. Rename the light as FillLight.

3. Position your FillLight to the right of the camera and slightly below it (see Figure 5–19).

Move the FillLight into position on the opposite side of the camera from the KeyLight. The KeyLight is above the camera, so you'd like the FillLight slightly low. Proceed as you did with the KeyLight, moving from viewport to viewport to get the FillLight positioned correctly. Your FillLight will probably end up somewhere near 700, 200, −475.

4. Render the active view.

figure | 5–19 |

Positioned Key and Fill Lights

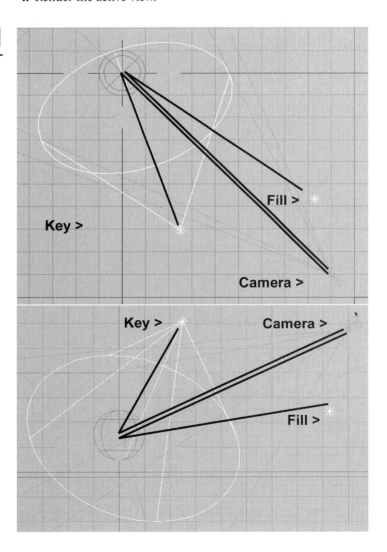

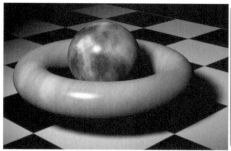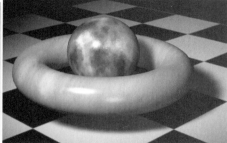

figure | 5–20 |

Key Light Only (left) versus Key and Fill Lights (right)

When you render the active view, you'll probably find that the scene is overly lit by the fill light. Remember, it's the key light in your scene that is typically the brightest. Rather than light the scene with your fill light, you're simply trying to shed some light on dark, obscured areas of your scene. So, you'll want to reduce the FillLight's brightness.

5. In the Attributes Manager, on the Details panel, reduce the FillLight Brightness setting to about 25%.

The fill light makes a big difference. Compare the two images in Figure 5–20.

Positioning the Backlight

Keep in mind that lighting is about much more than simple illumination. It's not enough to throw light onto your scene. Instead, you want to use light much like a painter might use paint. That is, light in your scenes is every bit the creative element that models and materials might be. You're working to optimize contrast and bring hidden detail into view and, with your backlight, increase contrast between the lighted object in your scene and the background. Careful use of a backlight can make your objects standout and demand attention.

1. Add another Target Light to your scene.

2. Rename the light BackLight and its target as BackTarget.

3. Set the Brightness of BackLight to about 75% on the details panel.

4. Using the same techniques as you used to position the other lights, position the BackLight on the opposite side of the sphere from the camera: about −390, 465, 445.

5. Position the target high on the sphere where you'd like the light emphasis to appear: about −35, 250, 25.

6. Render the active view.

When you render the active view, you'll notice a crescent of light along the top of the sphere, which is exactly what you were looking for.

7. The camera you added earlier was only an aid to positioning your lights. It's no longer needed, so delete it.

Adjusting Lights

You have a key light high and to the left that establishes direction of the main scene light and casts shadows, a fill light that softens especially dark areas and evens the lighting across the image, and a backlight that outlines the top of the sphere and pulls it out from the darker background. But could things be improved at all?

Once you've added several lights to a scene, it becomes a bit difficult to pinpoint problem areas. One approach to evaluating the combined influences of several lights is to set each light to a different color and then evaluate the color mix in your scene.

1. In the Attributes Manager, change the color of the Key Light to blue (0, 0, 255).

2. Change the color of the Fill Light to red (255, 0, 0).

3. Change the color of the Backlight to green (0, 255, 0). Render the active view.

Where the image is solid green, only backlight is lighting that part of the scene; where the image is pure blue, only the key light is illuminating that part of the scene; and where pure red, only the fill light.

It appears that the blue light (key light) dominates, as it should. After all, it is the key light. Still, it may be a bit too bright, causing the hot spot on the front left of the torus and sphere. The image is pure red only on the lower-right outside edge of the torus, lower-

left inside of the torus, and in the shadow cast by the sphere on the back side of the torus' inside. The image is green only across the top of the sphere, along a bit of the front lip of the torus, and on the floor beneath the objects.

4. Reduce the key light's brightness to 90% and render again. Look carefully at the distribution of colors.

5. Increase the fill light's brightness to 30%, pull it up a bit on the Y axis, to about 250, and render again.

6. Now, reset the color of all your lights back to white (255, 255, 255) and render again.

What have you done? You have added three lights to your scene: a key light, fill light, and backlight. You positioned each where it would ensure a sense of depth (shadows of the key light), detail (fill light brightening shaded areas of objects just a bit), and pulled objects out of a darker background (the backlight's bright crescent across the top of the sphere). To help you get a sense of where light was striking objects you temporarily altered the color of lights and looked for pure versus mixed colors in the scene. This is the approach you'll probably want to take in much of the 3D work you do.

Light Gels

A *light gel*, also called a *light-map*, essentially sits between your light and your scene. You might use it to cast shadows into your scene: things like Venetian blinds, window frames, etc. You can even use colored elements with your gels to produce interesting effects, like a stained glass window.

1. Create a new material.

2. Deactivate (uncheck) every channel except Transparency.

3. In the Transparency channel, click the ellipsis to load an image.

4. From the Chapter_05 folder, and inside the Tex folder, find and load StainedGlass.tif.

5. Add the new material to your KeyLight object and render the active view.

Open the StainedGlass.tif file in your favorite image editor (Adobe Photoshop, Corel Paint Shop Pro, etc.) to see what's going on. The

file is an especially simple black frame with color-filled cells. The frame and colors are being cast onto the scene with the key light.

6. Select the KeyLight object in the Objects Manager and, in the Attributes Manager, General panel, set Visible Light to Volumetric and render the scene once more.

Now you can even see the color in the light's rays. Add noise if you'd like, adjust the settings on the Noise panel, and increase the Outer Distance on the Visibility panel to emphasize the effect.

LIGHTS AS SUPPORTING CHARACTERS

Lighting a scene is a skill you'll want to master. However, there will be times when you want to bring lights into scenes not to illuminate the environment, but to act as objects in and of themselves or as modeled elements associated with objects. C4D includes several light types to help you do this, as explained in Table 5–1. Take a few

table | 5–1 | C4D's Light Types

Omni	Light is cast in all directions from a single point. Light rays are distributed in a radial pattern. Uses include light-bulbs, candles, and stars.
Spot (round/square)	Light is distributed from a single point either in the shape of a cone (round) or four-sided pyramid (square) with the center of the projection being along the Z axis. Uses include theatrical spotlights, broad-beam car lights, and broad-beam flashlights.
Distant	This light source has no origin per se but provides even illumination across a large area along its Z axis. A Distant light source might be used to simulate illumination of the sun.
Parallel	Light is emitted in a single direction, along the Z axis, as if from a wall instead of a point, so light rays are parallel to one another. Only objects on the positive Z side of the light are illuminated.
Parallel Spot (round/square)	Light is emitted much the same as with spotlights, except rather than using a single point, light emits from a circle or square. Uses include narrow-beam light sources such as flashlights, car lights, and lasers.
Tube	Light is emitted in all directions not from a point or plane, but from a line. Uses include items such as light swords, neon tubes, florescent lights, and lasers.
Area	Omni-directional light emitted from a flat plate, such as a television screen.

minutes and work through the exercises that follow to see how you might use these light types in unique ways.

Radiated Light: A Flashlight

In this brief exercise, you'll use two light types, Omni and Parallel Spot (Round), to create moonlight illumination and a flashlight beam.

1. Open the file Flashlight_Start.c4d on your CD-ROM. This file contains a simple flashlight created using a lathed spline, a few cylinders for the grip, and a sliced capsule for the on-off switch.

You need to add a beam of light shining out from the end of the flashlight, but you're going to have a problem. What's going to happen as soon as you add that light? The scene will go dark and although you may be able to see your light, the flashlight will disappear in the darkness. So, quickly add a light source just to brighten the overall environment a bit.

2. Add a regular light to the scene.

It's an Omni light that appears at 0, 0, 0, right in the center of your flashlight.

3. Drag it straight up along the Y axis to about 300 m.

4. Rename it Moonlight and set its color to an R, G, B of 150, 200, 255 (light blue).

5. Render the active view.

6. Add another regular light to the scene and name it Beam.

This, too, is an Omni light. That won't do. You want this to be some sort of unidirectional spotlight.

7. Change its type, on the General page of the Attributes Manager, to Parallel Spot (Round).

Why not add a Target Light? You don't want the light to stay fixed on a target all the time but, instead, move with the flashlight.

The light appears as a cylinder of light (see Figure 5–21), but the beam is pointing in the wrong direction.

8. Rotate the beam: Either select the Rotate Active Element tool, lock the X and Z axes, and rotate the beam around its Y axis or, alternatively, enter 90 degree as the Heading on the Coord. panel (see Figure 5–22).

figure | 5–21 |

Parallel Spot (Round) as It Initially Appears

9. On the General page, set the color to white but the Brightness to 75%.

Why? You want the beam to look gray instead of bright white. A small amount of noise would have a similar effect.

10. Set Visible Light to Visible; otherwise there'll be no beam of light.

figure | 5-22 |

Rotate the Light's Heading in the Attributes Manager, Coord. Page

11. Render the active view.

12. Switch from viewport to viewport and center the light source in the center of the flashlight's lens, roughly where the bulb would be.

13. Now, resize the diameter of the light cylinder using either the orange handles around its edge or by altering the value for the Outer Radius on the Details page, probably something close to 55.

14. On the Visibility page, set Use Falloff to 50% and Use Edge Falloff to 5%.

15. Set Inner Distance to 1000 and Outer Distance to 2000.

16. Render the perspective view.

Contrained Light: Light Sword

Tube lights are especially interesting, although they require a fair bit of manipulation in many instances.

1. Start by opening the LightSword_Start.c4d file.

This scene includes a quick light sword handle and some ambient light. You'll add the light to the sword.

2. Add a light to the scene.

3. Change the Type to Tube.

A small white line with orange control handles on each end will appear in your scene. These orange handles control the Outer Radius.

4. Drag a handle or use the input field on the Details panel to increase the Outer Radius to 700.

5. On the General panel, set Visible Light to Visible.

White lines appear in your view. These define the Outer Distance of the visible light. You may have to zoom out to see the orange handles that control Outer Distance.

6. Decrease the Outer Distance to 25 using either the orange handles or the input field for Outer Distance on the Visibility panel.

7. Also on the Visibility page, set Falloff to 5% to ensure a strong, steady light to the edges of the sword.

8. Rotate and drag the light into position at the end of the Handle object.

You might start by rotating the light 35 degrees in heading and 30 degrees in pitch. That will get you pretty close and you can tweak it in from there.

9. On the General panel, set a color of your choosing: perhaps red, yellow, or orange.

10. Render the active view.

Notice that some of the light's color bleeds over onto the handle. If that bothers you, return to the General page and check the No Light Radiation checkbox on the bottom of the page. Your final render should look something like Figure 5–23. If you'd like the beam to be better-defined, increase the brightness on the General panel substantially or uncheck Use Falloff on the Visibility panel.

Gaseous Nebula > Red Planet

In this next exercise, your goal will not be to produce a tightly defined shape, such as the beam of a light sword, but instead an especially open gaseous cloud of colored light.

figure | 5–23 |

Light Sword

1. Create a new scene in C4D.

2. Add a light to the scene.

3. On the General page, set the color to red (255, 0, 0), Visible Light to Visible, and Noise to Visibility.

4. Render the active view.

Because gravity keeps particles in the cloud together in somewhat constrained space, you don't want complete falloff. So, reduce the Falloff.

5. On the Visibility panel, set Falloff to 70%.

6. On the Noise page, change the Type to Hard Turbulence.

7. Render the active view to see a gas cloud like that in Figure 5–24.

Continue and you'll change the gas cloud into a red planet.

8. On the Visibility page, reduce the Outer Distance to 300 and uncheck the Use Falloff box.

figure | 5-24 |

Gas Cloud

9. Render the active view to see that the light now stays consistent to the edges of the light sphere.

10. On the Noise panel, firm up the planet's surface a bit: leave Type set to Hard Turbulence and increase Octaves to 8.

11. Still on the Noise panel, set Contrast to 350% in order to make the tracks pop out on the surface, almost like the canals on Mars.

12. Render the active view.

Continue to experiment with other settings.

13. On the Noise panel, set the Visibility Scale to 300, 100, 300 to create bands of clouds streaming across the surface.

14. On the Details panel, set Brightness to 80% and Contrast to 200% to make the clouds better defined.

15. Zoom out a bit so that you can add a second light source: a sun.

16. Add the second Omni light and position it at $-1000, 300, 300$.

17. Set the color to bright yellow-orange and Visible Light to Visible.

18. Render the active view to see how things are progressing.

19. On the Visibility page, set the Falloff to 90% and the Outer Distance to 150.

20. On the Lens page, select Star 3 for Glow and Brightness to 75%.

21. On this same page, set Reflexes to Flashlight 3.

22. Render the active view.

These last few settings on the Lens page simulate defects, imperfections, and limitations in conventional cameras and lenses. The options can be quite interesting. Experiment with a few different selections.

SUMMARY

Light is all around you. Few environments are blanketed in total darkness. There's always a tiny ray of light that sneaks under your bedroom door at night, a candle in the corner, or a star that breaks through the clouds on a moonless evening. And in most instances, you'll want to communicate detail and depth, which requires multiple light sources. In this chapter, you learned about three-point lighting and light sources as supplements to modeled objects. This is a starting point, a foundation upon which you can build. Spend time experimenting with light settings and give serious consideration to light for every scene you create.

in review

1. Your goal is seldom to flood a scene with light such that the tiniest detail is bright and clear. Such an approach often robs a scene of depth and character. Instead, you should seek an appropriate balance of light and shadow by using, as your starting position, three-point lighting.

2. The key light is typically the brightest light in your scene, and communicates to your audience something about the primary light source: time of day, size of objects, etc. It typically sits 15 to 45 degrees to either the left or right and 15 to 45 degrees above the camera.

3. The fill light brings detail out of the shadows but doesn't overpower the key light. It may give the audience a clue about the nature of unseen objects that might be reflecting light back into the scene from outside. Usually, it will be positioned on the opposite side of the camera from the key and, assuming that the key is high, slightly low.

4. The backlight helps bring objects out of the background. It is positioned on the opposite side of objects from the camera, above and behind those objects.

5. In C4D, settings on the General panel influence settings on other panels.

6. Target Lights appear in scenes along with their targets. The two are linked such that the light remains fixed on the target. The target can be made the child of an object and, subsequently, the light stays fixed on that object even when the object is moved.

7. Parameters you'll want to be especially familiar with include light color and brightness; inner and outer angle, radius, and distance; and visible light and falloff.

8. Each light can be set to cause specific types of shadows, if any at all. While Area shadows may be most realistic, they consume more computing resources than Hard or Soft. Consequently, Soft is often a good compromise.

9. Environmental impurities, such as dust, fog, and smoke can be applied to visible light, illumination as it strikes objects, or both.

10. Light types are frequently used not only as sources of illumination, but also as elements in modeled objects.

↗ EXPLORING ON YOUR OWN

1. Open your Toy Train project and use three-point lighting to illuminate that scene.

2. Open your Goblet project and use three-point lighting to illuminate that scene.

3. Repeat the Light Sword exercise but this time, use a Parallel Spot (Round) light with a small outer radius and no falloff.

4. Open the Lightbulb_Start project on the CD-ROM and add an Omni light to the scene. Position it in the center of the semi-transparent bulb and light it. Compare your results to those in Lightbulb_Complete.

5. Open the Spaceship_Start project on the CD-ROM and add lights for engines (exhaust flame) and perhaps a gas cloud or planet in the background. Compare your results to those in Spaceship_Complete.

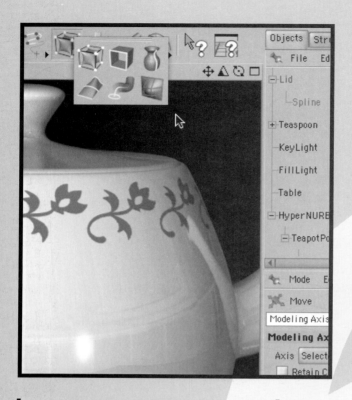

hyperNURBS and polygonal modeling

 charting your course

Some objects aren't easily modeled with Parametric Primitives or Extrude, Lathe, Loft, or Sweep NURBS. Each of those modeling tools is best applied to the creation of objects that are fairly uniform: objects with regular and predictable forms. However, for complex, irregular forms, a different approach to modeling is required. Modeling at the level of polygons, edges, and points allows you to build substantial detail into your objects. And while the manipulation of these underlying elements of 3D objects doesn't necessarily compel you to work simultaneously with HyperNURBS, it's common to do so. Consequently, polygonal, edge, and point manipulation will be introduced here along with HyperNURBS modeling.

 goals

In this chapter you will:

● **Create and manipulate polygons, edges, and points in support of modeling 3D objects**

● **Explain the basic concept of HyperNURBS as a modeling tool**

● **Create and edit HyperNURBS objects**

AN INTRODUCTION TO HYPERNURBS

You're aware that your car consists of thousands of parts: wheels, engine, seats, windows, lights, fenders, etc. Now imagine that in order to move your car along the highway, you have to move it one part at a time. First, you might drag one of the wheels a few yards along the road and then return to the car for your next part. You grab a door and pull it along until it sits close to your wheel. Next, you run back to the car for another piece; perhaps the rearview mirror. Of course, this is a ridiculous notion. You'd never get anywhere moving your car one piece at a time. Now image that you have an object that consists of thousands of points. If you were modeling a human face and had to do so by pulling each of those points into place one at a time, it would take a lifetime to see your results.

That's where HyperNURBS come into play. The child of a Hyper-NURBS object can be quite simple; for instance, a cube of only eight points. But as the child of a HyperNURBS object, it behaves as if it were subdivided into many more points—which is why Hy-perNURBS are sometimes called subdivision surfaces. And when you pull one point along, other points follow. So, working with Hy-perNURBS is a bit like working with a pliable substance such as clay. This makes it ideal for smooth-flowing, organic models.

B-Splines

You might remember from the discussion of splines that all of C4D's spline types cross their anchor points except for b-splines. B-splines are, of course, influenced by their anchor points but in a way that might be analogous to the influence that gravity has on a spacecraft. If you wanted to launch a spacecraft into deep space, you would use the gravity of the outer planets to pull it along and even to make course changes or corrections, but you'd be disappointed if the spacecraft crashed directly into a planet in the process. B-splines are pulled toward points, but they don't intercept them (except at the first and last point, when those points are not the same). A short exercise will help explain.

1. Launch C4D and press F4 to enter the front view.

2. Select the Draw B-Spline tool (Objects > Create Spline > B-Spline or from the horizontal toolbar).

You'll be drawing a square onscreen, creating one point at a time for each of the square's four corners. The size of the square isn't especially important nor is precise positioning of your points.

figure | 6–1 |

B-Spline: Three Points (left), Four Points (center), Closed (right)

3. Click once to create the square's upper-left corner.

4. Click to the right of this first point to create the square's upper-right corner.

These first two point create a straight, horizontal line; no surprises there.

5. Click again to create the square's bottom-right corner.

Because you are creating this spline with the Draw B-Spline tool, the line becomes an arc between the first and third points (see Figure 6–1). It doesn't cross the second point.

6. Click again to create the lower-left corner, and the arc bends around touching neither the second or third points.

7. Either click on your starting point or check the Close Spline checkbox in the Attributes Manager.

Now, the spline is pulled toward each of the four points, but doesn't cross any of them.

HyperNURBS

So, what happens when the previous exercise is taken out of two dimensions—square becomes circle—and moved into three dimensions? If you guessed "cube becomes sphere," you're correct.

1. In a new scene, create a cube primitive.

2. Add a HyperNURBS object to the scene (Objects > NURBS > HyperNURBS or select the icon from the horizontal toolbar).

3. Make the cube primitive a child of the HyperNURBS object.

Poof: instant sphere! Each point of the cube—one in each corner for a total of eight—is pulling at the object inside, but the pull is insufficient to bring the object into any corner. Instead, the edges of the cube become like B-Splines, gently flowing inside their points. As a matter of fact, viewed in 2D in the front, top, or side viewport, it appears like a circle inside a square; just like the third image in Figure 6–1.

So, what has happened to the cube? Has it disappeared? No, it's still there.

4. Press the Q key on your keyboard.

Pressing Q deactivates the influence of HyperNURBS and allows you to view the underlying structure of your polygonal model. Notice that the HyperNURBS object in the Objects Manager now has a red X next to it, indicating that it has been deactivated.

5. Press Q a few more times to go back and forth between the HyperNURBS version of your model and its polygonal structure.

Don't close this scene just yet. You'll continue working with it momentarily.

Weighted Polygons, Edges, and Points

Back to the planet and spacecraft analogy. What would happen if the gravitational pull of a planet were somehow increased; say, you were able to triple its mass? Of course, the planet would have a greater influence on your spacecraft, pulling it closer than other planets in the system. In C4D, increasing the pull of a polygon, edge, or point is called *weighting*.

1. Make sure the HyperNURBS object is activated so that you are seeing the cube as a sphere.

2. Make the cube primitive editable (Functions > Make Editable or the Make Object Editable icon in the vertical toolbar).

3. Enter the Points mode by clicking on the Use Points Tool in the vertical toolbar.

4. With the Live Selection tool, click on a brown point in any one of the cube's corners to select it.

5. Hold down the period key on your keyboard while clicking and dragging to the right somewhere in the viewport.

This increases the weight of the point. Alternately, you can first select Structure > Weight HyperNURBS from the main menus and then click and drag to the right in the viewport.

As you drag your mouse to the right, the sphere will be deformed, with the selected point exerting greater pull on the surface of the object.

6. Select Edit > Undo to release the weight added to the point.

7. Using the Live Selection tool, select two adjacent points on the cube.

8. Repeat step 5, but this time, hold down both the period and the Shift key as you click and drag.

Using the period and Shift keys together weights the points, but also weights all the edges connected to those points.

9. Select Edit > Undo to release the weight added to the points and their edges.

10. Repeat step 5, but this time, hold down both the period and the Control key as you click and drag.

Using the period and Control keys together weights the points, but also weights all the edges between the points.

11. Select Edit > Undo to release the weight added to the points and edges.

12. Press F4 to see your object from the front view.

13. From the main menus, choose Structure > Knife.

14. Hold down the Shift key as you drag a straight, vertical cut just inside the left side of the cube (see Figure 6–2).

Holding down the Shift key keeps your cut straight. Begin your cut outside the cube and drag clear through out the other side.

15. Press F1 to return to the Perspective view.

16. Notice that you've deformed the sphere.

figure | 6–2 |

Use the Knife Tool
to Cut the Polygon

figure | 6–3 |

Where Points Are
Closest, Curvature
is Most Severe

By cutting the polygon facing you in the front view, you added two new points to the object and created a new polygon. What is especially interesting is that by doing so, you've increased the weight in that particular part of the object. Again, where two planets are close together, they exert greater gravitational pull than a single planet alone. Where two points are close together, they deform the object more aggressively, resulting in a sharper corner on the left, and an almost flat edge immediately right of the cut to about midway between along the top of the cube (see Figure 6–3).

That, in a nutshell, is HyperNURBS. That the cube becomes a sphere should tell you that by using HyperNURBS, only a few polygons (six in this case: one for each side of the cube) can be made to appear as many polygons (the number it would take to create an elementary sphere: in this case, somewhere in the neighborhood of 128). With HyperNURBS, you can manipulate only a few polygons, edges, and points to create an object that appears far more complex and, were it actually as complex as it appears, would be much more difficult to model. In the following exercises, you'll work with several new modeling tools, each designed to give you constructive power over polygons, edges, and points; and sitting atop these basic structures will be powerful HyperNURBS, multiplying your actions.

Selecting and Moving Points

In this exercise, you'll create a simple teapot. As is often the case with polygonal modeling, you'll start with a parametric primitive, make it editable, and add detail as desired. Here, you'll start with a sphere and then extrude a handle and a spout.

1. Open a new scene in C4D.

2. Click F3 to enter the Side view.

3. From the viewport's Edit menu, select Configure.

4. In the Attributes Manager, click the Back button.

5. Click the Ellipsis to load an image into the background of this viewport.

6. In the Chapter_06 folder, find the TeapotOutline01.jpg file and select it.

This isn't a perfect background image. It was drawn to include a bit of perspective and so it includes some curvature that you'll have to work around, but that's okay. It will serve as a suitable rough guide.

7. From the viewport's Display menu, choose Quick Shading and Wireframe.

8. Drop a sphere primitive into the scene.

Because you'll be working to craft fine detail, you'll need more polygons than are currently associated with this sphere. Now, while the sphere is still a primitive, is the easiest time to add that increased complexity.

9. Increase the sphere's radius to 200 and its segments to 36 in the Attributes Manager.

10. Make the sphere editable.

11. Rename the sphere TeapotPolys.

12. From under the viewport's Display menu, select X-Ray so that you can see through the polygons to the image behind (see Figure 6–4).

13. Select the Rectangle Selection tool.

The Rectangle Selection tool may be hidden under the Live Selection tool. Click and hold on the Live Selection icon to reveal other selection options (see Figure 6–5), including the Rectangle Selection tool.

14. Select the Use Point Tool in the vertical toolbar.

15. In the Attributes Manager, make sure Only Select Visible Elements is unchecked.

figure | 6–4 |

Choose X-Ray to
See Through the
Sphere

figure | 6–5 |

Rectangle Selection
Tool

If you fail to do this, you'll select only those points that are immediately visible and not those that are, for instance, on the far side of the sphere, hidden by points closer to you.

16. Select the bottom-center point and the four sets of points immediately above it (see Figure 6–6).

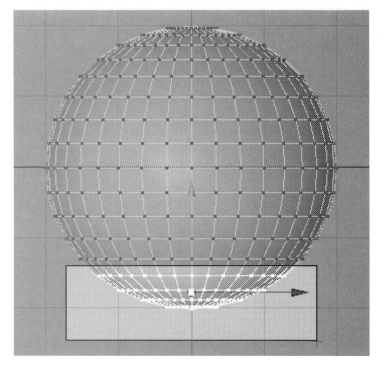

figure | 6–6 |

Select the Bottom-
Center Point and
Four Sets of Points
Above

In Figure 6–6 the background image has been hidden just to improve your view of the points to be selected. There's no need for you to hide the image.

17. Choose Structure > Set Point Value

18. In the Attributes Manager, change Y to Set and Val. to −150 and then hit Return.

Press F1 to return to the Perspective view for a moment and rotate the view so that you can see the bottom of the sphere. Notice that this last step pulled all of the points up so that they sit together on a plane at Y = −150.

Return to the Right view and look carefully at the sets of points near the top of the teapot. One set of points sits almost perfectly along the top of the pot. The next set of points above will become the inside rim of the pot. The set of points above that will form part of the depression that the lid sits into. The set above that will become the circumference of the hole. Everything above that—one set of points and the point at top center—needs to be deleted to open up the top of the pot.

19. Using the Rectangle Selection tool, select the point at top center and the first set of points below that (see Figure 6–7).

20. Hit the Delete key to delete those points.

21. Select the set of points above the pot top (see Figure 6–8).

figure | 6–7 |

Right View Showing Points to Be Selected

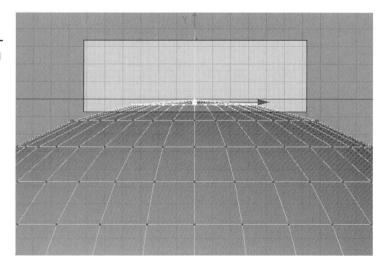

figure | 6–8 |

Select Points Imme-
diately Above Top of
Teapot

22. Move these points straight down on the Y axis until they are roughly at the same height as the row that will serve as the top of the pot: about Y = 129.

23. Select the next set of points up.

24. Pull these points straight down until they are slightly below the top of the pot: about Y = 124.

25. Select the top set of points and drag then down to approximately the same height as the previous set: Y = 124.

Select and Scale Point and Polygon Loops

You have the basic frame of the teapot established, and so now you need to refine details. Until now, you have been using the Rectangle Selection tool to select points. That works fine, but there's another way to select sets of points, polygons, and edges that can be especially quick and interactive: Loop Selection. The Loop Selection feature will be introduced here as you create a rim at the bottom of the teapot, widen the hole at the teapot's top, and create an edge to secure the lid in-place. Continue to work with the file you have open now or, if you'd prefer, open BasicFrame.c4d in the Chapter_06 folder on your CD. If you choose to open BasicFrame.c4d, you may need to reload the reference image into the side viewport.

1. Press F1 to enter the Perspective view.

2. Rotate the teapot so that you can see its bottom.

3. Select the Use Point Tool.

4. From under the Selection menu, choose Loop Selection.

As you move your cursor over the TeapotPolys object, bright yellow rings will show possible selections.

5. Click between any two points on the third loop from the bottom center to select that loop of points (see Figure 6–9).

6. Resize the loop of points to about 240m (X and Z).

In the Coordinates Manager, notice that this ring size is currently 200m. You can resize the loop either with the Scale Tool, keeping one eye on the Coordinates Manager, or you can simply enter 240 as the X and Z values, and click Apply.

7. Using the Loop Selection tool again, select the next ring of points in toward the center.

8. Resize this ring to 230m X and Z.

9. Select the Use Polygon Tool.

10. Again, use Loop Selection to select this narrow ring of polygons between 230 and 240m (see Figure 6–10).

figure | 6–9 |

Loop Selection of
Points

figure | 6–10 |

Loop Selection of
Polygons

11. From the Structure menu, choose Extrude.

12. Extrude the selected polygons downward.

You can either click and drag inside the viewport to extrude these
polygons downward, keeping an eye on the Attributes Manager as
you do, or just set 10 in the Offset field and hit Enter.

13. Return to the Right view.

14. Return to Points mode.

15. Select the set of points just below the bottom edge of the
teapot handle (see Figure 6–11).

16. Drag these points up just a little so that they sit a bit closer to
the handle's bottom: Y = approximately −61m.

17. Select the next set of points above and move them up a bit,
so that they are in line with the upper edge of the handle's
bottom: Y = −25m.

18. Select the next higher set of points and pull then up to be
even with the top of the spout, where it connects to the body:
Y = 15m.

figure | 6–11 |

Select the Set of
Points Below the
Handle

19. From under the Structure menu, select Knife.

20. In the Attributes Manager, make sure that both Restrict to Selection and Visible Only are unchecked.

21. Hold down the Shift key, and cut across the teapot just below the handle (see Figure 6–12).

Next, you'll reposition points so that they (1) more accurately reflect the curvature of the teapot body and (2) are positioned to allow a spout and handle to be created. Although you can use the Loop Selection tool to select each set of points, you may find it easier to use the Rectangle Selection tool. Why? You can toggle back and forth between the Rectangle Selection tool and the Scale Tool using the spacebar. Unfortunately, this feature is not available when using the Loop Selection tool.

figure | 6–12 |

Use Knife to Make a
New Set of Points
and Polygons

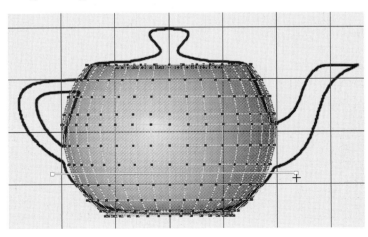

The procedure will go something like this. First, you'll use the Rectangle Selection tool to select a set of points. Then, you'll click and drag the bright green Y axis indicator for the group of selected points to position them as desired. Next, you'll use the Scale Tool to pull the selected points onto the outline of the teapot. Then, you can tap the Spacebar on your keyboard to return to the Rectangle Selection tool. Tap the Spacebar again to go back to the Scale Tool. Back and forth, back and forth: select, move, spacebar, scale, spacebar and then repeat. It's a real time-saver. In the Chapter_06 folder, there's a short movie that demonstrates the concept and covers steps 15 through 22. It's called SelectMoveScale.mov.

22. Select each loop of points one at a time, move it up or down as desired to evenly space out the loops, and scale the points so that they are aligned with the outline of the teapot.

23. After you've scaled all the points, your Side view should look like Figure 6–13.

You'll notice that the teapot is a bit angular in spots. This is especially evident in the lower-left corner of Figure 6–13. It lacks sufficient geometry; that is, an adequate number of polygons. You could add more polygons by subdividing the current polygons but, as noted earlier, HyperNURBS can produce a similar effect.

24. Add a HyperNURBS object to the Objects Manager.

25. Make the TeapotPolys a child of the HyperNURBS object.

figure | 6–13 |

Rendered Teapot Body

Render the active view and note the improved shape of the teapot. Next, clean up the top of the pot, where the lid will eventually sit.

26. Return to the Perspective view.

27. Using the Loop Selection tool, select the third set of points in from the top center of the teapot (see Figure 6–14) and increase its size to 280m X and Z.

28. Select the next set of points nearer the center and increase the size of that ring to 275m.

29. Resize the set of points that define the hole in the top of the pot to 240m.

30. Render the active view (see Figure 6–15).

Rotate the Teapot and Reset the Axes

You might remember from an earlier chapter, the discussion about object axes versus world axes. Of course, they do not need to be

figure | 6–14 |

Select Third Ring and Resize to 280m

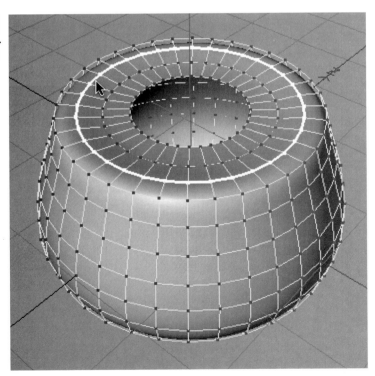

figure | 6–15 |

Lid Area Complete

aligned with one another; and often are not after rotating an object. The same is true for polygons and edges. You will frequently find that the axes associated with a polygon or edge are out of alignment with the world coordinate system. What's more, you'll find that polygons and edges don't respond as anticipated when the World Coordinate System is selected. While this complicates matters, it doesn't make work impossible. Still, when you can keep things aligned, you may find it easier to anticipate the results of a move, scale, or rotate action. With that in mind, rotate the sphere to prepare for creation of the spout and handle.

At present, the edge between two sets of polygons sits on the Z axis. Remember, your original sphere had 36 rotational segments: one every 10 degrees. So, if you rotate the TeapotPolys object 5 degrees, a set of polygons will then be aligned with the Z axis.

1. Press the F2 key for the Top view.

2. From the viewport's Display menu, choose Quick Shading and then Wireframe.

3. From the viewport's Edit menu, choose Frame Active Objects to improve your view of the teapot.

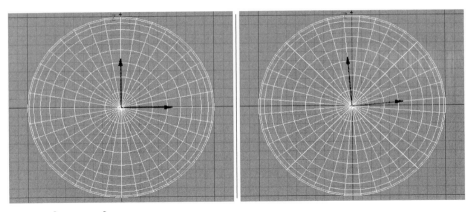

figure | 6–16 |

TeapotPolys: Before Rotation (left), After Rotation (right)

4. In the Objects Manager, make sure the TeapotPolys object is selected.

5. Select the Use Model Tool from the vertical toolbar.

6. In the Coordinates Manager, under Rotation, set 5 degrees next to H, for Heading, and hit Enter (see Figure 6–16).

7. Next, select the Use Object Axis Tool.

8. In the Coordinates Manager, under Rotation, set 0 degrees next to H and hit Enter.

This brings the object's axis back into alignment with the world's axis system while the teapot body stays rotated.

Deleting Polygons and Bridging New Ones

There are several ways to create the spout and handle. Perhaps the easiest way would be to model them as separate objects: the spout as a LoftNURBS object and the handle as a SweepNURBS object. You could create the spout by generating several Circle Splines, making them editable, moving them into place, scaling them, and then making them children of a LoftNURBS object. The handle might be a Circle Spline pulled along a custom-made Bézier Spline. You'd then simply stick them into the model. The results would be pretty fair, especially if you were modeling a machine-fabricated metal teapot.

If, however, you wanted to model a ceramic teapot, this wouldn't do. The transition from the body of the teapot to the handle or spout would be too stark. A ceramic teapot, or a metal teapot with substantial welds where the teapot body meets the handle and spout, would have a smoother transition from body to handle or spout. It would look as if the teapot had been sculpted or hand-crafted, instead of machined.

Given that your goal in this chapter is to learn about manipulating polygons, edges, and points and HyperNURBS, avoid the temptation to model the spout and handle separately and, instead, pull them from the existing teapot body. First, you'll extrude a group of polygons, delete those that aren't needed, and then use the Bridge tool to bridge points and create new polygons and close up holes in the structure.

If you had problems with the preceding, feel free to open the Just-Body.c4d file in the Chapter_06 folder of the CD-ROM and continue from there. Otherwise, continue to work with your open file.

1. Press F3 to see the Right view.

2. From the viewport's Edit menu, choose Frame Active Objects.

3. With reference to the teapot outline in the background, make note of the polygons that sit abeam the top and bottom portions of the handle: second from the top and fifth from the bottom.

4. Press F1 for the Perspective view.

5. Rotate the teapot so that you are looking down the Z axis toward +Z values.

6. Select the Use Polygon Tool in the vertical toolbar.

7. Using the Live Selection tool, select the five polygons stacked vertically along the YZ plane, closest to you, beginning with the second from the top and continuing down to the fifth from the bottom (see Figure 6–17).

8. Choose Structure > Extrude from the main menus.

9. Return to the Right view.

10. Click and drag to the right inside the viewport until the extruded polygons reach the inside of the teapot handle (about 70m Offset in the Attributes Manager).

figure | 6–17 |

Select Polygons for
the Handle

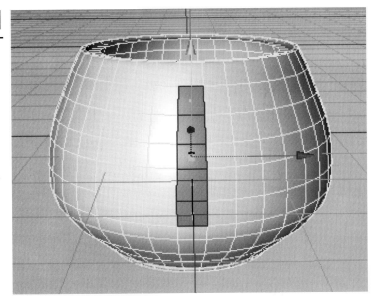

11. Click and drag to the right once again until the extruded poly-
gons reach the outside of the teapot handle (about 30m Offset).

12. Select the Live Selection tool and make sure that Only Select
Visible Elements is unchecked in the Attributes Manager.

13. Select the three polygons on the inside of the teapot handle
(see Figure 6–18) and hit the Delete key to delete them.

figure | 6–18 |

Select and Delete
Polygons to Form
Handle

14. Return to the Perspective view.

This next part can be a bit tricky. You'll use the Bridge tool to connect points and, thereby, create new polygons. The challenging bit is rotating the teapot around so that you can see the points. In some places, the rounding effect of the HyperNURBS results in points being hidden behind polygons. The problem is worse where the handle meets the body of the teapot. But there is a partial solution.

15. Rotate the teapot around so that you can see the handle and the hole in the teapot body left by the deleted polygons.

16. Press the Q key on your keyboard.

Remember, pressing Q disables HyperNURBS for the selected object. Now, the skin of the teapot is pulled straight from point to point so that points are easier to locate. Still, you need to rotate the teapot around as you stitch together points. Before continuing, it might help if you viewed the short movie, BridgePoints.mov, on the CD.

17. Make sure you're in Points mode.

18. Choose Structure > Bridge from the menus.

You can start anywhere you'd like, perhaps the two points where the top part of the handle meets the teapot body. As you position your cursor over a point, it turns bright yellow. You'll click on one point and drag your mouse across the gap to the adjacent point. Again, you'll know that it's safe to release the mouse and complete the bridge when the point you're trying to connect to turns bright yellow. You'll work your way around the inside of the handle until you return to reconnect the first two points you connected.

19. Place your cursor over a point on one side of the gap.

20. Click and hold the mouse button down while you drag to the adjacent point on the opposite side of the gap, and then release your mouse button.

21. Move along the gap in either direction to the next set of points and repeat this process, creating polygon after polygon until you've closed the opening in the teapot body and handle.

22. Return to the Right view.

23. Press Q to reactivate hyperNURBS smoothing.

24. Use the Rectangle Selection tool to select points and then pull them into place around the outline of the handle.

There's a short movie file on the CD, HandlePoints.mov, which will get you started. Work with the points for a while and you should be able to match the shape of the handle fairly well. Of course, you're really stretching some of the polygons quite large. You could remedy that by using the Knife tool to create more points and polygons. You could also subdivide the polygons to add more points and increase your control over the shape of the handle. Later in this exercise, you'll try that and see how it works.

25. Return to the Perspective view.

26. Choose the Use Polygon Tool.

27. Select the Live Selection tool and make sure Only Select Visible Elements is checked in the Attributes Manager.

28. Select all of the polygons that comprise the handle.

Again, this may be easiest to do with HyperNURBS deactivated, so you might want to press the Q key first. Remember, you add polygons to the current selection by holding down the Shift key and clicking on them. If you accidentally select polygons you hadn't intended to, you can deselect those polygons by control-clicking them.

Normals

Selected polygons will have a small yellow tail sticking out of their middles (see Figure 6–19). These are called *normals*. Note, if your normals aren't showing as small yellow tails, choose Edit > Configure from the viewport's menu and, in the Display panel of the Attributes Manager, check the Normals checkbox. A normal represents the surface direction of the polygon and is aligned with the polygon's Z axis. Having the normals right-way-around is very important for a variety of reasons. For instance, when you enable backface culling, C4D calculates which surfaces it will hide based on normals and their relationship to the camera. Try it and see. If, in this instance, you enable backface culling, under the viewport's Display menu, polygons on the inside of the handle disappear (see Figure 6–20).

figure | 6–19 |

Small Yellow Tails
Show Normals

1. From under the Functions menu, select Align Normals.

2. From under the Functions menu, select Subdivide.

3. Set Subdivisions to 1, check HyperNURBS Subdivide, leave Maximum Angle at 180 degrees, and click Okay.

Checking HyperNURBS Subdivide smoothes the surface as polygons are added.

Now you'll have many more points that you can use to craft the teapot handle. Move them into position as you see fit.

figure | 6–20 |

Backface Culling
Hides Reversed
Normals

DON'T GO THERE

Adding points isn't always a good idea. There are at least two reasons for this. The first is modeling economy. To reiterate the idea made elsewhere in the book, adding points and polygons to a scene will eventually slow things down and bloat your file size. The other reason is that you are working against your HyperNURBS by adding extra points. Remember, HyperNURBS smooth an object and allow you to alter large areas of the object by manipulating only a few points or polygons. When you create more points, you reduce the area you can alter with any given point. In the chapter on spline-based modeling, you created splines with as few points as possible. The idea is the same here. Only use as many points as needed. Let HyperNURBS do the smoothing for you.

Command Keys for Quick Polygon Editing

Next, create the spout for your teapot. Again, there are several ways to do this. Because you're learning to work with polygons, points, and edges here, you'll employ a method that focuses on careful manipulation of those. This time, however, you'll make aggressive use of keyboard equivalents and see how quickly you can create and alter a shape.

With a set of polygons selected, the D key on your keyboard allows you to extrude. In the keyboard row above, the E, R, and T keys allow you to move, rotate, and scale, respectively. So, you'll want to keep your left hand near the D, E, R, and T keys as you model.

1. In the Perspective viewport, rotate the teapot around to see the side opposite the handle.

2. Choose the Live Selection tool and make sure Only Select Visible Elements is checked.

3. Select the fifth and sixth polygons from the top: those right on the Z axis on the YZ plane.

If you'd like, you can briefly return to the Right view and confirm that you've got the correct polygons selected (the ones there where the spout connects to the teapot body). Then, return to the perspective view.

4. From under the Edit menu in the viewport, select Frame Selected Elements to zoom into a close view of the selected polygons.

5. Go to points mode for a moment and pull each of the two points that define the edge between the selected polygons out about 10m to open up the spout a bit (see Figure 6–21).

6. Return to Polygon mode.

7. Return to the Right view.

8. From under the viewport's Edit menu, choose Configure.

9. In the Attributes Manager, from within the Back panel, open the file TeapotOutline02.jpg to use as your new background.

This file is no different than the file you were using as your background earlier except that it includes five red lines to act as guides for the next few steps.

10. Hit the D key on your keyboard.

11. Click and drag to the right inside the viewport to extrude the selected polygons to the first red line.

12. Hit the R key on your keyboard.

13. Rotate the polygons by dragging the outside of the rotation sphere counterclockwise until the blue axis indicator is aligned to the red guideline.

This should be about 7.5 degrees counterclockwise. Notice that when you release the rotation sphere, it snaps back to its original position; so try to rotate the polygons to an appropriate angle in

figure | 6–21 |

Widen the Spout at Its Base

one try. Otherwise, it may be difficult to see the polygons behind the rotation sphere on subsequent attempts, and the blue axis indicator will no longer be of much help.

14. Press the D key to extrude the polygons out to the next red guide.

15. Grab the Y and Z axis arrowheads and drag the polygons up so that their center (where the Y and Z axis indicators meet) sits on the center of the red guide (see Figure 6–22).

16. Hit R and rotate the polygons to sit flush on the red guide (about 28 degrees counterclockwise).

17. Hit the E key and adjust the polygons' location.

18. D key again and extrude.

19. Move into position: center the polygons on the red guide.

20. R key and rotate.

21. Press the T key and click and drag in the open area of the viewport to scale in all three axes simultaneously.

22. Repeat this process all the way to the last red guide.

figure | 6–22 |

Move Polygons to Red Guide

figure | 6–23 |

Selected Polygons at
Spout's End

You'll need to rotate the last point quite a bit and scale it as well.
Take a look at the movie ExtrudeSpout.mov on the CD to see this
entire process.

All that's left is to pull the end of the spout back in on itself in order
to form the opening. First, you'll extrude the selected polygons up
a bit to add a bit of a lip to the spout, extrude the polygons inward
to reduce the size of the selection, scale the opening a little to round
it off, then extrude straight down and hide the polygons inside the
neck of the spout.

23. Return to the Perspective view.

24. Make sure you are in Polygons mode.

25. Make sure the two polygons at the end of the extrude are still
selected (see Figure 6–23).

26. Extrude the polygons up about 5m.

27. From under the Structure menu, select Extrude Inner.

28. Click and drag left in the viewport until the Offset value in the
Attributes Manager reads about 5m.

29. Select the Scale tool.

30. Click and drag the handle at the end of the blue Z axis left until
you've scaled the opening down to about 0.7 (see Figure 6–24).

figure | 6–24 |

Scale Down the
Polygons

31. Extrude the polygons downward about 50m.

32. Scale the polygons along the Z axis down to about half their current size, 0.5.

33. Use the Move tool to tuck the polygons back into the spout neck.

34. Finally, zoom in, select all of the points at the very top of the spout's opening, and pull them forward to smooth things out (see Figure 6–25).

35. Move points around the end of the spout as necessary to clean it up.

36. Save your work but leave the file open.

figure | 6–25 |

Smooth the Lip at the
Spout's End

There's a lot of complexity there in the teapot but if you were able to work through that without a lot of trouble, you are ready to tackle other modeling tasks that require manipulation of points, polygons, and edges and use of HyperNURBS. Try another one.

Editing Points and Polygons with Symmetry Objects

Of course, you'll need something to stir your tea with, so next you'll create a teaspoon.

1. Create a new scene in C4D.

2. Press F2 to see the Top view.

3. Set Display to Lines and Wireframe.

4. Choose Edit > Configure from the viewport's menus.

5. Click Back in the Attributes Manager and load the file SpoonTop.tif from the CD-ROM.

6. Enter 600 for Size Y (Size X should automatically scale to about 150 after you enter the Y value).

7. Add a Cube primitive to the scene.

8. Set the Cube X, Y, and Z dimensions to 130, 10, and 580, respectively, to resize the cube to about the same size as the spoon.

9. Set the Cube's Segments X to 2.

10. Rename the cube object SpoonPolys.

11. Make SpoonPolys editable.

12. Select the Use Point Tool and the Rectangle Selection tool.

13. Make sure Only Select Visible Elements is unchecked in the Attributes Manager.

14. Select the points along the far left side of SpoonPolys (see Figure 6–26).

15. Hit Delete on your keyboard to delete them.

16. Render the active view and notice that half the SpoonPolys object has been deleted.

17. Add a Symmetry Object to your scene (see Figure 6–27).

figure | 6–26 |

Select Points at Far
Left of Cube Primitive

figure | 6–27 |

Add a Symmetry
Object to the Scene

18. Make the SpoonPolys object a child of the Symmetry object.

19. Render the active view and notice that the missing half the SpoonPolys object has returned.

A brief explanation is in order. Looking from above, a spoon is a symmetrical object: its left half is identical to its right. So, wouldn't it be nice if you could model one side only and have C4D create the opposite side for you automatically? That's what the Symmetry Object does. In the following steps, you'll use the Knife tool to create new points and when you adjust the points on the right side of the spoon, your actions will be mirrored on the left side of the spoon.

Look carefully at the picture of the spoon in the background of your Top view. You'll need to add points to define that shape. Where the shape changes most dramatically—for instance, around the ends of the spoon and around the bowl—you'll need more points. Along straight, unchanging areas—the handle—you'll need few points.

So as to speed up the modeling process, you'll probably want to jump back and forth between the Knife tool and the Rectangle Selection tool.

20. Add a HyperNURBS Object to the scene.

21. Make the Symmetry Object a child of the HyperNURBS Object (see Figure 6–28).

22. Make sure the Rectangle Selection tool is active.

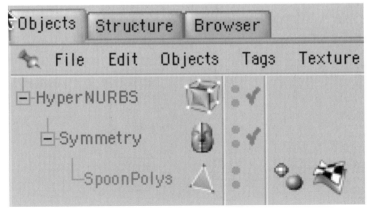

figure | 6–28 |

HyperNURBS Object Becomes Parent to Symmetry Object

23. Make sure the SpoonPolys object is selected in the Objects Manager.

24. Press the K key on your keyboard to activate the Knife tool.

25. In the Attributes Manager, make sure Restrict to Selection and Visible Only are unchecked.

26. Click abeam that part of the spoon where the handle seems to begin, hold down the Shift key to ensure a straight cut, and drag all the way across the SpoonPolys object (see Figure 6–29).

27. Make two more cuts: the first about 20m above the cut you made in step 26 and the second about 20m below.

28. Press the Spacebar to switch back to the Rectangle Selection tool.

This process of cutting and moving and cutting and moving can be a bit confusing. You are working toward a series of points as depicted in Figure 6–30. You might find that a quick look at the Spoon.mov file on the CD-ROM helps clarify the process.

figure | 6–29 |

First Cut

figure | 6–30 |

Cut to Add Points as
Shown

29. Select all of the points you just created and drag them left to
the edge of the spoon.

30. Select the lower two sets of points and drag them further left.

31. Select the lowest set of the three and drag it further left to
complete the curve at the intersection of the bowl and handle.

32. Press the Spacebar to switch back to the Knife.

33. Cut across the spoon again, about 50m above the very bottom
end of the handle.

34. Spacebar to return to the Rectangle Selection.

35. Select the new points and drag them right to the edge of the
spoon.

36. Select the points that were once the bottom right corner of the
cube (looking from above) and move them up just a little bit
and then left.

37. Back nearer the bowl-end of the spoon, make a cut at about 250m Z, a bit below the end points.

38. Move these new points and the points that were once the top-right corner of the cube into position along the edge of the spoon.

39. Another cut is needed about halfway down the bowl.

40. Now, it's just a matter of moving points into place to conform to the outline of the picture of the spoon in the background of the Top view.

At this point, the background image is of little use and might even get in the way. The following steps hide the picture, but do not delete it from C4D's memory. You can return at any time and turn it back on by checking Show Picture in the Back panel.

41. From the Top view's menus, choose Edit > Configure.

42. On the Back panel, uncheck Show Picture.

43. Select the Rectangular Selection tool and make sure the Only Select Visible Elements checkbox in the Attributes Manager is unchecked.

44. Select the four sets of points along the Z axis that define the middle of the bowl (see Figure 6–31).

figure | 6–31 |

Select Middle Points to Form Bowl

45. Press F3 for the Side view.

46. Pull the selected points down along the Y axis about 25m.

47. Press F2 for Top view.

48. Select the middle two of the four sets of points previously selected.

49. Press F3 for Side view.

50. Pull the selected points down along the Y axis another 20m.

51. Select all of the handle points up to but not including those at the start of the spoon's bowl (see Figure 6–32).

52. Select the Rotate Tool.

53. Click on the ring around the Rotate Tool interface, hold down shift, drag counter-clockwise, and rotate the handle 5 degrees.

Notice that holding down the Shift key causes the rotation to snap to 5-degree increments.

54. Select the six points that define the tip of the handle (see Figure 6–33).

55. Rotate clockwise 15 degrees.

56. Click once on the HyperNURBS object in the Objects Manager.

figure | 6–32 |

Select Handle Points

figure | 6–33 |

Select Points at Handle Tip

57. In the Object panel of the Attributes Manager, set Subdivision Editor to 3 and Subdivision Render to 4.

Increasing the subdivisions smoothens the spoon. So, why not keep these settings pushed up to higher values all of the time? The answer is: economy. Higher settings result in longer render times. As always, use values only as high as necessary to achieve the desired look.

Copying, Pasting, and Scaling Objects

Well, your spoon looks pretty good but it's sitting in a file apart from the teapot. So, to finish up this part of the tutorial, you'll bring it over into your teapot file and scale it to an appropriate size.

1. Rename the HyperNURBS object Teaspoon.

2. Save your work.

3. Make sure the Teaspoon object is selected and choose Edit Copy from under the Objects Manager's menus.

If you didn't close the teapot file, it should still be accessible at the very bottom of C4D's Window menu. If you did close the teapot file, go ahead and open it up again now.

4. Bring the teapot file to the front with Window > Teapot.c4d.

5. Choose Edit > Paste from under the Objects Manager's menus.

figure | 6–34 |

Scale the Spoon to Fit the Teapot Scene

6. Make sure the Use Model Tool is selected in the vertical toolbar.

7. Move the teaspoon out from inside the teapot: in front of and slightly right of the teapot as you're looking at it.

8. From the dropdown menu below Size in the Coordinates Manager, choose Scale (see Figure 6–34).

9. Enter 0.66 as the value for X, Y, and Z and click Apply.

Finish up your project by adding a tabletop, position the spoon and teapot on the tabletop, add lights, and add convincing textures.

As you get use to using keyboard equivalents for C4D's commands and develop a feel for creating new points and polygons with the knife tool, and then moving those points and polygons into place, rotating and scaling them along the way, you'll find that your modeling work goes a lot faster and becomes more enjoyable.

SUMMARY

You've come a long way in a very short time. Modeling at the level of points, polygons, and edges can be especially challenging work, but the results are clearly worth the trouble.

In the chapter, you learned that HyperNURBS are special modeling tools that allow an object composed of only a few points, polygons, and edges to appear as if it had very many more. They appear to subdivide existing polygons and, because they smooth any object

that is their child, they are especially useful when modeling organic characters or sculpted objects.

Also in this chapter, you learned to use the Knife tool to create new geometry, and the Symmetry Object which allows you to model one side of an object while C4D completes the other half. Other important tools and concepts introduced include the Set Point Value feature, which allows you to move many points to a specific position all at once and the Loop Selection feature which makes it easy to select a series of points, polygons, or edges. Several keyboard shortcuts were also introduced to help you speed up your modeling. Unfortunately, you seldom have the time to invest in a project that you'd like, which is why efficiency and economy are two important concepts to keep in mind.

Your modeling arsenal is fairly substantial now: parametric primitives; Lathe, Extrude, Sweep, and Loft NURBS; HyperNURBS; and techniques for manipulating the tiniest details of your work. There's still much to learn, but you should be prepared to model a very wide range of objects, texture them, and light them effectively.

in review

1. Into a new C4D scene, add a cube and make it editable. Make it the child of a HyperNURBS object. Use the Knife tool to cut away at the object. Explain why the shape changes as it does. Press the Q key periodically to deactivate HyperNURBS and see the underlying polygonal structure.

2. What are Normals? Why are they important?

3. What advantages do HyperNURBS introduce into the modeling process?

4. You can model quickly by keeping one hand on the keyboard's E, R, T, and D keys. What does each do?

5. Explain the operation of C4D's Loop Selection tool. What are the pros and cons of using that tool compared to the Rectangle Selection tool?

↗ EXPLORING ON YOUR OWN

1. Complete your tea set by creating teacups, a cream pitcher, saucers, and other objects.

2. Launch C4D and drop a cube into your 3D workspace: X, Y, and Z dimensions of 300, 200, and 450, respectively, and Segments X set to 2. Make the cube editable. Make sure you're editing in Polygon mode. In the Right view, knife a horizontal cut close to the bottom of the cube. In the Top view, delete the points on the left side of the cube and then make the cube a child of a Symmetry object. Next, make the Symmetry object the child of a HyperNURBS object. Return to the Perspective view. You're well on your way to creating a computer mouse. Finish the project.

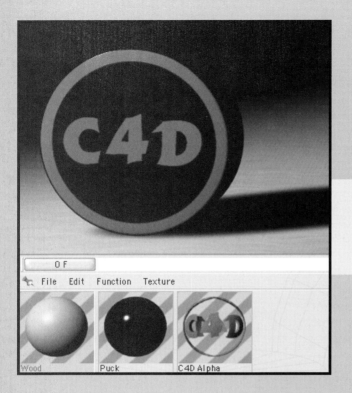

texturing: part ii

 charting your course

In an earlier chapter, you learned to apply basic textures to models. You learned how to adjust settings in several of C4D's material channels in order to customize the look of materials. In this chapter, you'll tackle a few more advanced topics. Using specific projection methods, you'll apply materials to objects in ways that best suit the structure of those objects. Although you can purchase textures for use with your models, and even find some textures available free via the Internet, you'll spend a small amount of time in this chapter creating your own textures. It's very reward-ing work, it's sometimes necessary in order to achieve a special look, and texturing can be a profitable career in its own right. You'll also learn to use the Displacement and Alpha channels in the Material Editor to alter the apparent structure of objects.

 goals

In this chapter you will:

- **Use various projection methods to ensure optimal coverage of an object with a material**

- **Create textures from scratch using a digital paint program**

- **Move, scale, and rotate textures for optimal placement**

- **Use the Alpha and Displacement channels to model objects**

<div style="text-align: right">TEXTURING: PART II</div>

APPLYING TEXTURES

Imagine that you've purchased a gift for a friend's birthday and you've decided to gift-wrap it. If it's rectangular-shaped—a box or a book, for example—the task is fairly straightforward unless your wrapping paper is irregularly shaped. If the gift isn't rectangular shaped—for instance, a basketball or a lamp—you've got a lot of work ahead of you. You'll have to pinch and gather the paper in some places, and stretch it flat in others. C4D faces similar challenges when you try to apply a material to an object. After all, your textures are composed of flat, 2D images. To meet these challenges, C4D allows you to specify any one of several different projection methods when applying a material to an object.

When you apply a material to an object, C4D projects—or maps—the material onto the object based on your assignment of a projection method. You select a projection method by first clicking on the object's texture tag (icon) in the Objects Manager and then making your selection from the Projection dropdown menu in the Attributes Manager (see Figure 7–1). So far, you've applied materials to objects using C4D's default projection method, UVW Mapping;

figure | 7–1 |

Projection Methods
in C4D

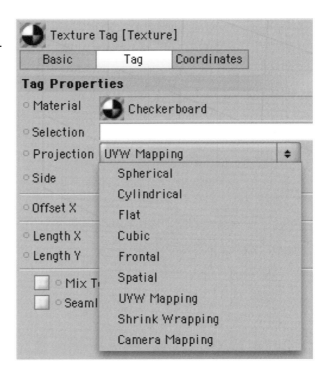

and while very powerful, this will not be your best option in many instances.

1. Launch C4D.

2. Looking into the perspective viewport, add a cube, a sphere, and a cylinder to your scene.

3. Increase the Radius of the Cylinder to 100.

4. Space the three objects apart along the X axis: cube at about X = −225, sphere at X = 0, and cylinder at X = 225.

5. Rotate your view such that you're looking at the three objects from directly in front and slightly above.

6. Create a new material and, in the Color channel, add a checkerboard texture (Texture > Surfaces > Checkerboard).

7. Name the material Checkerboard and apply it to all three objects.

Texture Attributes

1. Click once on the Texture Tag to the right of the Sphere object (see Figure 7–2).

2. When you do, you'll notice several editable parameters in the Attributes Manager (see Figure 7–3).

Before you begin to experiment with the Projection method, take a look at Offset X and Y, Length X and Y, and Tiles X and Y.

3. Set Length X to 50% and hit Enter.

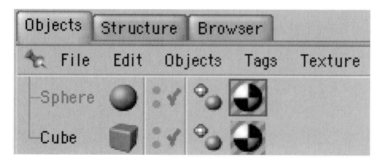

figure | 7–2 |

Texture Tag in the Object Manager

figure | 7–3 |

Texture Properties
in the Attributes
Manager

Notice that Tiles X setting automatically changes to 2, and observe that the checkered patches on your sphere have doubled in number and halved in size.

4. Set Tiles Y to 2 and hit Enter.

Notice that Length Y automatically changes to 50%, and observe that the number of checkered patches has doubled again, with each patch ending up half its previous size. So, by default, Length and Tiles are linked. If you increase the number of tiles along an axis, you automatically decrease the length of the tiles along that same axis.

5. Set Offset X to 10% and hit Enter.

Notice that the material rotates around the sphere counterclockwise (looking from above) 36 degrees (10% of 360 degrees = 36 degrees).

6. Set Offset Y to 25%.

Notice that the material shifts downward on the sphere 90 degrees.

7. Uncheck the Tile checkbox.

Now the material appears only once on the sphere. It's there on the left side of the sphere, one-quarter its full size and shifted down and right.

8. Before you move on, check the Tile checkbox, set the Offset X and Offset Y to 0%, and set the Tiles X and Tiles Y to 4.

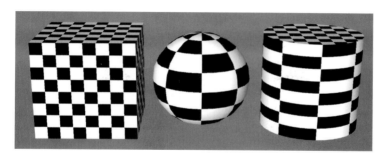

figure | 7–4 |

UVW Mapping
Applied to Objects

9. Apply these same settings to the Checkerboard material of the cube and cylinder.

You'll use these settings as the starting point (see Figure 7–4) for experimentation with projection methods.

UVW Mapping

UVW Mapping is the C4D default for materials applied to objects. It is among the most sophisticated projection methods. As you've seen, 3D space and objects in that space can be described in terms of X, Y, and Z coordinates and dimensions. UVW is a similar means of describing the surface area of an object or, more appropriately, the coordinates for a material applied to an object's surface. For some objects, UVW coordinates are predetermined and automatically applied, for example, parametric primitives and NURBS objects. Other objects with associated UVW coordinates will display an icon like that in Figure 7–5. At this stage of the game, it's enough that you understand that UVW is one of your many available projection options.

What's not to like about UVW mapping? Well, it's fixed. Coordinates assigned to the material are matched to the surface coordinates of your object. You can still tile the texture but, as you'll see momentarily, other projection methods may offer a bit more flexibility. On the positive side, when UVW coordinates are locked to

figure | 7–5 |

The Flag-Like Icon
Indicates UVW
Coordinates

an object, the object can be deformed and the material will auto-matically deform with it.

Spherical Projection

Spherical mapping projects the material onto the object as if the ob-ject were a sphere. This is probably your best alternative when you're mapping a material onto a planet, bubble, baseball, or similar object.

1. In the Attributes Manager, set Spherical as the projection method for the material applied to each object.

2. Render the active view and compare your work to Figure 7–6.

Look carefully at the top of the cube and the cylinder. Can you see influence of Spherical mapping? Also, notice the curvature of the material on the sides of the cube. What's the problem with Spherical projection? Remember, you're applying a flat, 2D image to your objects. Spherical projection shrinks that part of the image near the poles in order to accommodate the reduced circumference in those areas. It's the problem mentioned earlier: trying to gift-wrap a basketball with a flat piece of wrapping paper. You end up pinching the materials near the poles. In many 3D modeling and texturing projects, that's not a problem; but sometimes you have to either try a different projection method or use an image that takes into account this limitation.

figure | 7–6 |

Spherical Mapping
Applied to Objects

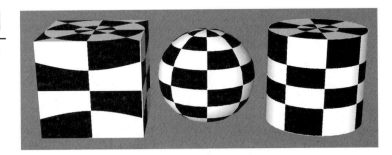

Cylindrical Projection

Cylindrical mapping projects the material onto the object as if it were a cylinder. This is probably your best bet when you're map-ping a material onto a pipe, handrail, tube, or similar object.

1. Select Cylindrical as the projection method for the material applied to each object.

2. Render the active view and compare your work to Figure 7–7.

figure | 7–7 |

Cylindrical Mapping
Applied to Objects

Look at your objects and compare what you see in the viewport now (see Figure 7–7) with UVW Mapping (see Figure 7–4). Clearly, the top of the cylinder is much different here; and so this particular projection method may be far more suited to cylindrical objects than the default UVW. Notice that the material runs parallel to the sides of the cube and you do not see the distortion there that you saw with Spherical projection.

Flat Mapping

Flat mapping is best used with flat objects: floors, walls, and desktops. When applied to other objects, the results are a bit unusual (see Figure 7–8). Notice, for instance, the sides and tops of the cylinder and sphere. There, the material is pulled and stretched across the object: an unwelcome distortion in some circumstances.

1. Select Flat as the projection method for the material applied to each object.

2. Render the active view and compare your work to Figure 7–8.

figure | 7–8 |

Flat Mapping
Applied to Objects

Cubic Projection

Cubic mapping applies your texture to six sides of the object, even when there are no such sides. You might use Cubic Mapping for dice, boxes, cabinets, and buildings. That Cubic Mapping assumes six sides is especially noticeable on the sphere in Figure 7–9. If you

figure | 7–9 |

look carefully, you can see the seams where the material appears slightly irregular. These are the edges of the Cubic projection. Still, when you'd like an image to be projected repeatedly across all six sides of a cube, Cubic projection does the trick.

1. Select Cubic as the projection method for the material applied to each object.

2. Render the active view and compare your work to Figure 7–9.

Frontal Mapping

Frontal mapping projects your material flat onto objects in the scene parallel to the viewing plane. An example will probably clarify.

1. Add another Cube primitive to your scene.

2. Resize the cube to 2000, 2000, 20.

3. Move the cube back along the Z axis to 150 or so, such that it sits behind your cube, sphere, and cylinder.

4. Select Frontal as the projection method for the material applied to your original cube, sphere, and cylinder.

5. Render the active view and compare your work to Figure 7–10.

figure | 7–10 |

Notice that the material doesn't appear to bend, even where the objects bend.

6. Now apply the Checkerboard material to the new cube as well.

7. Set Tiles X and Y to 4, the same setting applied to the material on the original cube, sphere, and cylinder.

8. Set Projection to Frontal.

9. Render the active view and compare your work to Figure 7–11.

What happened? The material is projected onto all objects with reference to the viewing plane. So, the material on each object is aligned with the material on all other objects and, consequently, foreground and background objects seem to dissolve into one another. Obviously, Frontal projection is best used for special effects and sight gags.

10. Delete the second cube from the scene before you continue.

figure | 7–11 |

Frontal Mapping Blends Foreground and Background Objects

Spatial Projection

Spatial mapping is similar to Flat mapping except that the material appears to be pulled left and up. This is especially noticeable along the bottom edge of the cylinder in Figure 7–12.

1. Select Spatial as the projection method for the material applied to each object.

2. Render the active view and compare your work to Figure 7–12.

figure | 7–12 |

Spatial Mapping Applied to Objects

Shrink Wrapping

Shrink Wrapping has some clear advantages for spherical objects that might be viewed from above. While the center of a material is, by default, applied at the front center of an object for most projection methods, with Shrink Wrapping the center is applied at top center. Consequently, the greatest distortion occurs at the bottom center.

1. Select Shrink Wrapping as the projection method for the material applied to each object.

2. Render the active view and compare your work to Figure 7–13.

Pay particular attention to the top center of the sphere and compare this with Figure 7–4.

3. Rotate your view so that you can see the bottoms of the objects.

4. Render the active view and compare your work to Figure 7–14.

5. Select Edit > Undo View from the viewport's menus to return to your previously established view.

figure | 7–13 |

Shrink Wrapping
Applied to Objects

figure | 7–14 |

Shrink Wrapping:
Distorted at Objects'
Bottoms

Projection Methods Summary

To summarize, you need to give some serious thought to how your 2D, rectangular image, pulled into your material, will be projected onto the objects in your scene. If the object is a cylinder, you might try Cylindrical projection. If it's a cube, try Cubic. There are a couple of files in the Chapter_07 Tex folder on your CD. Experiment

with these files and see if you can get a better grasp of how projection methods work.

1. Open the Checkerboard material in the Material Editor.

2. In the Color channel, click on the ellipsis to bring in an image.

3. Find the Tex_Grid_08.tif file in the Chapter_07 > Tex folder on your CD and open it.

The material is already applied to your three objects so all you need to do is experiment with different projection methods to see how the grid differs with each (see Figure 7–15). With which projection methods is the text pinched? With which projection methods does C4D seem to apply the texture once, wrapping it around the object in a single pass, and with which does it apply the texture multiple times?

You can also find a projection that generally meets your needs using this file, then pull the file into Adobe Photoshop and paint your texture directly onto it. That is, make a note to yourself that, for instance, you want a fracture at about grid location G2 and a rust spot at F6. Bring the file into Photoshop, create a new layer, and paint your fracture at G2. Create another layer in Photoshop and paint your rust spot at F6. Bring the image back into your C4D material. Your fracture and rust spot will be positioned as desired.

Use Texture Tool

You may find that the real power of the varied projection methods isn't necessarily in their underlying forms, but in the way each provides you with unique editing capabilities. Each offers its own paradigm for moving, scaling, and rotating the applied material.

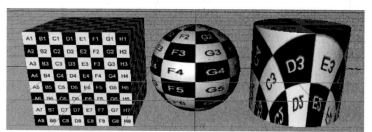

figure | 7–15 |

Texture Grid Image
Applied to Objects

Rotate Texture

1. From the Chapter_07 folder on your CD-ROM, open the file TrainEngine.c4d.

2. Save the file to your hard drive with File > Save Project. Name the project ToyTrain.

You should find yourself in the perspective view, zoomed in for a tight shot of the toy train engine you created in an earlier chapter on modeling with parametric primitives. Here, you'll apply a wood texture already created for you, but you'll notice a problem right away. The texture runs around the engine's steam tank when it seems that it should run lengthwise. You'll fix that using the Use Texture Tool.

3. Create a new material and name it LightWood.

4. Into the Color channel, add the image RoughLarch.tif, to be found in the Tex folder inside the Chapter_07 folder on your CD.

5. In the Objects Manager, open the SteamTank object to reveal its children.

6. Apply the LightWood material to the SteamTankOuter object.

7. Save your work and render the active view.

If you look carefully at the steam tank, you'll see that the grain runs around the cylinder and at the cylinder's end, near the front of the engine, it runs horizontally. This makes no sense at all. Perhaps some projection method other than UVW Mapping will give you a better look.

8. Select the SteamTankOuter object in the Objects Manager.

9. Next, in the Objects Manager, select the texture tag for the LightWood material applied to the SteamTankOuter object.

10. Select the Use Texture Tool in the vertical toolbar.

11. In the Attributes Manager, change the Projection method to Cylindrical.

With the SteamTankOuter object and the texture tag for that object selected, a new interface element appears onscreen (see Figure 7–16). It looks like a light-blue cylindrical frame. Look carefully and notice the green Y axis indicator running vertically along one side and the red X axis indicator running around the top circum-

ference. This frame can now be moved, scaled, and rotated just as if it were an object; and when you move, scale, or rotate it, the material on your object shifts and resizes accordingly. As you'll see momentarily, the form of this frame changes with the selected projection method.

figure | 7–16 |

Cylindrical Frame for Modifying the Texture Projection

12. Render the active view.

Simply changing the projection method to Cylindrical results in a substantially improved look to the model. The grain of the wood runs lengthwise and the texture at the end of the cylinder is joined to its pattern on the sides. Think about why this is. A cylindrical projection runs the texture around the object and so the grain remains intact around the length of the steam tank. If you rotate your view a bit so that you can see the steam tank from above, you'll see that the texture is pinched a bit at top center, just as you might expect. If you hadn't anticipated this, go back and look at Figure 7–7 again. The fact that the steam tack is a cylinder on its side confuses the issue a bit. It'll be best if you can stop thinking of the steam tank as a cylinder and, instead, concentrate on the light-blue cylindrical frame. Anyway, while Cylindrical is better than UVW Mapping in this case, it's not perfect.

13. Next, try Cubic (see Figure 7–17) and then Shrink Wrapping (see Figure 7–18).

Notice how the light-blue Use Texture Tool interface element changes as you change projection methods. Look carefully at the steam tank. Can you see the edges of the texture with Cubic projection? How about the distortion at the bottom of the tank with Shrink Wrapping? Obviously, neither of these methods will do.

figure | 7–17 |

Cubic Projection of
the LightWood
Material

figure | 7–18 |

Shrink Wrapping of
the LightWood
Material

14. Now try Frontal.

Frontal doesn't look too bad, but remember that with Frontal projection, the texture is always parallel to the viewing plane. This means that if you rotate the engine, the texture will move on the tank. That is, when you shoot the scene from different angles, the texture on the steam tank will appear to have moved from shot to shot. That won't do.

15. Now try Flat.

Flat looks pretty good. No pinch at the top center and the grain meets at the sides and ends. The look is fairly satisfying, albeit rather predictable and boring. You can come back to Flat later if you really like what you see now, but continue to explore a bit before you settle on this particular projection method.

16. Make sure the SteamTankOuter object and the texture tag are still selected.

17. Change the Projection method to Spatial.

The Use Texture Tool interface now appears as a flat plane near the front of the tank. The grain runs from the upper-left edge of the tank, down and to the right. It's almost as if the carpenter milled the piece of wood at an angle. Certainly, this irregularity provides a more interesting look, even if it's a bit askew.

18. Select the Rotate Tool in the horizontal toolbar Click and drag the red handle center-scene to rotate the texture up and back about 27 degrees (see Figure 7–19) or set −27 degrees for the pitch in the Coordinates panel of the Attributes Manager while the texture tag is selected.

figure | 7–19 |

Rotating the Spatial Projection

19. Render the active view.

Rotate your view to examine the texture now. There's no pinch at the top. The slight wave in the wood's grain adds a touch of realism and interest to the image. This is a great solution. Still, one more modification may add to your understanding of projection methods.

20. Set the pitch back to 0.

21. Change the projection method to Spherical and render the active view.

Notice the rounding of the texture at top center. It's not pinched, just pulled around the pole to form a circle.

22. Select the Scale Tool in the horizontal toolbar.

23. Click and drag the blue handle at the end of the Z axis indicator for the texture or use the Coordinates panel in the Attributes Manager but either way, increase the Z length of the texture to about 500.

24. Next, rotate the texture around the Z axis using the Rotate Tool or the Coordinates panel in the Attributes Manager to about 90 degrees.

25. Render the active view (see Figure 7–20).

The circles around the pole have been elongated and rotated to the side of the steam tank. Actually, the circles now look a bit like a knothole in the grain of the wood. You can extend the illusion by pulling this same image into the Bump channel.

figure | 7–20 |

Spherical Projection,
Stretched and
Rotated

Continue to experiment with the different projection methods. Get to know the way each works: how each can be moved, scaled, and rotated. There's an enormous amount of flexibility and power here and you'll want to have plenty of experience with projection methods when you tackle especially complex scenes.

Texture Cutaways with Alpha

The Alpha channel of the Material Editor is useful in a couple instances. Later in this chapter, you'll cut away parts of an object using a texture in the Alpha channel. First, however, you'll cut away part of a material using the Alpha channel. This is a handy technique when you want to apply only part of an image to a model, for example, a decal, logo, or a rust spot in one specific location.

Surfboard Logo

1. From the Chapter_07 folder on your CD, open the Surfboard file.

Let's assume that you want to apply the logo for a client's surf shop to the surfboard model you've created. The board needs to be a bright, shiny red to fit in with a special holiday promotion: Santa at the beach or something along those lines. The client provides you with their company logo: the name of the surf shop along with two feet, one of which is missing a couple toes, hence their name, Missing Toes Surf Shop.

2. Create a new material and name it Logo.

3. Open the Material Editor and bring the file, MissingToes-Logo.tif, into the Color channel. It can be found in the Tex folder of Chapter_07.

4. Apply the material to the Board child of the Surfboard object and render the active view.

A couple of problems appear right away. First, the board is no longer bright red but, instead, it has adopted the dark red color from the tiff file. Also, the logo appears on the surfboard not once, but six times: top, bottom, left, right, front, and back.

5. Make the Alpha channel of the Logo material active, bring this same MissingToesLogo.tif file into the Alpha channel, and check the Invert checkbox.

6. Render the active view.

It may appear that things have improved, but that's not really the case. Your surfboard isn't a dark red anymore, but it isn't a bright red either. Remember that the Alpha channel works with the grayscale values in an image. The text and feet in the MissingToes-Logo file are black but the red background isn't especially light. That is, its grayscale value isn't white but a medium gray. So, it has let some, but not all, of the shiny red bleed through; an improvement, but not what you were going for. You really need to create a separate image for the Alpha channel. It's easy to do. Simply open the MissingToesLogo.tif file in Photoshop, select and then replace the red with white (if white is set as the background color you can just delete the red after it has been selected), then desaturate the image with Image > Adjustments > Desaturate. This allows you to see where the red will bleed through easily (white), where it will not bleed through at all (black), and where it will be only partially ob-

scured (grays). In the interest of time and assuming that you may not have access to Photoshop, this grayscale file has been created for you.

7. Still in the Alpha channel, replace the MissingToesLogo.tif file with MissingToesLogoAlpha.tif, or your own custom-made Alpha file.

8. Render the active view.

Don't be alarmed if your surfboard seems to disappear while you're working in the viewport. It's still there. With the application of your alpha, C4D mistakenly thinks it's been cut away. But when rendered: hey, big difference! The surfboard is a bright red now but the logo still repeats itself too many times.

9. Select the texture tag for the Logo material in the Objects Manager.

10. Change the Projection method to Flat in the Attributes Manager and uncheck the Tile checkbox.

11. Render the active view.

Better still! The texture appears on the board only twice now, once on top and once on the bottom. Look carefully at where the logo appears on the bottom of the board. It's inverted. Actually, it's projected straight down through the board.

12. Still in the Attributes Manager, change Side from Both to Front and render the active view.

That's it. To summarize, you used the Alpha channel of the Logo material to cut away all parts of the MissingToesLogo.tif you didn't need: the dark red areas. UVW Mapping wasn't appropriate for this application so you changed that to Flat to impose a single projection onto the board. However, because that single projection carried all the way through the board, you changed Side from Both to Front so that the logo would appear on one side of the model only.

Hockey Puck Logo

Try one more:

1. Into a new scene, add a Cylinder primitive.

2. In the Attributes Manager, in the Object panel, change the Radius to 100, Height to 50, Rotation Segments to 64, and Orientation to −Z.

3. On the Caps panel, set Segments to 5, check the Fillet checkbox, and set both Segments and Radius to 5. The result is a puck-like object.

4. Create a shiny black material for the puck: R, G, B to 255, 255, 255; Brightness to 0%; Brightness in the Reflection channel to 50%; and Specular Width to 24%, Height to 100%, and Inner Width to 10%.

5. Apply the material to the puck.

6. Add a Target Light and, on the Details panel for the light's properties, set the Outer Angle to 60 degrees and the Brightness to 120%.

7. On the General panel for the light, set the Shadow type to Soft.

8. Add a Cube primitive to the scene, for your table top, and resize it to X, Y, Z dimensions of 2000, 20, 2000. Move this down along the Y axis to act as a floor or tabletop beneath your puck: Y = approximately −110.

9. Create a material for the table top—perhaps a wood or checkerboard—and apply it.

10. Create another new material: R, G, B to 255, 0, 0; Brightness to 200%; Brightness in the Reflection channel to 25%; and Specular Width to 24%, Height to 100%, and Inner Width to 10%.

figure | 7–21 |

C4D Hockey Puck

11. In the Alpha channel, load the image called C4D_Alpha.tif, and apply this new material to the puck.

12. With this new texture selected in the Object Manager, change the Projection to Flat and the Side to Front.

13. Render the active view (see Figure 7–21).

14. For an interesting effect, check the Invert checkbox for the Alpha channel in the Material dialog box.

CREATING YOUR OWN TEXTURES

Although you can find downloadable textures on the Internet and through commercial retailers, there's a lot to be said for knowing how to create your own textures. In this brief section of the chapter, you'll use Adobe Photoshop to create a few textures on your own. If you don't have access to Photoshop, you should be able to duplicate many of the steps with Adobe Photoshop Elements, Corel Paint Shop Pro, Corel Painter, or a similar digital paint program. If you don't have access to any of these, skim this material anyway. The concepts will come in handy later. Also note that all of the textures you'll create here are available in the Chapter_07 folder on the CD-ROM.

Stained Mahogany

You'll probably need wood textures for many of your scenes. The wood texture you'll create here will look a bit like a sheet of stained mahogany. The grain will appear clear, but neither heavy nor obtrusive. Your goal is to produce a wood sample with a lot of small fibers. This procedure is easily modified to produce wood textures of different colors and patterns.

1. Launch Photoshop.

2. Create a new file (File > New): Width = 512 pixels, Height = 512 pixels, Resolution = 72 pixels/inch, Color Mode = RGB, and Background Contents = White.

3. Set the background to white and the foreground to a medium brown (RGB of 156, 114, 54, respectively).

4. Fill the background layer with your medium brown.

5. From the Filter menu, select Noise > Add Noise.

6. Set Amount to 10%, Distribution to Gaussian, and make sure Monochromatic is checked, then click OK.

7. From the Filter menu, select Blur > Motion Blur.

8. Set Angle to 0 degrees and Distance to 15.

9. From the Filter menu, choose Sharpen > Sharpen (or Sharpen More if you want a rough-looking piece of wood).

At this point, you have a good looking piece of wood. The grain is very fine and regular. This could easily pass for a stained piece of interior-grade plywood. You might want to go ahead and save the material as it currently exists. It could easily be modified and would suit many purposes. The edges will need to be cleaned up, but you can come back and do that later. For now, continue modifying the texture because what you are going for here is something a little less uniform.

10. From the Filter menu, choose Distort > Ripple.

11. Set Amount to 100% and Size to Small (experiment with these settings for different types of grain).

12. From the Filter menu, select Other > Offset.

13. Set Horizontal to 256 pixels right, Vertical to 256 pixels down, and make sure Wrap Around is selected.

This last step brings the edges of the image to its center. Now it's abundantly clear that the process you've just completed has left the image's edges ragged. This ugly seam will appear over and over again if you apply this image as a texture to an object and tile it. So, you've got to fix this if the image is to be of any use. You'll use Photoshop's Clone Stamp tool.

14. Select the Clone Stamp tool from Photoshop's tool's palette.

15. From the Option Bar that runs horizontally across the top of the screen, select a soft 50 pixel brush.

16. Hold down the Option key (Mac OS) or the Alt key (Windows) and sample the image slightly right of the seam (see Figure 7–22) by clicking your mouse button.

17. Release the Option or Alt key and paint a line vertically down the seam. The seam disappears.

18. Again, this is a great texture as it stands. Feel free to save it for later use.

19. From Photoshop's Image menu, select Adjustments > Hue/
Saturation.

20. Make sure the Colorize checkbox is checked.

21. Set Hue to 35, Saturation to 50, and Lightness to 10. Click OK.

22. From the Image menu, choose Adjustments > Brightness/
Contrast.

23. Set Brightness to 5 and Contrast to 25, and click OK.

24. Save the file as StainedMahogany.tif.

Rusty Metal

This next one is really easy. You're going to produce a heavily oxi-
dized metal texture.

1. Open a new file in Photoshop: 512 pixels by 512 pixels by 72
pixels/inch, RGB, and with a white background.

2. Select the Single Column Marquee tool from the toolbar.

It will probably be hidden under the Rectangular Marquee tool.
Click and hold the Rectangular Marquee tool to select it.

3. Click once in the upper left corner of the image to select a single column of pixels.

4. From the Filter menu, choose Noise > Add Noise.

5. Set Amount to 400, select Gaussian, and make sure that Monochrome is unchecked.

6. Click OK to add the noise to your column.

7. From Photoshop's Edit menu, choose Transform > Scale.

8. Grab the handle at the mid-point of the column and drag it right to streak colored lines across the image (see Figure 7–23) and accept the transformation.

9. From the Filter menu, select Blur > Blur More.

10. From the Image menu, choose Adjustments > Hue/Saturation.

11. Check the Colorize box, set Hue to 30, Saturation to 100, and Lightness to 0. Click OK.

12. From the Filter menu, select Distort > Glass.

figure | 7–23 |

Noise Scaled Across the Image

13. Set Distortion to 5, Smoothness to 3, Texture to Frosted, and Scaling to 100%. Click OK.

14. Save the file as QuickRust.tif.

Green Marble

Marble is quite common in home and commercial interiors. You can use the material you'll create here, and slight variations, with floor tiles, counter-tops, and statues.

1. Open a new file in Photoshop: 512 pixels by 512 pixels by 72 pixels/inch, RGB, and with a white background.

2. Make sure the foreground and background are set to black and white respectively.

3. Under the Filter menu, choose Render > Clouds. This will result is a black and white image like that in Figure 7–24.

4. Under the Filter menu, select Stylize > Find Edges. The result looks like gray strings on a white background.

5. From the Image menu, choose Adjustments > Invert.

6. From the Image menu, select Adjustments > Brightness/Contrast.

7. Set Brightness to 0 and Contrast to 80.

figure | **7–24** |

Render > Clouds

8. From the Image menu, choose Adjustments > Hue/Saturation.

9. Make sure the Colorize checkbox is checked.

10. The rest is up to you and depends on the type of marble you're looking for. Start with Hue = 130, Saturation = 30, and Lightness = −10. The result is a nice, dark-green marble; but experiment a bit and see what you can come up with that pleases you.

MODELING WITH TEXTURES

To this point, you've applied materials to change the apparent surface properties of objects. However, textures can actually do more. The Alpha and Displacement channels can be used to alter the apparent structure of objects.

Alpha

As you've seen, the Alpha channel in the C4D Material Editor can be use to cut away (make transparent) parts of a material. It can also be used to cut away parts of an object.

1. Open a new scene in C4D and press F1 to view the scene through the perspective viewport.

2. Insert a Cube primitive into the scene. Do not change its size.

3. Create a new material and set Color, Specular, Bump, and Reflection as desired.

4. Apply the material to the cube and render the active view.

5. Select the Alpha channel in the Material Editor dialog box.

6. Next to Texture, click the black arrowhead and select Load Image. . .or click the ellipsis button to pull an image into the Alpha channel.

7. Find the Square.tif file in the Chapter_07 folder on the CD-ROM and open it.

8. Render the active view once again to see that square holes have been cut into your cube (see Figure 7–25).

Where the image used in the Alpha channel is black, the cube is transparent. Where the image is white, the cube is opaque and appears solid. What happens if you use an image that includes grays? Try it and see. Replace the image in the Alpha channel with a

shader that includes blacks, whites, and grays—perhaps Galaxy or Cloud—and render the active view again. Notice that the gray areas appear semitransparent.

One other point to make note of: If you ever find that you have the image you plan to use in the Alpha channel backwards—that is, blacks where you want material but white where you don't—check the Invert checkbox in the Alpha channel to adjust for this. Again, try it and see what happens with your cube.

figure | 7–25 |

Alpha Cutaway

9. Click the Invert checkbox in the Alpha channel.

10. Render the active view (see Figure 7–26).

Perhaps using the Alpha channel in the Material Editor seems similar to the cut you might make into a cube using a Boolean object. Well, it may appear similar, but there's an important difference. Look closely at Figure 7–27. The cube on the left has been cut with a Boolean object. The one on the right has been cut with an Alpha. The cut into the cube on the left appears to have walls of its own while the hole in the cube on the right does not. It's as if the cut using the Boolean was a cut into solid wood, but the cut using the Alpha was a cut into a hollow cardboard box.

figure | 7–26 |

Invert Alpha

figure | 7–27 |

Boolean (left) versus
Alpha (right)

Displacement

The last channel you'll work with here is Displacement. Displacement is similar to Bump. It uses the grayscale values of an image to create the appearance of raised and depressed areas on your object. So, what's the difference between Bump and Displacement? Displacement actually deforms the object it's applied to. This difference is especially noticeable at the edges of your objects. Take a look at Figure 7–28. The sphere on the left has a Bump applied. If

you look closely at the right side of the sphere, you'll see that the bumps don't actually protrude into open space. Compare that with the left edge of the other sphere. The sphere on the right has been deformed with Displacement. Its bumps extend into the space around the sphere.

So, why not use Displacement all of the time instead of Bump? There are a couple of reasons. First, Bump can be used with any type of object while Displacement cannot. If the surface of an object is to be displaced, it must be polygonal. It cannot be a parametric primitive. That can have a substantial influence on file size. A scene full of parametric primitive spheres will be much smaller than a scene full of spheres that have been made editable. Also, using Displacement increases render times. So, use Displacement when you need to: when you might zoom in on the edge of an object and the bumps on that object need to extend out into space. But when you'll shoot an object from head-on, and its edges won't be seen or will be obscured by other objects, Bump may be a better choice.

figure | 7–28 |

Bump (left) versus Displacement (right)

SUMMARY

In this chapter, you learned how to project materials onto objects such that the material's coverage of the object best suits your needs. You also learned how to model with textures: Alpha and Displacement. You created a few texture maps using a digital paint program, images that should serve as the starting point for lots of your own custom-made textures.

Applying great materials to your objects and fitting them just right is very important. It can make all the difference between a scene that looks real and engaging and one that looks faked and amateurish. Review the pages early in this chapter until you're able to anticipate which projection method will best serve a specific purpose. A thorough knowledge in that regard will improve your ability to create and apply your textures, including those you create yourself.

1. Launch C4D and drop a sphere into your 3D workspace. Assume that this sphere will be a shiny glass ornament on a holiday tree. How might you project a snowflake onto it? Load the SnowFlake.jpg file from the Tex folder inside the Chapter_07 folder on your CD. How might Length X and Y and Tiles X and Y be used to create one snowflake on the ornament? Many snowflakes on the ornament? Try various projection methods and see if you can anticipate the results.

2. Start with an empty Photoshop file and, from the Filter menu, Add Noise or Render Clouds. This is a great starting point for wood grain and brushed metals. How might Motion Blur and Distort change the specs of Noise into a wood grain? How could you use Hue/Saturation to Colorize the wood? Try other effects filters and see what you can come up with.

3. What are the differences between Bump and Displacement? What are the pros and cons of each?

↗ EXPLORING ON YOUR OWN

1. Create a light that will sit outside your house next to your garage door:

 a. Open the GarageLightStart.c4d file found on your CD-ROM. The scene consists of a tiled brick garage wall and a brass light fixture.

 b. Save the project to your hard drive.

 c. Render the active view.

 d. Create a new material and name it BrassCutAway.

 e. Into the Color channel, load the image Brass.jpg from the CD-ROM.

 f. Into the Alpha channel, load the file FourSquares.jpg.

 g. Apply this new material to the LightHousing object in the Object Manager.

 h. Render the active view.

Deconstruct this scene, examining all of its components. Pay particular attention to the files used in development of the materials. You should be able to create similar files yourself.

2. Create a lock with a keyhole in it. Create the metal texture and the keyhole alpha yourself.

3. Ceiling fans are quite common nowadays. Model a ceiling fan, texture the blades with wood, and alpha cooling vents into it where appropriate.

4. Open the JuustPlane.c4d file in the Chapter_01 folder of your CD. Create decals and apply them to the wings, tail, and fuselage. You'll almost certainly need to alpha away unwanted parts of the decals.

ADVENTURES IN DESIGN

IN AN INSTANCE

Repetition is a key principle in 3D design. Shapes and patterns are repeated over and over to unify a larger whole. Simple repetition can, however, lead to boredom and so designers will frequently employ what is called "repetition with variation." Square-framed pictures might cover a wall but each square will be of a different size. Several small cylindrical planters might populate a shelf but each of a different hue or texture.

Professional Project Example

A small study space was crafted in the attic above a family room in a moderately-priced suburban home. Insufficient space was available for a traditional staircase; it would have consumed precious space in an especially busy part of the house. Because the area would be well-utilized, a durable tiled flooring was selected and a simple spiral staircase was chosen to route traffic up into the study. In advance of costly construction, the homeowners asked to see how the project would look when completed (see Figure B–1).

Repetition with variation abounds in this example. Each step on the staircase is the same size and shape as all others, but each is rotated. Each tile in the floor is the same size and shape as all

figure | B–1 |

Staircase Project

others, but each varies in color and saturation. The matching wall-sconces pull the eyes upward toward the study and generally follow the flow of the staircase.

C4D makes it easy to duplicate an object, distribute the duplicates, and alter each one in size, shape, or orientation. In this particular example, a single step, the support structure for that step, and a vertical bar were grouped together. The group was selected in the Objects Manager and then Functions > Duplicate was selected from the main menubar. In the Attributes Manager (see Figure B–2), the number of copies was set to 12; Mode set to Linear so that the duplicates would be reproduced along a straight line; Move set to 75, the distance from step to step; and Rotation set to X = 22 degrees. This process created 12 *instances* of the original step and not 12 new objects. That is, checking the Generate Instances checkbox causes C4D to create copies that remain linked to the original. There are pros and cons to this approach. Whenever the original is altered—say, you decide to change the material that's applied to the stair or alter its size or shape—all of the instances change, too. Also, files with many instances are generally quite a bit smaller than files with the same number of discrete objects. Unfortunately, there's little you can change about an instance other than its location and orientation. So, if you think you might want to make structural changes to each instance later, you might be better off leaving Generate Instances unchecked, thereby creating copies with their own geometry.

figure | B–2 |

Duplicate Settings in Attributes Manager

Your Turn

Now, come up with your own idea for a scene that will make use of C4D's Duplicate feature; perhaps a legion of droids in a square battlefield formation, a row of parking meters along a city street, or trees in an orchard. Notice that C4D allows you to create duplicates along a line, in a circle, or along a spline.

Self Project Guidelines

1. As always, start with an end-state in mind. Do some research and planning and get your ideas down on paper.

2. As you consider possible projects, focus on the role repetition might play. The duplicated objects should be a focal point in your work. For instance, a row of lampposts might convey distance or lead the viewer's eye to a particular element in your scene.

3. Think about the benefits of instances. Do you want your duplicated objects to follow the parameters set by the original, or will you need to modify each later in your work? Consider your computer's memory and processing power; ten thousand marching ants, each a separate object, might push your computer to its limits.

4. Try to organize modeled elements into a group before duplicating, and then duplicate the entire group. In the staircase example, it was easier to create a stair, support, and column for the handrail and group those together for duplication than to duplicate each one on its own.

5. You can always duplicate duplicated objects if you wish. That is, you might create a single sphere, duplicate that sphere to create a row, and then duplicate that row to create multiple columns.

NOTES

| rendering |

 charting your course

As self-satisfying as work in 3D modeling might be, it's almost certain that at some point you'll want to output your work to video or print it out as hard copy for others to see and enjoy. So far, you've rendered all your work in the active viewport. If you want to share your work with others, you need to go beyond that and render to an external file. Rendering to either an external file or in the active viewport can be quick and easy if you're not especially concerned about file format or image quality, but that's not usually the case. Instead, you'll want to make adjustments that result in well-defined, realistic, and compelling models and scenes. In this chapter, you'll learn about the options available in C4D's render settings panel that allow you to control the look of your rendered work.

 goals

In this chapter you will:

- Understand the cause of aliasing in computer graphics and how antialiasing remedies the problem

- Learn how to set your own render preferences and save those settings for future use

- Learn the most common causes for missing texture alerts

- Understand refraction as it relates to rendered images with transparency

- Learn how to save your rendered images

RENDERING

RENDER SETTINGS

The control center of the C4D render process is the Render Settings dialog box (see Figure 8–1). Here, you'll select the types of shadows to be displayed in your final image, how transparencies appear, whether or not reflections will be rendered, and much more. Some settings apply only to scenes rendered externally as graphic images while others apply to both saved images and also rendering you do in the active viewport.

Generating realistic-looking scenes can demand a lot of your computer. Elements of a rendered scene, such as transparency, reflections, caustics, radiosity, and shadows, require a lot of computing power. A scene that included all of these elements could take many hours to render. At this point in time, while you're just beginning to understand rendering options and settings, it wouldn't be prudent to work with so complex a file. With each and every minor change, you'd have to re-render the scene and that would take a very long time. So, you'll find that several scenes have been created for you here, each designed to demonstrate a particular feature of C4D's render settings. You can find all of these in the Chapter 8 folder on your CD-ROM.

figure | 8–1 |

C4D Render
Settings Dialog Box

Antialiasing

If you've used other computer graphics programs, like Adobe Photoshop, you're probably familiar with the concept of *antialiasing*. Pixels on your computer screen and the tiny dots produced by printers are typically arranged in rows and columns. That means that perfectly straight vertical or horizontal lines and edges usually look great. However, as soon as you deviate from the strictly vertical or strictly horizontal, things get a bit nasty. This problem is also manifested where colors meet one another at an angle. The result is

a jagged edge that takes away from the sense of realism you've worked so hard to achieve in your scene.

Take a look at Figure 8–2 to see an example of aliasing. The figure shows a small area along the edge of a green sphere where it intersects a purple cube. Look closely at the areas near the arrowheads and notice the jagged edges.

Antialiasing is a process by which the appearance of jagged edges is reduced by softening the contrast along the line or edge. When a black line sits on a white background, gray pixels are introduced to reduce the jaggedness. Where the green sphere intersects the purple cube, grays, violets, dark greens, and similarly-colored pixels are introduced to soften the stark, jagged transitions from sphere to cube and green to purple. Clearly, the edges between shapes and colors in Figure 8–3 are much smoother than in Figure 8–2.

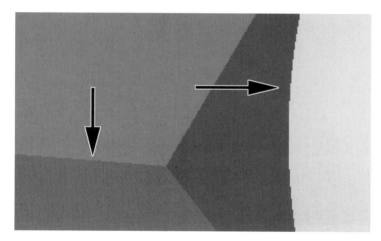

figure | 8–2 |

An Example of
Aliasing Where
Colors Meet

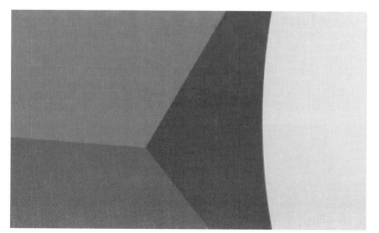

figure | 8–3 |

Antialiasing
Smoothes Edges

1. Open the file Compact.c4d in the Chapter 8 folder on the CD.

The scene—a compact sitting on a bathroom countertop—should open in the Perspective view.

2. Render the active view to see the compact, a gold-marble countertop, and lightly-textured gold walls.

3. Notice the jagged edge of the compact (near the arrowhead in Figure 8–4) and the edge of the mirror near this same point.

4. Open the Render Settings dialog box (Render > Render Settings or via the icon in the horizontal toolbar).

Notice that Antialiasing is currently set to None and that you can click and hold the dropdown menu to reveal two other options: Geometry and Best (see Figure 8–5). With None selected, your

figure | 8–4 |

Jagged Compact
and Mirror Edges

figure | 8–5 |

Antialias Settings
in C4D

scene renders very quickly but the edges are quite jagged. Geometry smoothes object edges, but takes a little longer to render. Best smoothes object edges and areas of color contrast, but takes the longest time to render.

Figure 8–6 shows three shots of the same image section. Render settings for each are, left to right, None, Geometry, and Best. Pay particular attention to the compact's edge and the area where the mirror and the plastic case of the compact intersect. In the image on the left, both these areas are jagged and rough. In the center image, the outside edge of the case looks much smoother but the inside edge next to the mirror is only slightly improved. The image on the right shows that smoothing has occurred in both areas, but that image took longer to render than the others. So, as is often the case, quality comes at a price: the time it takes to render. Test each setting, paying particular attention to image quality where colors meet, and the amount of time required to render the image.

figure | 8–6 |

Antialiasing Set to None (left), Geometry (center), and Best (right)

While you're thinking about antialiasing, take a look at the Min/Max Level settings on the Antialiasing panel.

5. Open the file Earring.c4d found on the CD.

6. Open the Render Settings dialog box.

7. Click on Antialiasing along the left edge of the Render Settings dialog box.

8. Note C4D's default settings: 1 × 1 for Min and 4 × 4 for Max.

The impact of the Max Level settings is usually the easiest to see, so start there.

9. Change the Max setting from 4 × 4 to 1 × 1.

10. Render the active view (see Figure 8–7).

figure | 8–7 |

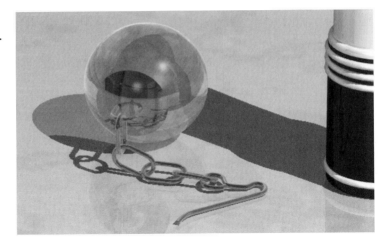

Rendered Scene
with Max Set to
1 × 1

You'll notice that the shadows appear jagged and rough, especially underneath the earring chain. Max Level has the greatest impact on antialiasing in areas of high contrast, such as where dark shadows fall on a light surface.

11. Reset the Max Level to 4 × 4 and render the active view again (see Figure 8–8).

Now you'll notice that area has been smoothed and looks much better.

The impact of the Min Level is harder to see. When Min Level is set too low, you may see small anomalies in areas where antialiasing tries to blend and smooth objects and colors.

figure | 8–8 |

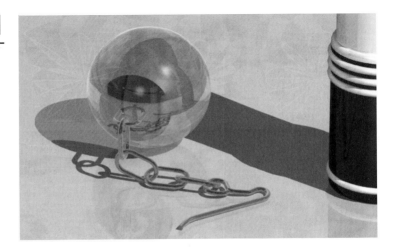

Rendered Scene
with Max Set to
4 × 4

12. Make sure the Min Level is set to 1 × 1 and render the active view.

Look very closely at the reflection of the chain in the metal piece at the top of the earring. You may notice that the edges of the reflected links are jagged and colors don't blend smoothly. Figure 8–9 is a close-up of the area.

figure | **8–9** |

Close-up of Render with Min Set to 1 × 1

13. Set the Min Level to 4 × 4 and render again.

The first thing you're likely to notice is that it takes a lot longer to render the scene with this higher Min Level setting. If you have the patience to wait it out, you'll see that the reflected links look much sharper and clearer with this higher Min Level setting (see Figure 8–10).

figure | **8–10** |

Close-up of Render with Min Set to 4 × 4

14. Reset the Min/Max Levels to 1 × 1 and 4 × 4, respectively.

These default settings will see you through most of your work, but it's good to know that you can change the settings to either increase the speed of your render or improve the quality of your work when you need to.

Saving Render Settings

One of the especially nice features of C4D is its ability to save a set of render settings, allowing you to quickly switch back and forth between preference sets, thereby saving you time when all you really need is a quick preview of how things will generally look. The full force of C4D's powerful rendering engine is just a menu selection away when you really want your work to look its very best.

1. Still in Render Settings, click General along the left side of the dialog box.

2. Set Antialiasing to None.

3. Type Quick into the Name field and hit Enter on your keyboard.

4. Close the dialog box.

5. From under the Render menu, choose New Render Settings.

The Render Settings dialog box will open once again, but now C4D's default render settings will be in place. These result in a higher quality image than the settings set for you earlier and saved as Quick in Step 5.

6. Change the Antialiasing setting to Best.

7. Type Best into the name field and hit Enter.

8. Close the dialog box.

9. From under the Render menu, choose Quick (see Figure 8–11).

10. Render the active view, making note of the time it takes to render the scene.

figure | 8-11 |

Selecting a
Rendering
Preference Set

The progress of the render process as well as the time taken to render your scene can be seen in the Status Bar (see Figure 8–12) immediately below the Materials Manager.

11. Also make note of the jagged edges in the scene.

12. From under the Render menu, choose Best.

13. Render the active view again, noting both time and the now smooth edges in the scene.

14. Choose File > New from the main menus.

15. Look under the Render menu and notice that Quick and Best aren't available there.

Your saved render preferences are available only in the file for which they were built. If you want to establish a number of preference settings and have them available for all your work, open a new file; establish and name your render preference settings as you did

figure | 8-12 |

Status Bar Showing
Render Progress and
Time

above; and then save this empty file as template.c4d into the same folder as your C4D application. Then, each time you open C4D, these sets of preferences will be available.

16. Close the new file.

17. Back in the earring scene, make sure Best is still selected under the Render menu.

18. Choose Render > Delete Render Settings.

19. Look under the Render menu again and notice that the Best preference set is gone.

20. Close the earring scene.

Missing Texture Alerts

As noted in an earlier chapter, managing your texture files is especially important. The best place to keep them is in a Tex folder, along side the C4D file with which they belong.

1. Open the Compact_2.c4d file.

2. Render the active view.

When you render the active view, you'll get an error message (see Figure 8–13) telling you that you have a missing texture. The problem is that the file Bathroom_1.jpg, used in the Color channel of the Bathroom material, can't be found. This common problem usually occurs when you save your C4D file (File > Save As. . .) without textures instead of saving everything together (File > Save Project. . .); you move your C4D file without bringing its Tex folder along with it; or you rename texture files without changing their names as referenced in the Material Editor.

3. Close this file.

figure | 8–13 |

Texture Error:
Missing Texture File

Transparency

Because transparencies can be especially demanding of your computer's processing power, C4D supplies you with an extra measure of control over how they render.

1. Open the file Perfume.c4d.

The file opens in the perspective view showing a perfume bottle in the near foreground and some lipstick farther back.

2. Render the active view.

Because Transparency, Reflection, and Shadow are set to None in the Render Settings dialog box, the image looks quite flat and unrealistic, but it renders very fast. Notice that the perfume bottle appears black, which was not intended.

3. Open the Render Settings dialog box.

4. Set Transparency to No Refraction and render the active view again.

Now, the bottle appears transparent instead of black and you can see through the bottle to the lipstick behind, but the glass doesn't appear very realistic. You'll remember that *refraction* was addressed in an earlier chapter on materials and textures. It's the bending of light rays as they pass through some substance other than air, in this case, glass and liquid. You'd expect the lipstick, countertop, and walls to appear a bit distorted when viewed through the bottle, but that's not the case here.

5. Change the Transparency setting to With Refraction and render again (see Figure 8–14).

Notice how the straw that extends down from the spray-top and into the perfume is distorted by the glass near the neck of the bottle and where it enters into the liquid. Also make note of how the lipstick and the countertop are distorted when seen through the glass as well.

Reflection and Shadow

While the image is greatly improved given the changes you've made to the Transparency setting, it's still rather flat. Out near the camera, there's a plane object that's been covered with a

figure | 8–14 |

Transparency With-
out (left) and With
(right) Refraction

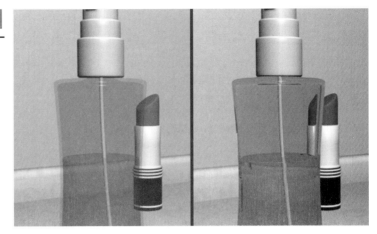

photograph of a bathroom (the same one you saw earlier reflected
in the compact mirror). At present, that's not showing up on the
bottle or lipstick case. Remedy that now.

1. In the Render Settings dialog box, set Reflections to All Objects.

2. Render the active view (see Figure 8–15).

figure | 8–15 |

No Objects Reflect-
ing (left), All Objects
Reflecting (right)

That makes a big difference. The reflected light brightens and warms the scene. You can see the frame of the shower doors as slightly dark vertical lines down the face of the perfume bottle. The lipstick tube is brighter and also reflects the bathroom image. Perhaps most impressive, the countertop now appears bright and polished, reflecting the objects sitting on it.

3. Finally, change the Shadow setting to All Types and render again.

There's only a single light source in the scene and it is set to generate soft shadows. When you render the scene, you'll see a shadow that runs back and slightly left of the perfume bottle. You've probably noticed that with each change to the render settings, render times have gotten longer and longer. A single light source was used in this file to help keep render times relatively short. If you'd like, open the file Perfume_2.c4d and render it. A second light source has been added, and noise has been added to the fill light to generate more interest in the image, giving the otherwise flat walls a little contrast. While this scene still renders fairly quickly, it takes about 15 times as much time to render as the original Perfume.c4d scene.

Rendering Regions and Objects

Before you can continue to explore the Render Settings dialog box, you'll need to spend just a couple of minutes with some of the options for rendering only parts of a scene and rendering externally to a file.

1. Open the file RenderSafe.c4d.

2. Click and hold the Render in Picture Viewer icon in the horizontal toolbar (see Figure 8–16).

Take note of the first four icons. From top to bottom, they are Render Region, Render Active Objects, Render to Picture Viewer, and Render View. The last of the four, Render View, simply renders the active viewport. This is nothing new to you.

3. Select the top item, Render Region.

4. Click and drag a rectangular selection in the middle of the screen to render just that portion of the screen (see Figure 8–17).

This is a quick and easy way to render only that portion of the scene you are currently interested in.

figure | 8–16 |

Unfolded Render Options

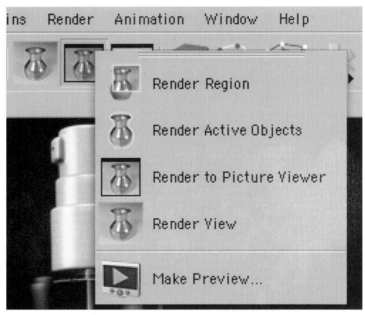

figure | 8–17 |

Rendered
Rectangular
Selection

5. Shift-click the Perfume and Lipstick objects in the Objects Manager.

6. Selected Render Active Objects from the folded render icon set.

7. Note that while the lipstick and perfume bottle render, nothing else does.

Picture Viewer and the Render Safe Area

You might render a scene for any one of several different media: for example, television, film, the Web, or print. For each case, the size and shape may differ. Also, the size and shape of your output may differ from your viewport workspace.

1. Select Render to Picture Viewer.

A separate window opens and, in it, your scene renders. In this particular case, you've got a problem. Notice that the lipstick is outside the scene, as is one end of the eyebrow pencil.

2. Under the viewport's Edit menu, select Configure.

3. Near the top of the Attributes Manager, click View.

4. Check the Safe Frames checkbox.

5. Check the Render Safe checkbox.

When you check Render Safe, two gray vertical lines will appear in the viewport. These gray lines show the bounds of the area to be rendered out to the picture view and your saved file. You can see that the lipstick and sharp end of the pencil are outside these lines. Title Safe and Action Safe are probably most important to you when you're animating a scene. Check, then uncheck, each to see where these boundaries lie. Leave Render Safe checked.

6. Zoom out a bit to bring the lipstick and eyebrow pencil into the Render Safe area, the space defined by the gray lines.

7. Render to Picture Viewer again to see that everything is now in-frame.

Render Output Settings

Each media type conforms to a particular set of specifications. For instance, if you're rendering for viewing on a computer screen, you'll want your image rendered at 72 pixels per inch. If you're thinking about printing the image out, you'll want a much higher value: something in the neighborhood of 300 dots per inch depending on your printer's capabilities. Until recently, the common aspect ratio of computer screens was 4:3, which yields settings such as 800 \times 600 and 1024 \times 768, but 16:9 is becoming increasingly popular. High-definition television, film, television in the U.S., and

television in Europe each has unique standards that you'll need to keep in mind as you arrange your scenes and render them out.

1. With the RenderSafe.c4d file still open, open the Render Settings dialog box.

2. Select Output along the left side of the dialog box.

Many of the options here become important later when you get into animation. The only setting you'll consider here is the Resolution.

3. Click and hold on the Resolution drop-down menu to see pre-defined options for screen resolution.

4. Select 800 × 600.

5. Select Render to Picture Viewer.

As before, your scene will begin to render in a new window. You may not notice much difference between this render and the one you did earlier at 320 × 240. That's because the window opens small and the rendering image is only a fraction of its true size.

6. Look at the status bar in the window where your scene is rendering (see Figure 8–18) and notice the Zoom value.

figure | 8–18 |

Rendering Image:
Zoomed Out

As you can see in Figure 8–18, you're 8 seconds into the render and the size of the image being rendered is 800 × 600. The Zoom value tells you that you are looking at the image zoomed out. You can, of course, grab the lower-right corner of this window and click-drag it to expand the window and see your rendering image full size. Also note that this window has move and zoom icons in its upper-right corner, just like those in your viewports. They work the same way. You'll see that the image in Figure 8–18 is rendering in two sections, one above the other. That's because the computer used to render this image has two processors and C4D distributes the task of rendering the scene to both; one processor has started at the top and the other near the middle.

In addition to using the resolutions C4D includes as standards, you can also enter your own values.

7. To the right of the Resolution drop-down menu, enter values of 200 then 100 into the two fields that read 800 and 600 earlier.

8. Note that the Resolution drop-down menu now reads Manual.

9. Also note that two gray horizontal lines have appeared in your viewport (see Figure 8–19).

Just like the vertical lines you saw earlier, these show the bounds of the Render Safe region. If you render the image now, the top of the perfume bottle and the lower-right end of the pencil will be cut off.

figure | 8–19 |

Lines Indicating
Render Safe Region

Saving Rendered Images

Having sized your image as desired and established transparency, shadow, and reflection settings that will ensure the most realistic-looking image possible, you want to save your work to disk in a format that will allow you to edit it in an application like Photoshop, print it out, or make immediate use of it as an image or video.

1. Reset the Resolution to 800 × 600.

2. Select Save along the left side of the Render Settings dialog box.

3. Click on Path to designate a place on your hard drive or network where you'd like to save your rendered image.

Remember, you're not saving the C4D file now, only the image that you render next time you click on Render to Picture Viewer.

4. Click and hold the Format drop-down menu to see the many types of file formats C4D can save your rendered image as.

The other options here presume that you have a basic understanding of computer graphics. You'll select 8 Bits/Channel for 24-bit color and 16 Bit/Channel for 48–bit color. The options for Name become especially important if you plan to render out a sequence of images that you might, for instance, bring into a video editing software application. Files can include a three- or four-digit number to identify their location in the sequence. You also have the option of adding a three-letter suffix to the file name to identify the file type: for example, .tif, .jpg, and .bmp. DPI and Resolution (on the Output page of the Render Settings dialog box) work hand in hand. While 72 DPI might be okay for output to the screen, you'll almost certainly want a higher value if you plan to print your image. To figure the size of your printed file, divide the resolution by the DPI. So, with Resolution set to 800 × 600 and DPI set to 72, your printed image would be in the neighborhood of 11.11 by 8.33 inches. Conversely, if you know you want to render at 300 DPI and you want an image that's 8 by 10 inches, you'll need to set resolution at 2400 × 3000.

5. Set Format to TIFF.

6. Leave Depth set to 8 Bit/Channel, Name to Name0000.tif, and DPI set to 72.

7. Render to the Picture Viewer.

Now look in the location you specified in step 3. You'll find your file there. Feel free to open it with your image editing software and adjust it as you desire.

Effects

There are several other options in the C4D Render Settings dialog box that can help you render especially engaging scenes and images. Radiosity and Caustics will be available only if you have the C4D Advanced Render module. The former produces very realistic lighting, with light rays filling space and illuminating an environment as light truly would in the real world. The settings under Caustics allow you to control the production of the light patterns caused by reflections off curved surfaces. If you've ever looked to the bottom of a swimming pool on a bright, sunny day you've seen this effect: ribbons of bright light dancing along the bottom of the pool, twisting and turning in time with the waves on the pool's surface. If you have the Advanced Render module, experiment with these settings. Now, however, turn your attention to the Effects page in the Render Settings dialog box. There are several fantastic effects you can experiment with here. Take a close look at two and come back later to play with the rest.

Cel Renderer

Using Cel Renderer, you can produce cartoon-like images quite easily.

1. From the CD, open the file earring.c4d.

2. Open the Render Settings dialog box.

3. Select Effects along the left side of the dialog box.

4. Click and hold the Post Effects arrow in the upper-right corner of the dialog box and choose Cel Renderer.

5. Check Outline and Edges, but leave Color unchecked.

6. Render the active view.

The results are especially striking. The image shows polygon edges as a black wireframe against a white background (see Figure 8–20).

figure | 8–20 |

Cel Renderer: Edges,
No Color

7. Uncheck edges.

8. Check Color, Outline, and Illumination.

9. Check Quantize and set Steps to 4.

10. Render the active view.

The result has a pop art or cartoon-like feel to it (see Figure 8–21). The value for Steps under Quantize determines the steps between color values. Set Steps to 2 and render again; then repeat with Steps set to 20 to get an idea of how this works.

figure | 8–21 |

Cel Renderer: Color,
Quantize Steps at 4

Depth of Field

There will be times when you'll want a particular item in a scene to stand out from its surroundings. Perhaps you've put together a promotional ad for perfume and so you've built a scene that shows a countertop with several items on it; but you want to draw your viewer's attention to the perfume bottle and away from everything else in the scene that might be distracting. One way to do that is by softening the focus in the foreground and background, leaving only the perfume bottle in the center of the shot crisp and clear: a trick you could pull off by adjusting the aperture if you were shooting the scene with a 35mm camera. This center part of the shot—the area along which everything is in focus—is called the *depth of field* (DOF). C4D makes it fairly easy to adjust DOF.

1. Open the DOF.c4d file, which includes lipstick, a bottle of perfume, and an eyebrow pencil.

2. Render the scene and notice that everything is in focus; that is, everything competes for attention.

3. Add a targeted camera to the scene.

4. Press F2 to see the scene from above (see Figure 8–22).

5. Select the Camera.Target object in the Objects Manager.

figure | 8–22 |

Countertop Viewed from Above

6. Using the Move Tool, reposition the Camera.Target object between the eyebrow pencil and the perfume bottle, favoring the perfume bottle.

As you move the camera target around the scene, the camera will rotate to remain fixed on it. The camera target will serve as the point at which you want greatest sharpness. Position it between the perfume bottle and the eyebrow pencil, immediately in front of the bottle.

7. Return to the perspective view.

8. Drag the Camera.Target object straight up on its Y axis about 200m, so that it sits a bit above the bottle's midpoint.

9. In the Objects Manager, rename the Camera object DOF_Camera.

10. From under the viewport's Cameras menu, select Scene Camera > DOF_Camera.

11. Make sure the Move Tool is still selected and that the X, Y, and Z axes are all unlocked so you can move the DOF_Camera around as required.

12. Click and drag inside the perspective viewport to reposition the DOF_Camera such that your scene looks like Figure 8–23 (X, Y, and Z of about 550, 275, and −275 in the Coordinates Manager).

Make sure that the eyebrow pencil is visible in the foreground and that the perfume bottle bisects the lipstick in the background.

figure | 8–23 |

Properly Framed
Scene

13. Open the Render Settings dialog box.

14. Select Effects along the left side of the dialog box.

15. Click and hold the Post Effects arrow in the upper-right corner of the dialog box and choose Depth of Field.

16. If any other effects are selected, uncheck them.

Your Render Settings dialog box should look like Figure 8–24.

figure | 8–24 |

Render Settings for Depth of Field

17. Increase the Blur Strength from 5% to 15% to increase the blurriness of out of focus objects.

You'll find that a little bit of Blur Strength goes a long way. Here, 15% is probably more than you need but this higher setting should make it especially easy for you to see how depth of field works in C4D.

18. Return to the Top view.

19. Select the DOF_Camera in the Objects Manager.

20. Click on the Depth button in the Attributes Manager to see that panel.

21. Check the Rear Blur checkbox.

When you check the Rear Blur checkbox, a new set of dark-green lines appears in the viewport (see Figure 8–25). The plane that appears opposite the camera at the far end of the dark-green lines is the rear depth of field plane. In its center is an orange handle that

figure | 8-25 |

Rear Blur: Far End of
Depth of Field

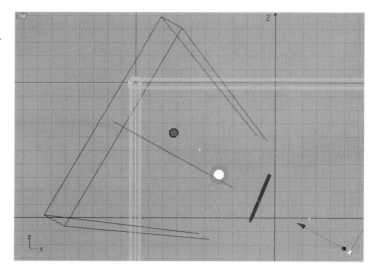

you can click and drag to manually adjust the location of this
plane. As you make changes in the viewport, those changes will also
show up in the Attributes Manager.

22. Click and drag the orange handle at the far end of the depth of
field toward the camera, until the End value for the Rear Blur
in the Attributes Manager reads approximately 600m.

23. Switch to the perspective view.

24. Render the active view.

Watch the viewport carefully as the scene renders. You'll notice that
the process takes place in stages. First the entire scene will render
clearly. Then, the background will be blurred in a separate pass.
Notice that the lipstick is now out of focus.

25. Switch to the Top view.

26. Back in the Attributes Manager, check the Front Blur check-
box.

The orange handle for the front edge of the field of view may be
hard to find. It may sit inside the camera. Still, you shouldn't have
any difficulty clicking and dragging it forward.

27. Click and drag the orange handle away from the camera until
the End value for the Front Blur reads approximately 220.

figure | 8–26 |

Rendered Scene with
Front and Rear Blur

28. Return to the Perspective view and render again.

If everything worked as expected, your final render should look like Figure 8–26. Both the eyebrow pencil and the lipstick should be out of focus. At present, with the Start values for Front Blur and Rear Blur at 0, only the camera target will be in sharp focus. To expand this area a bit, increase the Start value for both the Front Blur and Rear Blur. This will open up the in-focus area a little bit.

29. Set Start for Front Blur to 100.

30. Set Start for Rear Blur to 200.

31. Render the active view.

If you ran into problems, take a look at the DOF_Final.c4d file on the CD. Also, feel free to bring the Blur Strength down a bit and play with some of the other Depth of Field parameters in the Render Settings dialog box.

SUMMARY

If you have worked through this book in linear fashion, you have come to the end; and the last stage in almost every modeling and animation project: rendering. In this chapter, you learned how to adjust settings in the Render Settings dialog box and how to save preference-sets in order to expedite rendering when all you need is a quick, rough preview and when you want the very best rendered

image C4D can produce. You managed rendering time and image quality by changing render settings for transparency, reflection, aliasing, and shadows. Also in this chapter, you were introduced to concepts and practices for rendering all or part of an image and how to render to external files of varied sizes, resolutions, and formats.

The chapter concluded with an introduction to C4D's special effects. As you can see, C4D makes it easy to produce images that mimic reality with depth of field as it would be seen when using a 35mm camera; but also the other extreme, fantastic pop art and cartoon-like images.

C4D is a first-rate modeling application, especially well-known for the power of its renderer. You've begun to harness that power here.

in review

1. Explain aliasing and how the problem is attended to by computer graphics applications like C4D.

2. What is the relationship between image complexity (reflections and transparencies in the rendered scene, high Min and Max antialiasing levels, and use of depth of field) and render times?

3. Antialiasing can be set to None, Geometry, or Best. Discuss the implications for using any one of the three.

4. You've decided to build several sets of render preferences and make them available for all of your future C4D scenes. How would you take care of that?

5. You attempt to render a scene but get the Texture Error message: Clouds.jpg (Sky). What's the problem? Be specific.

6. What is refraction and how is it associated with transparency?

7. The parts of your scene at the far edges don't appear when you render to an external file. What is most likely the problem?

8. You wish to render out a scene that you'll subsequently print on glossy photo-quality paper. You decide to print at 300 DPI and you want the image to be 5" by 8". What will your resolution need to be?

9. How might you use depth of field to blur objects in the foreground and background of a rendered image?

10. Using the Cel Renderer, how does increasing the value of Quantize > Steps influence the look of your rendered image?

↗ EXPLORING ON YOUR OWN

1. Ball and Jacks used to be a popular game with children. You spread jacks across a small surface. Then you bounce the ball once and, with the same hand, pick up one jack in time to catch the ball again. You repeat this process, increasing the number of jacks you pick up with each bounce. Model a scene with jacks spread between the foreground and the background and the ball near the middle of the spread. Use Depth of Field to render the image with some of the jacks in both the foreground and background out of focus, but a small number of jacks and the ball in sharp focus.

2. Create three or four rendering preference sets (one optimized for speed, one for highest possible quality, one that renders everything except reflections, and one that will do a cel render) and save them (in an empty scene) as template.c4d to the same folder as your Cinema 4D application.

3. Go back and open scenes you worked on earlier in the book and render them out for printing. Print a couple of your favorites. Use Cel Renderer to create a couple that look like cartoons.

NOTES

index